social media
and music

Steve Jones
General Editor

Vol. 77

The Digital Formations series is part of the Peter Lang Media and Communication list.
Every volume is peer reviewed and meets
the highest quality standards for content and production.

PETER LANG
New York • Washington, D.C./Baltimore • Bern
Frankfurt • Berlin • Brussels • Vienna • Oxford

H. Cecilia Suhr

social media
and music

The Digital Field
of Cultural Production

PETER LANG
New York • Washington, D.C./Baltimore • Bern
Frankfurt • Berlin • Brussels • Vienna • Oxford

Library of Congress Cataloging-in-Publication Data

Suhr, H. Cecilia (Hiesun Cecilia)
Social media and music: the digital field of cultural production / H. Cecilia Suhr.
p. cm. — (Digital formations; v. 77)
Includes bibliographical references and index.
1. Music—Social aspects. 2. Social media. I. Title.
ML3916.S89 780.285—dc23 2012000739
ISBN 978-1-4331-1448-9 (hardcover)
ISBN 978-1-4331-1447-2 (paperback)
ISBN 978-1-4539-0591-3 (e-book)
ISSN 1526-3169

Bibliographic information published by **Die Deutsche Nationalbibliothek.**
Die Deutsche Nationalbibliothek lists this publication in the "Deutsche
Nationalbibliografie"; detailed bibliographic data is available
on the Internet at http://dnb.d-nb.de/.

The paper in this book meets the guidelines for permanence and durability
of the Committee on Production Guidelines for Book Longevity
of the Council of Library Resources.

© 2012 Peter Lang Publishing, Inc., New York
29 Broadway, 18th floor, New York, NY 10006
www.peterlang.com

Printed in the United States of America

Dedicated to
Mom and Dad and, to all True Artists

Contents

Acknowledgments

Writing this book was not a result of my own singular effort, but the work and inspiration of many. The initial stage of this book was conceived after having much needed interactions with my mentor, Jack Bratich, at Rutgers University. He introduced me to what would end up being important theoretical frameworks in this book, such as immaterial, affective, and free labor, and helped me articulate my passion in music and social media in a scholarly context. I am indebted to him as he was instrumental to equipping me with critical components of this work. I would like to also express my gratitude to John Pavlik and David Hesmondhalgh for their comments in the early stage. During a more advanced stage, Steve Jones, the series editor of this book, has shed light on the issues I needed to expand. I am truly grateful for his faith in this project along with timely and important feedback. Finally, I would like to thank my copyeditor, Rachel Hildebrandt, for lending me her shrewd set of eyes and helping me hone my writing, as well as Mary Savigar, an acquisition editor at Peter Lang Publisher, for making sure that everything moved swiftly throughout the entire process.

In addition to my mentors and editors, I would like to deeply thank fellow musicians and others who have participated in my research. Although some musicians I encountered were not directly a part of the study, I also want to thank them for influencing my thoughts on the plight of being an artist in the digital era. Simone Vitale reminded me not to lose sight of *spirit* in all creative processes and made me cautious of a writer's egoistic need to be "right" for the sake of prov-

ing something, since such endeavors only lead to destruction and futility. He and Cheri Chuang both exemplified charitable musicians and allowed me to understand that being an artist is essentially equivalent to being a saint. Walter Santucci linked me with useful information on music and altruistically shared connections in the music industry. Akira Katani enthusiastically shared his invaluable experiences on social networking sites. I also thank dear friends, Spiro Pantazatos and Katherine Henry, and colleague Yi-Fan Chen for providing loving support during my isolated period revising the draft.

Lastly, I would like to dedicate this book to the most amazing parents in the world, Jungkarp Suhr and Wonkyong Suhr. Growing up, my father, a retired professor, inculcated in me the value and beauty of intellectual endeavors. My mother, on the other hand, has inspired me to have the voice of humanity and soul in a scholarly and creative work. This book is a result of their undying love and support. Without their selfless sacrifices, neither I nor this book would have existed, so I thank my parents from the bottom of my soul and heart.

Parts of chapter two appeared in *International Journal of Knowledge, Technology and Society* (forthcoming); Parts of chapter Three appeared in *New Media and Society (2009), Comunicar (2010)* and *International Journal of the Humanities* (forthcoming).

Preface

A deep yearning to create music has driven me since my adolescence. When I was in my late teens, I strove to express myself through music but other than improvising music alone, I did not know how to convey to others about my musical ideas and passion. I vividly remember feeling helpless when I wanted to share my music but was unsure how to fulfill such desire. It was only when I moved to New York City in 2003 that I found ways to explore various opportunities in music, as a performer as well as in the business side of music industry. I started off as an intern for an independent artist, Shelly Nicole Blackbushe, who had recently released her first album. I witnessed firsthand the process involved in an artist producing an album independently. Another intern and I helped with the promotion of the album in a truly bottom-up guerrilla marketing fashion. I handed out flyers for Blackbushe's upcoming shows in Central Park and compiled contact lists of audience members during her performances.

Soon after working for Blackbushe, I had an opportunity to intern at Columbia Records (Sony) and at Motown Records (Universal). My time at Columbia Records was especially memorable, as I was involved in the process of selecting rising talents as an Artist and Repertoire (A & R) intern. At the time, a select group of interns was chosen to discover artists who were making buzz. At regular intervals, we worked in a small room called "The War Room," where we considered various artists that might be suitable candidates for new contracts. We searched for artists online using various search engines, such as mp3.com and garageband. com. (MySpace had not yet been launched but was under development at that

time.) When we discovered an artist that we felt had the potential for a recording contract, we brought examples of the artist's music to the weekly listening meeting, where we discussed personal reactions and each artist's commercial viability. As an incentive, whenever an artist was signed, each intern, even those who had not been involved in the discovery, received a small paycheck; this bonus was meant to reduce unnecessary competition among us interns. In fact, John Legend was signed as a result of one intern's efforts.

At one listening meeting, the vice president of Columbia Records was present, where he informed us about recent efforts to strengthen the online division. I could sense the urgency in his voice, but little did I know that the internet would create a critical juncture for the music industry. Before too long, the industry was confronted with the challenging question: "How are we going to wrestle with the increasingly popular internet realm, where musicians are gaining more independence, while fans and consumers are finding alternative ways to buy music both legally and illegally?"

On the other hand, my internship at Motown Records in the Artist Relations Department provided a personal learning experience. My own moment of potential discovery by an A & R agent happened on one unexpected day. As I waited for the elevator, I encountered the A & R agent of Universal Records. However, I did not know that he was an A & R agent until I had finished playing music in his office. Although a brief discussion about my work in the studio followed, there was no fairytale ending. Nothing developed from this encounter, perhaps due to my own passivity or unwillingness to accept the unbalanced power relations that exist between aspiring musicians and A & R agents.

As I shifted from one band to another and from one internship to the next, I came into contact with various people, ranging from fellow aspiring musicians in New York City to successful music industry associates. During this period, I enrolled in a doctoral program, and I transitioned from being a performer to a distant spectator. Simultaneously, I found myself growing away from the off-line music community while taking a closer look at the online music communities such as social networking sites. It was in this particular context that this book was initially conceived. As both a casual and a musician user on the social networking sites, I studied them with the eyes of a critical thinker and a shrewd observer. Although there were times when my irrational passion as a musician had difficulty negotiating with my critical voice as an academic, with much reflection and revision, I was able to reconcile my various conflicting voices. This book, therefore, is the result of my effort to interweave into my scholarly work the affective dimension of the musician's struggles, difficulties that can easily be overlooked or simplified in critical scholarship. As a whole, it is my hope that this book will contribute to the research on musicians and the music industry in the social media age by mapping out the "digital field of cultural production."

Introduction

Justin Bieber, Colbie Caillat, OK Go, Soulja Boy, Tila Tequila, and Rebecca Black share one commonality. They have gained enormous popularity on the social networking sites. While some names may be familiar to the reader, others may not be. Nonetheless, regardless of whether or not a performer has become a "household name," these people have successfully capitalized on their fame gained on the social networking sites. As evinced by these examples, social networking sites are perceived as places where musicians can exercise full control over their careers, gaining independence and empowerment through do-it-yourself methods. This general conception is considered well-established, and I offer no criticism of this phenomenon. However, the way musicians gain recognition is not always uncontroversial, accidental, or the result of hard work and talent. The public discourse about social networking sites has often been positive when it comes to musicians. Frequently, Americans are regaled with news reports about performers breaking out of obscurity to overnight fame. The nature of social networking sites allows artists through the click of a button to gain exposure to hundreds, thousands, and millions of people instantly.

Through a selective depiction of various prominent social networking sites, this book seeks to present an overarching view of the sites' impact on musicians and the music industry while recognizing the musicians' individualism and power. I will provide a detailed account of the social media phenomenon by untangling the various nodes that anchor the web of networks, where power, politics, and

control interconnect in the quest for ultimate approval. The overarching framework for this study is drawn from Pierre Bourdieu's theories related to fields and capital. In *The Field of Cultural Production*, Bourdieu (1993) sought to explain how writers and artists work to gain recognition and legitimation for their work:

> to make one's name means making one's mark, achieving recognition (in both senses) of one's difference from other producers, especially the most consecrated of them; at the same time, it means creating a new position beyond the positions presently occupied, ahead of them, in the avant-garde. (Bourdieu, 1993, p. 106)

On social networking sites, musicians go through a similar process to gain recognition for their work. In the context of his arts study, Bourdieu (1993) focuses on the interplay of power in the generation of meaning and influence: "who is the true producer of the value of the work—the painter or the dealer, the writer or the publisher, the playwright or the theatre manager" (p. 76). Although Bourdieu's analysis does not pertain to musicians in particular, his arguments about attaining recognition can be easily applied to the context of musicians. Therefore, a similar line of inquiry can be raised in connection to the social networking sites. Who determines the value of works produced by musicians? How is the "value" of musicians measured? What forces create the evaluative mechanism?

Of course, Bourdieu's questions have definite limitations in terms of applicability, since this study is dealing with a different time period, and Bourdieu focused his study to writers and painters. Painting and writing require a degree of expertise and a set of predisposed tastes developed through contentious politics. Hence, becoming an artist has been considered a tough journey for many, as reflected in the stories of artists dying without recognition during their lifetimes but sometimes gaining recognition many years after death. Art is a precarious sector, where an endorsement or negative comment from a renowned critic can make or break an artist's career. So much of one's career depends on others who have the power to make decisions (and, of course, on luck), which is an issue that Bourdieu finds questionable and troublesome. Bourdieu is critical of the way in which "training" that discerns good art from bad art is a predisposed and constructed taste.

In the context of music, aural qualities function differently than those tied to the visual or literary arts. As Ong writes, "sight isolates, sound incorporates. Whereas sight situates the observer outside what he views, at a distance, sound pours into the hearer" (Ong, 1982, p. 70). He further explains that sound is different from vision in terms of the senses: "sound is thus a unifying sense..." (p. 70). Although I do not seek to prove that sound is superior or inferior to vision, sound impacts the senses in a more complete and encompassing way than vision. In other words, sound seems to elicit more amateur criticism than art or writing per se, perhaps because sound appears to have a direct impact on the personal

senses. Many individuals can at least describe what they like or dislike about specific musical pieces or performances even if they do not have the technical language to critique music in a professional manner.

Another distinction between Bourdieu's subject of study and the subject introduced in this book concerns the architectural foundation of the fields in question. Bourdieu's fields are not grounded in the mediated environment. His examination consisted of non-mediated encounters, whereas the fields presented here are in the digital context of the social networking sites. I view the social networking sites as a digital field of cultural production, where values are assigned and the "consecration" of art works is contested. While a drawing may be overlooked by many viewers, if it is discovered by one person with credible expertise, the painting is "consecrated" and shifts from being "just a drawing" to being an "art work." According to Bourdieu, the process of "consecration" is extremely political and contentious in the art and literary world. On the social networking sites, artistic "consecration" is often left to the network bodies and to the various types of decision makers connected to them.

Unlike many painters and writers who commonly struggle for the right to be called "a painter" or "a writer," musicians who use the social networking sites enter the field without a need to be legitimized as such. To a certain degree, any individual could be considered a musician if he or she wished to make that claim. However, there is a clear distinction within the field; there are musicians who are signed to the record labels and those who are unsigned/independent musicians. The musician already signed to a record label has been "consecrated" in the digital field of cultural production, while the musician who is unsigned must still compete to be "consecrated." In this context, it is important to note that the unsigned, independent musician's process of consecration is often similar to the standard process of incorporation related to the mainstream media industry. However, I do not mean to assert that every musician desires to be signed or discovered by the mainstream major record labels. Regardless, the growing trends in the digital field of cultural production is based on a partially pre-configured field where the rules and prizes are intended to attract talented, unsigned musicians. The impulse behind the evolving configuration of the field is, first and foremost, based on the ability to drive heavy traffic to the networking sites, attracting attention, and generating hopeful rhetoric among musicians about how so and so has "made it" by putting videos or music online. Thus, a single discovery of a musician is sufficient to convince countless musicians to enter the digital field. However, this does not mean that the digital field of cultural production only exists to satiate the needs of the social networking sites and the mainstream industry. From time to time, musicians' agencies can be exercised, increasing the need to revisit and explore the new configuration of the fields.

In this book, I focus on the digital field of cultural production as a paradigm that parallels Jenkins' (2006) notion of "convergence culture." Convergence culture is defined as the activities of bottom-up, consumer-driven processes and of top-down, corporate media forces colliding with one another. Social networking sites embody both the mainstream media industry and the grassroots activities of everyday, non-professional users. In this respect, the case studies of social networking sites in this book reflect the division between Bourdieu's two subfields in which large-scale productions and restricted productions co-exist. Although the shortcomings of Bourdieu's concept of large-scale productions are discussed in the next chapter, in the digital field of cultural production, such a demarcation is arbitrary and precariously analogous to the division between the major record labels and the independent labels. (This aspect will be contextualized fully in the next chapter.)

While I only loosely apply Bourdieu's field theories, by utilizing his concepts in my study, I seek to clarify the intent of my research. It is important to understand that my analysis of the value / fame / popularity from a sociological angle does not take into account the aesthetics related to music and personal taste. My goal is to reduce any serious, unjustified assumptions about the relationship between the aesthetics of music and its perceived value, an issue that must be tackled with extreme sensitivity. To critique artworks from a sociological angle essentially means that one holds a skeptical view on creativity and artistic "genius." According to Wolff (1981), to study art from the sociological angle is to argue

> against the romantic and mystical notion of art as the creation of "genius," transcending existence, society and time, and that it is rather the complex construction of a number of real historical factors. (p. 1)

One of the critical and paradoxical claims that underlies Bourdieu's view and the arguments set forth in this book is based on this framework. While I adopt Bourdieu's concepts to unpack the digital field of cultural production, I do not seek to debunk the belief that relates to the immanent power of art. In other words, the goal of my analysis is neither to deconstruct nor demystify the romantic notion of creativity. Holding on to the conception of "aura" or divine creativity may appear rather naïve and irrelevant in the context of critical scholarship, but my goal is to establish the groundwork for a scholarly study that rests and oscillates in between the social / ideological construction of artistic value and the auratic, mystical conception of creativity. In short, my argument does not fall in either framework. While recognizing the politics that pertain to artistic consecration, I also valorize the sheer immanent or auratic power of the artistic endeavor.

Echoing Becker's (1982) seminal work *Art Worlds,* I will examine the "social network" of cultural production on the social networking sites. Becker empha-

sizes the collective aspect of artistic activities by defending and clarifying that his work is not "the sociology of art at all, but rather the sociology of occupations applied to artistic work" (p. xi). In this vein, I will study the perceived value of musicians' productions (the notion of value here will later be interpreted in terms of Bourdieu's different types of capital) by untangling various coterminous forces. The music industry, the mainstream culture, social networking sites, musicians, and fans / audiences do not play alone in this field but are very much interconnected. By invoking the notion of collective intelligence as formulated by Pierre Levy (1997),* I will explore the collective network of forces in order to fulfill three specific aims.

My first and primary goal is to contribute to an overall depiction of the digital field of cultural production by addressing the following questions in the context of four case studies on MySpace, YouTube, Second Life, and Indaba Music. With the rise of the social media, how do musicians and the music industry work together? How do musicians and the industry impact one another? On a related note, how does the social networking sites' involvement with the mainstream music and media industries impact musicians and vice versa? What are the new and emerging trends in the digital field of cultural production? What has changed, remained, and transitioned as new forms of practice? In this context, I will introduce the rise of self-promotion and will further analyze a variety of groundbreaking communication mechanisms and competitions that were not available prior to the social media era.

Secondly, my study offers an alternative viewpoint on the exploitative aspects of user-generated content by examining the complexity related to the rewards that musicians receive by participating on the social networking sites. Much of the discussion about the social networking sites has been contextualized through problematizing the implications of immaterial and affective labor, concepts formulated by Lazzarato (1996) and Hardt and Negri (2000), and of free labor as conceptualized by Terranova (2004). Various scholars have argued that users in the digital environments knowingly and unknowingly work for free on behalf of the mainstream corporations, and this helps the companies build their brands (Hearn, 2010; Andrejevic, 2011). An in-depth analysis of this issue will be carried throughout each chapter, and I will focus on musicians as artists who have different motivations and evince different types of rewards. In order to further distinguish the different types of rewards, I will adopt Bourdieu's notion of symbolic, cultural, social, and economic capitals. In doing so, I will argue that while exploitative elements may exist in the digital field of cultural production, musicians' conflicting interests are often inevitably aligned with their participation in the mainstream industry. While this book does not intend to resolve the conten-

* Levy (1997) defines collective intelligence as "a form of universally distributed intelligence, constantly enhanced, coordinated in real time, and resulting in the effective mobilization of skills" (p. 13).

tious and vexing problem of the rise of the digital economy (Terranova, 2004), I will address this issue in the context of each case study, questioning how it might be applied to the digital field of cultural production.

My third and final goal in this book is to juxtapose the optimistic narrative pertaining to the potential of social networking sites (as discussed in my first goal) to influence the emergence of problems related to the evaluative system. In doing so, I will explore the politics of popularity, ratings, and the ranking systems on the social networking sites, and I will further examine the broad implications of evaluations in the overall context of the digital field of cultural production. To achieve this aim, my analysis is grounded in the negotiation of four processes: 1) analyzing how musicians work to gain popularity; 2) exploring the experts' recommendations on how to earn popularity through the observation of certain protocols and tips; 3) examining the mediated discourse pertaining to the media's construction of popularity through a close scrutiny of the rhetoric used to describe the process whereby musicians gain fame; and 4) studying the rewards and impact of increasing popularity. In other words, do the mainstream industry and the record labels reward musicians for being popular? If so, what is the implication of such rewards for our cultural landscape? With this in mind, I argue that in the digital field of cultural production, the musicians' field is a partially preconfigured ground where ascribing value to specific musicians often benefits corporate mainstream agendas, although it can mutually benefit musicians.

Furthermore, the evaluative mechanisms reduce the complex understanding and appreciation of music to simple binary concepts of likes and dislikes, popular and unpopular judgments, thereby recreating the hierarchy and format that exists in the mainstream media. Thus, the music field is constantly in flux and partially preconfigured. The field is constantly being altered as different interest groups negotiate and compromise each other's benefits, drawbacks, pros, and cons. To avoid ignoring small, minor examples that pose challenges to my argument, I have purposefully grounded my study in a dialectical framework where contradiction and paradox are highlighted and problematized.

Wrestling with Temporality and the Genres of Music

It is very important to point out that in the midst of a close observation of the social media revolution, documenting current trends and explaining them in a consistent voice or point-of-view is extremely challenging. The primary reason is the fleeting and precarious nature of the social networking sites, the activities and features of which are constantly in flux. Almost every day there is a new development in the social media which can easily distract a researcher from the direction in which he or she is logically headed. In comparison to other media formats, such as television, radio, movies, and magazines, social networking sites

are developing at a faster speed, which poses various challenges. For instance, I devoted several weeks to explaining the recent features that MySpace had introduced and the consequences and impact thereof, but within a few months, a report of MySpace being sold to another company hit the media. In the case of Indaba Music, I wrote about the lack of contests devoted to original music compositions, but several months later, an original music contest was announced.

The same holds true for the explanation of various features. On one hand, such descriptions may seem rather tedious; however, the descriptions of communication mechanisms on the social networking sites should not be taken lightly or omitted. While such mechanisms change and are updated periodically (sometimes rather quickly), those features can either hinder or assist musicians in connecting with fans and gaining recognition from professionals in the music industry. Although particular features on each social networking site will inevitably be upgraded, documenting their functionality in a certain time period is important for understanding the gradual shift in the online environments. However, in explaining the need for various features, I strove to keep myself from sounding like a technological determinist. Technologies advance, and people adopt the upgraded features of technology; here the word "adopt" is critical because it does not necessarily mean "change." Musicians might use the social networking sites as major resources these days, but that does not mean that the older practices have died out completely. If having a street team as promoters was once important to create buzz about a break-out artist, now virtual street teams continue to operate in the social networking context, especially on Reverbnation.com. Thus, the older forms do not necessarily vanish. Instead, they are adapted to the newer communication mechanisms that reach out to online fan bases. Although the changes that occur within each social networking site may still reflect the older practices and trends, some significant developments are unique to the social media revolution.

While wrestling with the inevitable reality of the fleeting nature of social networking sites, I approached this book with two particular aims. First, this book was tackled with the notion of temporality intact. Every year, there are new reports and updates on certain social networking sites. Understanding how social networking has risen, fallen, or maintained its momentum is an important aspect to remember. While some interviews, textual analyses, and reports pertain to a specific time period, even with the passing of time, they provide important evidence of what took place during a particular time frame. Along with the commentaries from the participants of my study, the online news reports never failed to offer information about the speed with which social networking sites were developing day by day. Throughout the process, every twist and turn, detour and dead-end that I encountered was the result of the somewhat paradoxical developments occurring within the social media related to musicians and the music industry. Therefore, although I sought to interweave the common trends through the use of

several important theoretical concepts, I recognize the importance of leaving the discussion open for oscillation and mutation, rather than locking my conclusions into a concrete theorization that overlooks subtle nuances and context.

The social media phenomenon is in continual flux, and efforts to understand this issue should seek to embrace the idea of uncertainty and mutability. However, even despite the continuous development of the social media, researchers can trace the transition and capture the characteristics that mark a certain time period. Hence, the reader should keep in mind that in a few years' time, this book may function as a historical study that captures the vivid occurrences and activities of once fleeting moments in social media history. Consequently, my arguments will need to be revisited and updated upon occasion.

The second approach I took with this book was to downplay the distinctions between each genre of music and its specific impact. Previously, in the cultural studies and media studies discipline, the discourse on musicians and the music industry has often focused on contemporary popular music. Keith Negus, Simon Frith, Steve Jones, Lawrence Grossberg, David Hesmondhalgh, Roy Shuker and Jason Toynbee (to name a few) have all contributed to a lively and in-depth discourse on the popular music industries. The reason for this particular focus is the fact that popular music "holds a central position in contemporary mass media" (Wells & Hakanen, 1997, p. 217). However, on the social networking sites, although the concept of popular music still exists, there is a wide spectrum of musicians in a variety of genres including non-popular music. In fact, the non-popular genres are experiencing increased musician participation in the social media, and the artists in these genres make equal use of the social media when compared to musicians in the popular music genre. This reality will be evident in the case studies conducted in this book.

Methodology and Chapter Outline

In each case study, I utilized multiple qualitative methods. Instead of applying only one approach, such as survey method, virtual ethnography, email interviews, or textual analysis, I explored multiple facets of the social networking experience. In short, I analyzed each case by taking into consideration a variety of viewpoints: users' experiences, experts' advice, and various testimonies and reports in news articles. The reason for incorporating numerous qualitative research methodologies was related to the nature of the information that I gathered. Although I posted a blog survey and publicly announced the posting, I recognized that the answers to the blog survey alone would not sufficiently capture the full breadth of sentiments held by users and musicians due to a limited number of responses. While any volunteered responses were obviously valuable, in an attempt to more precisely depict the activities of users and musicians, it was important to capture other dis-

courses that took place in public forums on the social networking sites. Although a researcher's survey may be perceived by some website users as an outsider intrusion (and to some extent, all surveys are contrived in nature because they create interview scenarios), the forums within each social networking site reveal the more organic and natural conversations created by the users. In addition to combining these two methods, understanding the "expert" tips and recommendations on how to succeed on these social networking sites was also significant because it allowed a view into to what is considered "norms" and "desired methods of communication" among those seeking to gain recognition and popularity.

In Chapter Two, I focus on laying the foundation to understand the digital field of cultural production by revisiting Bourdieu's notion of fields, cultural intermediaries, and capital. While the primary task is to unpack the constitution of the "digital field" in order to better understand the nature of the field in terms of the music industry, I also provide an overview of the characteristics of the major and independent record labels prior to the advent of the digital field. Furthermore, I also describe how the tension that exists between major and independent labels intersects with the two subfields in the digital field. I underpin the people who are involved in the "field," the rules of the game, the people who make the rules in the field, the people who determine the winners and losers, and the overall implications of the operation of the digital field of cultural production. While the goal of this chapter is to introduce the various characteristics of the digital field, I also present the common types of work musicians undertake in the digital field by utilizing the immaterial, affective, and free labor frameworks and exploring the issues that are at stake in them. Thus, in this chapter, I provide an overview of the emerging problems in the digital field of cultural production by interweaving the historical, cultural, and scholarly contexts of the music industry with the transitional currents of the digital field.

In the ensuing chapters, I focus on various case studies in the digital field of cultural production. While the general characteristics outlined in the second chapter recur as common themes in each case study description, underpinning the distinctness of each website is important. The four social networking case study sites were chosen because they all have a specific and unique function critical to musicians. MySpace was once pivotal as a site that helped to generate fan bases; YouTube is a popular distribution forum which allows for the showcasing of one's music; Second Life is a real-time live performance platform; and Indaba Music is a collaborative recording platform.

In Chapter Three, I concentrate on MySpace, the groundbreaking social networking site created specifically for musicians. Despite its innovative nature, MySpace was not the first social networking site ever created to aid independent musicians in their quest for exposure and social interaction. Prior to MySpace, other similar types of social networking sites existed, such as mp3.com and ga-

rageband.com. In fact, as of 2011, mp3.com still provided services for musicians. On the other hand, on July 15, 2010, garageband shut down permanently, and the existing members of the site were asked to transfer their accounts to ilike. com and other similar music social networking sites (Wauters, 2010). As seen in this example, music social networking sites are going through various transitions. Although mp.3 and garageband did not have the mainstream success of MySpace and YouTube, it is important to recognize that MySpace was not the very first site to provide exposure for independent musicians.

The history of the earlier music social networking sites contrasts sharply with MySpace's quick rise to prominence. However, despite great success, MySpace's momentum could not be maintained indefinitely. For the chapter on MySpace, I posted a blog with general questions. Users were asked to write responses in a free-form style. By not conditioning or eliciting a certain response, I thought blogging would be more effective than utilizing specific survey questions. Users were not only meant to feel at ease with participating in the convenience of their homes, but they also were allowed to respond however they saw fit, thereby reducing the odds of receiving partial answers. On my blog, I posted general questions pertaining to user perspectives on MySpace's success, what they attributed this success to, and what, if any, shortcomings they perceived in the network. The blog posting was up for about six months, and all blog visitors were invited to answer the survey questions. In addition to the blog survey, the other sources of data include the experts' tips on succeeding on MySpace, various news articles on MySpace, and the overall textual analysis of the site.

In Chapter, Four, I provide a case study of YouTube. I concentrate on a variety of musicians who won contracts with record labels and examine how some of these individuals became enormously popular via mainstream media outlets. Furthermore, I also introduce how already signed musicians utilize YouTube for various promotional purposes. Besides YouTube's emphasis on "discovery," another important aspect of the site is its competitions. The rationales behind the competitions are varied, and I explore a number of examples to understand how the contexts impact musicians and the music industry. Finally, a study of the copyrights battle is included to unpack the legal issues that YouTube is dealing with as a result of the overlapping of two different subfields. Although I only address the legal aspects in a limited manner, I explore how the lawsuits relate to amateur musicians' personal freedom and to the increasing desire of musicians to be compensated for their work. For this chapter, I not only examined the YouTube site, but I also analyzed various news articles. In addition, I also reviewed various self-help books about how to become popular and successful on YouTube.

In Chapter Five, I explore the internal operation of Second Life and how record labels and amateur musicians use the site. Does Second Life provide a platform for both record companies and musicians? What is the site's impact on the

larger scheme of the social media revolution? For the case study of Second Life, I conducted a virtual ethnography of real time live music performances held in various music venues. In addition, I also reviewed various news articles to understand current trends and marginalized discourses. Second Life is a unique social networking site, unlike the others where users form "cult like" communities. Although the news of Second Life users and trends have been widely reported by the media, the analysis of user activities was crafted in a discursive form. Hence I examined forums and blogs created for Second Life musicians to see what types of conversations and concerns users were having.

Finally, Indaba Music will be the last case study. Indaba Music is a collaborative and contest platform where musicians can digitally collaborate with anyone regardless of geographical constraints. In the beginning, Indaba Music's competitions mainly focused on remixing popular tunes by mainstream artists; however, in 2010, Indaba Music opened its doors for more musicians to submit original music. The site provides cutting-edge developments in the context of the social media revolution through its adoption of both old and new types of cultural intermediaries, such as music industry insiders and professional musicians, and its promotion of popular voting practices among the people who listen to the site's online submissions. Indaba Music emphasizes new ways for musicians to network and to contribute to the building of a community of musicians. The site users learn from each other via feedback and compete with one another in contests that result in concrete rewards that allow musicians to build their careers and earn money.

As for methodology, I visited various Indaba Music site forums to understand the sentiments and activities of the musicians who used the site. I also conducted a textual analysis of the site in terms of features, and collected the testimonies of musicians, focusing primarily on their experiences with the Yo Yo Ma contest. In addition, I conducted an online survey and an electronic interview with the co-founder of Indaba Music. I announced my online survey on the discussion boards, as well as on my personal Indaba Music blog. This blog was advertised to the entire Indaba Music community through a front-page announcement on the site on the day of the posting. After the announcement had been posted on several other locations, I waited on the responses from those who volunteered for the study. The survey questions related to the process of collaboration, the benefits that the users had discovered through use of the website, and the unique characteristics of this website in comparison to others. I provided open-ended questions to the participants so that I would not elicit a certain type of response.

In the final chapter, I reflect on the four case studies by revisiting the three main goals of the book; in this context, I summarize and evaluate the predominant trends and their impact to date (2011). Furthermore, I discuss new concerns about the intersection of the evaluative mechanisms and the exercise of demo-

cratic actions, and touch on the ambiguous and potentially exploitative nature of the digital field of cultural production.

Social Networking Sites as a Digital Field of Cultural Production

Social networking sites represent a digital "battlefield," both metaphorically and figuratively. In this chapter, I will further delve into the nature of Bourdieu's notion of cultural field as it pertains to social networking sites, and I will also analyze the details concerning the people in the field, the rules of the game, the judges, and the rewards. All four of these categories are in flux and are prone to change at any moment. The goal of this chapter is not only to reconfigure Bourdieu's key concepts but to also provide an in-depth context that will be critical to understanding what is at stake in the field of digital music production.

From the onset, we need to examine the constitution of the "field." Bourdieu's (1993) field of cultural production is divided into two principles related to hierarchy: the heteronomous principle (e.g., bourgeois art) and the autonomous principle (e.g., "art for art's sake"). In short, these categories are divided into the subfields of large-scale production and restricted production. Bourdieu's subfield divisions are analogous to the cultural production that is occurring in the social media age, but there are two critical distinctions between Bourdieu's field and the digital field. The first is Bourdieu's neglect of the culture industry. Hesmondalgh (2006) points out that "Bourdieu has [little] to say about large scale, 'heteronomous' commercial cultural production, given not only its enormous social and cultural importance in the contemporary world, but also its significance in determining conditions in the sub field..." (p. 217). While this is Bourdieu's major shortcoming in terms of the digital field of cultural production, I revisit

Bourdieu's framework in order to provide an overview of the links between large-scale and restricted production models and by extension, to those between major and independent (or indie) record labels. Understanding how the major and indie recording industries operated prior to the social networking era is important, as it illustrates how the line between the two is precarious and often short lived. At this juncture, I will explore the characteristics of the major recording industry and then segue into the independent recording industry and the intersection between the two.

Major Recording Industry

The major recording industry operates in a predictable and carefully planned manner (Negus, 1999). Negus explains that major record companies are disinclined to take risks. To explain the avoidance of risks, Laing (2003) borrows the idea of the "construction of markets" and explains the three strategies that the markets utilize. The first strategy is the "portfolio approach." In this approach, a record company promotes a varied range of recordings with the expectation that some of the recordings will be successful. The second strategy involves research into the consumers' proclivities and behavior. The third strategy is to "influence the various gatekeepers or intermediaries perceived to be influential in consumer decisions" (Laing, p. 313). This category of individuals includes broadcasting executives, journalists, and disc jockeys.

Furthermore, Laing asserts that since the 1990s, groups interested in radical marketing tactics, called "street teams," have targeted the opinion formers and tastemakers within the audiences. This tactic strategy is consistently employed by large corporations, such as Sony, Warner, BMG, Universal, and EMI. The three strategies described here reveal that the recording industry places an enormous emphasis on audiences' tastes and penchants as indicators of the potential success of the market. To this extent, although there may only be a limited number of decision makers in the record industry, the end goal is to understand how mass audiences will react to their decisions.

The popular recording industry, however, did not remain static in the methods it employed. In the 1990s, the music industry shifted its focus. Burnett (1996) noted that "the 1990s will see the industry move away from the selling of products to concentrate on the selling of musical rights and the collecting of royalties" (p. 46). He also reported on a pivotal change occurring in the international music industry. Not only were the music industries still interested in pleasing large numbers of audience members, they were now beginning to merge with other types of entertainment companies and record labels, resulting in the creation of a large-scale buying and selling process. This merger also involved a new type of entity: the independent record labels.

Independent Labels

Roy Shuker (2008) defines independent labels as "small record labels that are independent of majors (at least in terms of the artist acquisition, recording, and promotion), though still reliant on a major for distribution and more extensive marketing" (p. 21). This statement implies that the operation of the independent labels is not clearly demarcated from that of the major labels. Secondly, it also notes that the term "independent" is, to a certain extent, arbitrary because independent labels can merge with major record labels.

Therefore, the definition of "independent" has been re-examined and challenged by a few scholars. For example, Lee (1995) questions how the notion of the independents has evolved throughout the history of the recording industry. Here, important themes emerge which underpin the mutable and evolving nature of the independent labels. He argues that independent labels frequently forged partnerships with major labels to expand their distribution outlets, while major labels used the labeling and ideology of independent labels as a new marketing strategy. In this context, the independent labels do not remain static: either they struggle financially and file for bankruptcy, or they eventually merge with major record labels, or they become successful, but only in terms of maintaining the ideology of the independent paradigm, not in terms of finance. The report that "over the past ten years the majors have systematically purchased all of the larger independent record companies operating in the USA" (Lee, 1995, p. 16), clearly indicates the harsh realities for independent record labels.

Hesmondhalgh (1998) also analyzes the claim that British dance music stands as an alternative to the mainstream music industry. He explains that while two defining characteristics of mainstream record labels are concentration and centralization, independent record labels are decentralized with many small companies taking part in the larger industry. Despite this sharp difference, Hesmondhalgh rejects the view that the independent recording industry operates in a purely independent manner. In Great Britain, dance music relies on the mainstream record industry in terms of crossover hits and compilation albums. In addition, independent labels work alongside mainstream record labels through the creation of partnerships. Independent music labels also face the pressure of branding for recognition's sake, just like the mainstream major labels. These findings point us back to Jenkins' notion of convergence culture, which highlights the overlap between top-down mainstream media and bottom-up grassroots media. Given this account, despite the different missions and ideologies that the major and indie labels embrace, in a closer analysis, the operations of each industry overlap at various points.

Another example that directly invokes the connection between independent record labels and major record labels is illustrated in Hesmondhalgh's (1999) article "Indie: The Institutional Politics and Aesthetics of a Popular Music Genre."

In this article, he states that "indie is a contemporary genre which has its roots in punk's institutional and aesthetic challenge to the popular music industry but which, in the 1990s, has become a part of the 'mainstream' of British pop" (p. 34). Given this example, the demarcation between indie music and mainstream music can overlap and transform at any time. However such transition from indie to mainstream does not come without compromise, tension and conflict.

Tension between Major and Indie Labels

To examine the gains and losses when independent and mainstream record labels collide with one another, Hesmondhalgh (1999) raises two critical questions: "What forces lie behind the move of such alternative independents towards professionalization, and towards partnership/collaboration with institutions which these companies had previously defined themselves strongly and explicitly against?" 2) "In terms of institutional and aesthetic politics, what losses and gains are involved in the move towards such professionalization and corporate partnership/collaboration?" (p. 35–36). The answers to these inquiries are critical as they not only shed light on the processes propelling the convergence of independent record labels with major record labels, but also reveal whether the convergence of two differing ideologies shape new values and politics or not. Do these ideologies yield new values and aesthetics, or are the results merely a consequence of surrendering to the ideology of the major record labels? Hesmondhalgh argues that it is all too easy to simplify the gains and losses of this process. While it may be tempting to portray convergence as the result of independent record labels "selling out" their principles, much more complex issues underlie the process.

Hesmondhalgh provides an historical overview of the post-punk scene in Britain in the 1980s. In doing so, he captures how indie labels began to form out of the dissipating post-punk genre. He explains that indie labels faced new problems as they gained popularity in the mainstream culture. Citing Born's (1993) work, Hesmondhalgh mentions a crucial point when he describes the complex and manifold definitions of popularity. Although the indie bands have attained popularity, this does not mean that they have "sold out" or that they lack aesthetic values:

> popularity, in this model, is not a "sell-out" but derives from fundamental but contradictory human drives. Alterity too has its positive and negative aspects: the exploration of the "exotic or complex, as opposed to the banal." But also the denigration of the ordinary, and the idealization of the different. (p. 52)

While indie bands strive for difference and alterity in aesthetic sounds, when they form partnerships with the mainstream institutions, what do they gain and lose?

Despite punk music's occasional abandonment of its goal of maintaining autonomy and independence from the mainstream music culture, Hesmondhalgh

explains that in the case of the indie label Creation, "[the company's] aesthetic position helped to form its institutional politics, rather than the other way round. This reverses the way in which often-noted moves from a (contradictory) oppositional politics towards something more conformist and conservative are explained 'within' popular culture" (p. 56). This statement challenges the negative criticism targeted at various entities for altering or influencing the aesthetic content of indie music. Nonetheless, it is important to be cautious of making any assumptions that are one-sided or simplistic. In the merging of indie and major record labels, the aesthetic consequences are not clear-cut.

Although the boundary between independent and major labels is somewhat vague, Strachan (2007) in "Micro-Independent Record Labels in the UK: Discourse, DIY Cultural Production and the Music Industry," presents a slightly different perspective, one that reinforces the division that exists between independent and major labels and between art and commerce. Strachan argues that the discourse on art and commerce "continues to hold power [since] they actively affect a variety of musical practices, are constantly negotiated across a number of musical cultures and continue to resonate with small-scale cultural practitioner and popular music consumers" (p. 249).

Strachan contends that while many independent labels may have merged with major labels, some independent labels continue to insist on their distinctness, and purposefully distance themselves from the major labels, regarding them as part of a corrupted industry. Thus, the refusal to merge with the major record labels becomes a political act rooted in an ideology purportedly opposed to capitalism and corporatism. Strachan further concludes that although small independent labels may not hold as much power as major labels in terms of scale, the independent label owners' "critique of the power relationships of cultural production is significant at a discursive level" (p. 261). In other words, although independent labels may not be able to become greatly successful, their continuing existence matters in the overall scheme of the cultural industry. The small labels may be marginalized as a result of refusing to merge with the major labels, however, there is power posited in that marginality.

An analysis of the tension between the major and indie record labels is important, since it undergirds my examination of the power dynamics and politics in the digital field. The convergence of the major and indie labels' efforts parallels the intersecting pattern of subfields where the player (musician) in mass production enters the subfield of restricted production and vice versa. The digital field allows for easy access between the two fields. For instance, in "Radiohead's Managerial Creativity," Morrow (2009) focuses on how Radiohead has continued to succeed, even after the band terminated its record contract with EMI Records. The author argues that the band's success is mainly due to its tight relationship with its management and its utilization of an online infrastructure. By relying on MySpace,

YouTube, and the band website, Radiohead has come up with a method of "marketing converging with distribution" (p. 167). In other words, the band members use the social networking sites as a marketing platform, a place where consumers and fans can buy albums. Even though Radiohead has allowed listeners to set prices on their albums, Morrow notes that being able to download music for free "did not so much devalue the music as a 'product,' rather it further facilitated the role that radio has played in music marketing processes in the past" (p. 167).

It can be argued that Radiohead's success is strongly based on its past relationship with EMI. Without receiving wide exposure, the band may not have ever gained such a large fan base, an outcome that may not have come to be if Radiohead had been compelled to build its success without the benefits of a major label. While Radiohead's brand may have already been in place prior to the decision to go independent, from this case study, it is clear that the direction of convergence does not necessarily entail moving from independent labels to major labels. The trend may also take the form of leaving major labels in favor of being independent. This illustrates that convergence can happen in both directions. However most importantly, Radiohead's decision to go independent is intricately tied to the digital revolution, namely the creation of social networking sites where band members can directly communicate to their fans. In the context of this example, it is important to understand that although the digital revolution in music took place prior to the advent of the social networking sites, with the rise of the sites, mobility between the categories of major, independent, and unsigned has become efficient, fluid and common.

Crossing in and out of the different subfields is a common trend in the digital field of cultural production. However, there is one more aspect to be contended with in the digital field; this does not just relate to the aforementioned subfields but to a third ground, the hybrid field. This is a rather contradictory concept that deserves a new mode of analysis. How is it that the social networking sites that embody both mass production and small-scale production have created a new subfield that is a cross between the two? Although the social networking field provides a platform for independent musicians, there is a growing trend for social networking sites to function as new type of cultural intermediary. This is how social networking sites function as a hybrid field.

On the one hand, social networking sites provide direct opportunities to advance independent musicians' careers, while on the other hand, they operate as a traditional type of cultural intermediary. An example of a hybrid field occurs when social networking sites operate as record labels, like MySpace Records, or as new decision makers or gatekeepers (which will be explained below). This type of hybrid field acts as an agent for unsigned musicians, yet it also partners with or maintains close ties to the mainstream industry. On YouTube, various competitions with mainstream sponsorships are other examples of hybrid iterations. In

the subsequent discussion of Indaba Music, the emergence of the hybrid field will be more clearly analyzed in the context of a variety of competitions.

Now that we have categorized the two subfields and the hybrid field, the next important step is to identify the game players in these subfields. Bourdieu's questioning of the "true" producer needs to be reframed in terms of the social networking sites on which musicians have not one but many roles. The pivotal difference lies in the fact that musicians are involved in the process of the consecration of the arts; they are not just the producers of the cultural content, the music, but they simultaneously work as agents in promoting, networking, and branding themselves. Moreover, the need to find a publisher, dealer, or manager no longer exists since musicians can autonomously produce and distribute their music on the social networking sites. Thus, in what I call "the digital field of cultural production," Bourdieu's concept of cultural intermediaries needs to be re-examined.

Cultural Intermediaries

The notion of cultural intermediaries was conceived by Bourdieu in *Distinction* (1984). Bourdieu (1993) explains how different types of agents and cultural intermediaries play a role in the making of a star. The recognition of a gifted artist does not necessarily pertain to the actual talent or a genius of an artist, but rather relates to the evaluations of people in authority and the creation of hype surrounding an artist.

Negus (2002) delves into a more detailed understanding of the role of intermediaries, and subsequently problematizes Bourdieu's notion. For Negus, cultural intermediaries are "those workers who come *in-between* creative artists and consumers (or, more generally, production and consumption)" (p. 503). Although Negus recognizes the key role that cultural intermediaries play, he finds Bourdieu's notion limiting due to the latter's separation of intermediaries into a discrete category: "it accords certain workers a pivotal role in these processes of symbolic mediation, prioritizing a narrow and reductionistic aesthetic definition of culture(...)." (p. 504). Negus describes other types of cultural intermediaries who play just as important a role as those discussed by Bourdieu. In the context of the music industries, Negus mentions that Artist and Repertoire (A & R) professionals may serve as the actual mediators between new talent acts and the industry. There are also other types of cultural intermediaries in the industry, such as accountants and lawyers (p. 506).

Negus sheds new light onto a previously under-analyzed aspect of cultural intermediaries. Not only are cultural intermediaries the ones who influence society in an intangible way, but they are also the ones that deal with the commercial and business affairs: "they are involved in the construction of what is to be 'commercial' at any one time, often retrospectively, and they are engaged in

mediating many of the values through which aesthetic work is realized" (p. 506). This point is crucial as we evolve into an era of convergence culture where the notion of cultural intermediaries is constantly changing. In the age of convergence culture, cultural intermediaries are not limited to the decision makers from a broad spectrum of music industry professions (accountants, A & R, executives, lawyers, marketing and public relations, etc.), but this category also includes the networked bodies which consist of "everyday" citizens, as well as other newly rising cultural intermediaries.

Although there has been a shift in terms of the concept of cultural intermediaries, this does not mean that other kinds of tastemakers did not exist prior to the convergence era. As the employment records of the major record labels suggest, there is still a wide range of cultural intermediaries; scouts from labels, various critics, MTV programmers, club promoters, opinion leaders, and disc jockeys all continue to serve in the role of cultural intermediaries. The only difference in the age of convergence culture is that other types of cultural intermediaries now exist, such as YouTube editors who choose "featured videos," Indaba Music staff members who highlight "featured artists," and Second Life live music venue promoters and bookers. These types of cultural intermediaries differ markedly from the traditional opinion leaders, such as DJs, magazine editors, television programmers, and entertainment venue bookers. The distinction is clearly obvious in the way in which many of the traditional cultural intermediaries were influenced by the market factors linked to the large number of consumers who supported only popular artists. The shift from a small number of cultural intermediaries to the inclusion of a larger collection of people reveals to us a critical differentiation from Bourdieu's (1993) emphasis on a dominant class that plays the most important role in the field:

> The struggle in the field of cultural production over the imposition of the legitimate mode of cultural production is inseparable from the struggle within the dominant class (with the opposition between "artists" and bourgeois) to impose the dominant principle of domination. (p. 41)

The significance of class is moot on the social networking sites as it is not the class of a citizen, but two other issues that determine value. Collective, mass power (the large number of endorsements) and the traditional cultural intermediaries ultimately ascribe value.

Labor in the Digital Field

Now that we have identified the key players and the nature of the field, we need to examine the rules of the game and the work entailed in the mastery of the game. In the digital field of cultural production, the artists have not one but many roles,

which include being self-promoters, distributors, creators, and advertisers. This situation needs to be highlighted in greater depth. Bourdieu unpacks the roles of agents and other people who contribute to cultural capital. However, for musicians on social networking sites, a new type of labor has replaced the older roles performed by agents and promoters. Because the subject of this particular analysis is *not on how musicians' agents* play the game in the field but *how musicians themselves* play the game (as in, a heavier emphasis on the creator/agent), a clarification of the rules of the game must occur. If the agents are not doing the work, what work must the artists do? Here, the concept of immaterial, affective, and free labor is crucial in terms of the digital economy and in terms of the work that musicians and other cultural producers undertake on user-generated sites.

Lazzarato (1996) defines immaterial labor as "the labour which produces the informational and cultural content of the commodity" (para. 2). He further explains that this concept diverges into two different methodologies of labor. While the first one directly refers to the labor of the working class, the second category is the one under which the labor on the social networking sites falls:

> [It is] the activity which produces the "cultural content" of the commodity, it alludes to a series of activities which, normally speaking, are not codified as labour, in other words to all the activities which tend to define and fix cultural and artistic norms, fashions, tastes, consumer standards and, more strategically, public opinion. (para. 2)

In a similar vein, Hardt and Negri (2000) elaborate on the nature of immaterial labor, which they define as "the labour that produces immaterial good, a cultural product, knowledge, or communication" (p. 290). Similar to the manner in which Lazzarato distinguishes between the two types of labor, Hardt and Negri identify three kinds of labor: 1) the communicative labor in the contemporary economy; 2) the interactive labor of symbolic analysis and problem solving; and 3) the labor of production and manipulation of affects (p. 30).

In their explanation of the three immaterial labor categories, Hardt and Negri emphasize cooperation and social interaction as vital components in the laboring process (p. 294). This aspect needs to be taken into account in the analysis of social networking sites, such as MySpace, YouTube, Second Life and Indaba Music, because work that one exerts while on these sites cannot occur without the cooperation of and interaction with others. Hardt and Negri's ideas of "immaterial and affective labour" have been applied as a framework to discussions of many social networking sites incorporating the aspects of "social interaction and cooperation" as an interplay between work and play (Pybus, 2002; Cote & Pybus, 2007; Wissinger, 2007).

While immaterial labor relates to the structural, macro-environment of social networking sites, affective labor deals with the micro, intimate levels of labor. In

Hardt's (1999) article "Affective labor," affective labor is regarded as one facet of immaterial labor:

> Affective labor is better understood by beginning from what feminist analyses of "woman's work" have called "labor in the bodily mode." Caring labor is certainly entirely immersed in the corporeal, the somatic, but the affects it produces are nonetheless immaterial. What affective labor produces are social networks, forms of community, biopower. (p. 8)

Affective labor occurs on many social networking sites linked with musicians because branding is vital to commercializing and marketing oneself. The process of branding oneself can occur by creating a website banner of one's name, adding pictures and website links, and sending private and public messages to network friends. A brand is important since it "offers an exemplary empirical manifestation of the value logic of informational capitalism... brands themselves are a form of immaterial capital" (Arvidsson, 2005a, p. 9). In this respect, affective labor intersects with immaterial labor. The affects of branding are embedded in the image the brand portrays. In other words, on social networking sites, the aura surrounding one's brand can also be instrumental to creating more popularity, because as Arvidsson contends "[brands] represent the additional value of the informational content of commodities" (p. 9).

Finally, the last type of labor that needs to be explained in relation to cultural production is "free" labor. Terranova (2004) provides a useful explanation of this type of labor:

> Simultaneously voluntarily given and unwaged, enjoyed and exploited, free labour on the Net includes the activity of building websites, modifying software packages, reading and participating in mailing lists and building virtual spaces. Far from being an "unreal" empty space, the Internet is animated by cultural and technical labour through and through, a continuous production of value which is completely immanent in the flows of the network society at large. (p. 74)

Terranova's analysis applies to fans' and audiences' voluntary efforts to contribute toward a musician's promotional and advertising goals. This type of labor is often evident on social networking sites, and helps to increase the renown and popularity of many musicians.

Besides the work required to make the music, new types of labor are emerging in the digital field of cultural production. Unlike the traditional roles of agent and manager, who represent the artist, the artists often do the work themselves in the digital field. However, to evaluate what determines the winners and the losers in the digital field, one cannot ignore the issue of compensation.

Winners vs. Losers in the Digital Field

Determining the winners and losers of the game is both tricky and controversial. On one side of the argument is the view that musicians are not gaining but are instead being exploited. In a *New York Times* op-ed article, Billy Bragg, a songwriter and musician, claimed that social networking sites, such as Bebo need to pay royalties to musicians (Bragg, 2008). Bebo resembles MySpace since it is a site on which musicians can upload their music to be shared with others. Bragg argues that the founders of the company have earned $600 million and that musicians deserve a share as they have contributed to the profit-making:

> The musicians who posted their work on Bebo.com are no different from investors in a start-up enterprise. Their investment is the content provided for free while the site has no liquid assets. Now that the business has reaped huge benefits, surely they deserve a dividend. (Bragg, 2008, para. 7)

Although this claim has been repudiated and criticized by other journalists and bloggers (Glazowski, 2008; Masnick, 2008), Bragg's opinion sheds light on the issue of the exploitation of musicians in the context of the social networking sites. Narratives such as this one infer that two simple arguments come into play. One argument is that musicians will end up being exploited in spite of their freedom to post music and gain exposure because they cannot compete with the gigantic forces of the mainstream industry. The counter-argument is that musicians are benefiting from online exposure since they are allowed to promote their music for free on websites such as MySpace and Bebo. The conflicting views may not result in any clear resolution, but a similar line of critique is being carried out in scholarly discussions that problematize the notion of immaterial and free labor by fans and musicians.

For instance, Andrejevic (2008) highlights the troublesome aspects of Terranova's notion of free labor in relations to fandom. In observing the productivity of fans online, Andrejevic rejects a positive interpretation of fans' laboring processes, thereby refuting Jenkins' (1992) assertion that "fandom constitutes the base for consumer activism" (p. 278). Even though fans may receive pleasure from having their comments viewed by others, Andrejevic contends that "the advantage to marketers of online communities is that they help build allegiance to particular products, serving as forums for practices of self-disclosure that generate detailed information about consumers" (p. 43). In short, for Andrejevic, the fan communities' free labor does not merely benefit the users through the enjoyment of sharing and communicating about the various types of entertainment that interest them. Whether it is known amongst the fan communities or not, their self-disclosures actually provide a platform for major markets to gain insights about

their consumers, thus giving the markets vital information about the targeted consumers.

Baym and Burnett (2009) in "Amateur Experts: International Fan Labor in Swedish Independent Music" also explore the complexity of fan labor. While Andrejevic argues for a more exploitative interpretation of participation in the interactive era, differences do exist when exploring the labor related to music creation and marketing. Although musicians may create and post their music just for the love of music-making, what inspires fans to promote their favorite musicians' music? Baym and Burnett explored the fan community in the Swedish independent music scene through a series of interviews with fans who provide free labor for their favorite bands. The authors argue that viewing fans as being merely exploited is reductionist, insofar as no account is taken of the many types of values that are attached to the products of the labor. The rewards do not always lie in economic value—rather there are other types of compensations such as "free music, access to live music performances, and in a few select cases, expense-paid invitations to Sweden" (Baym & Burnett, p. 443). In addition to these concrete rewards, there are also intellectual and self-enriching rewards, such as the broadening of one's knowledge of music, increased listening opportunities, and even the social advantages of mingling with other fans. A simple sign of gratitude by telling someone "thank you" may be sufficient reward for some fans (p. 443).

Besides the immaterial rewards mentioned, the authors also provide the three distinct fan perspectives related to labor. The first group of fans strives "to lessen the value of their own work by positioning themselves as enthusiastic, too far outside the scene to merit economic reward" (p. 444). In other words, these fans do not view their efforts as significant when compared to what their favored musicians do. Thus, they perceive their endeavors as inferior and insignificant. Sheer enthusiasm legitimizes their efforts. The second stance is as follows: "the fans see themselves as doing favors for people who either are or could easily be friends" (p. 444). In this case, fans do not expect any type of reward, but see their work as an investment in new friendships. The third category of fans "view[s] their labour as an investment toward a future career that may eventually lead to appropriate financial compensation" (p. 445). These fans are not just working for the sheer joy or support of their favorite artists, but instead expect some kind of financial reward in the end as a result of their hard work.

As indicated by these three different stances, fan labor can be located within the boundaries of general enjoyment, even if the fans hope for a reward in the end: "these fans value spreading the pleasures they have enjoyed and building relationships with others in their online and offline communities more than they value cash" (p. 446). As a result of interviewing fans of Swedish independent music groups, the authors argue that fans are doing the work with full knowledge that there may be no material or financial rewards. The conclusions strongly sug-

gest that despite the awareness of possible exploitation, fans would still voluntarily put themselves out there to help the artists.

In a similar vein, the active expressions of fans' preferences can also carry significant weight as influential agencies. In a case study conducted by Yang (2009), the support of fans was crucial in maintaining the independence of the musical artist, Li Yuchun, and in protecting the band from the mainstream industry's controls. As Yang (2009) states, "the utopian vision of a Corn conglomerate could be seen as fans' appropriation of the business model of the entertainment industry to radically uproot the unequal power relations between industry and fans, as opposed to corporate appropriation of fandom for profits" (p. 539). To this end, fans' free labor can also function as a mechanism to potentially disrupt the hegemony between the artists and the mainstream industry.

While the reward of fan labor is significant not only in terms of one's intrinsic pleasure but also in the context of reshaping the mainstream media industry on some occasions, what about the labor exerted by the actual users of social networking sites? Cote and Pybus's (2007) article "Learning to Immaterial Labour 2.0: MySpace and Social Network" explores the ambiguous dimension of social networking sites whereby the immaterial labor can potentially be exploited. The authors posit that although MySpace may belong within the territory of corporatism, the site functions as a place where users can express themselves and build their social capital, as well as basically have fun. However, not everything that takes place on MySpace can be regarded as a mere leisure-time activity; users of MySpace "learn to produce their networked subjectivity on the social network which offers an unprecedented milieu for myriad forms of circulation and valorization" (Cote & Pybus, p. 95). Cote and Pybus further argue that "this apprenticeship is not only socially 'profitable' for youth, it helps capital construct the foundations of a future of networked subjectivity and affect" (p. 95). Not only do users learn to express and subjectify themselves online, but their activities also provide a platform for corporations to reap benefits and evaluate user preferences.

Given both the scholarly and the current event contexts, how can we problematize the immaterial and free labor of musicians on social networking sites? To further examine the issue, I align my arguments with Banks and Humphreny (2008), Banks and Deuze (2009), and Banks and Potts (2010), who challenge the reductionist claims of exploitation vs. empowerment/market vs. non-market/extrinsic vs. intrinsic rewards. In doing so, I propose to examine the subtleties and complexities of the issue that rest in between various dichotomous concepts. Hesmondhalgh (2010) reworks the complex definition of exploitation and argues that free labor is not necessarily an exploitative kind of labor. While I am in partial agreement with his view, in order to fully examine this issue, it is important to separate musicians from the category of regular users. All cultural producers may be susceptible to exploitation but what makes the case of musicians different

is that they seek not just financial gain but also recognition for their work and names. Arguably, recognition and financial gain are often symbiotic. Thus, in order to unpack this issue, we need to specifically examine the rewards that musicians hope to gain.

The argument that every musician entering the field of social networking is after recognition or monetary rewards is, at best, a generalized statement. However, while there are musicians who share their music simply for the intrinsic pleasure that stems from sharing, others enter the field of social networking with a specific goal, such as to raise awareness, receive exposure, begin a career, or receive a contract offer. Also, there have been cases in which musicians entered the field with few intentions and unexpectedly received rewards. While it is fair to claim that not everyone enters the field with specific aims, hardly any musicians entering the social networking field will deny the positive rewards that can come out of their involvement.

Rewards in the Digital Field

In this book, the rewards for immaterial, affective, and free labor are interpreted in relation to Bourdieu's notion of symbolic, cultural, social, and economic capitals. Bourdieu (1993) defines symbolic capital as "economic or political capital that is disavowed, misrecognized and thereby recognized, hence legitimate, a 'credit' which, under certain conditions, always in the long run, guarantees 'economic' profits" (p. 75). For Bourdieu, symbolic capital is often regarded as prestigious and is often associated with small-scale productions, such as avant-garde work, while economic capital concerns financial rewards. Artists having symbolic capital may not always have economic capital.

On social networking sites, besides the obvious monetary rewards, other important rewards relate to the attainment of symbolic capital, which may involve receiving a high honor or increasing personal prestige through one's work. While this could occur through an endorsement by a well-known critic or winning a competition juried by famous music professionals, I do not seek to explore the ability of social networking sites to yield symbolic capital. Through my case studies, a clear example of symbolic capital is not demonstrated, since the mechanism for acquiring symbolic capital is problematic and is frequently underplayed in the digital field of cultural production.

Instead, the greatest issue in the digital field of cultural production relates to social capital, and the transformation of social capital into cultural capital outweighs the attainment of symbolic capital. Social capital is a significant concept in the framework of the social networking sites. Bourdieu and Wacquant (1992) define social capital as "the sum of the resources, actual or virtual, that accrue to an individual or a group by virtue of possessing a durable network of more

or less institutionalized relationships of mutual acquaintance and recognition" (p. 14). As Ellison, Steinfield, and Lampe (2007) note, there is a great benefit in maintaining one's social capital on sites such as Facebook. For musicians, the notion of having "friends" on the social networking sites is far more significant than associations with users who simply maintain friendships from previous face-to-face encounters. Throughout the case studies, it will be clearly shown that many musicians have been "awarded" by the mainstream media or major record labels for having strong social capital.

Social capital does not just remain at the level of popularity, but it has the power to extend its value further to the cultural level. According to Bourdieu (1986), "cultural capital can be acquired to a varying extent, depending on the period, the society, and the social class, in the absence of any deliberate inculcation, and therefore quite unconsciously" (p. 84). Bourdieu further divides the notion of cultural capital into three distinct forms (1986), but in this book, I define cultural capital differently. In the context of the social networking sites, cultural capital is acquired when an artist is discussed through a mediated discourse such as television, books, articles, or films. Regardless of the conversation related to an artist's musical aesthetics, cultural capital pronounces the artist "relevant" in today's context. This conviction is almost synonymous with the outlook that valorizes any press coverage regardless of its content. According to this logic, the acquisition of cultural capital can positively impact an artist's career. Social capital is a pre-condition for acquiring cultural capital. An example of this is when musicians gain a large fan base, which generates "buzz" and perpetuates the mediated discourse.

Social capital is acquired through popularity on the social networking sites, and the concept of popularity in this context is more complex than popularity resulting from the mass media. The ordering process is established through the classifications of rating, ranking, and viewing. The reliance on rating and ranking may remind one of the manner in which the mainstream media classify artists, which is typically based on album sales. However, this divide is more complicated on the social networking sites because popularity here is often perceived as the result of the democratic process. This is in part due to the fact that the social media, which is considered participatory in nature, is rooted in the democratic spirit (Suhr, 2008a).

Popularity and the Issues of Ranking and Rating

At this juncture, it is necessary to explore how the notion of popularity has been newly conceptualized within the social media context. Over the previous decades, various authors have focused their attention on the conceptualization process. Adorno (2001) argued that mass culture was of little value and that an emphasis

on profits and mass consumption resulted in the degradation of high culture. In a similar tone, Bourdieu (1984) demarcates "popular aesthetics" from "pure aesthetics," adopting the position that popular aesthetics are anti-Kantian and repudiate a universal outlook on aesthetic tastes (p. 41). According to Bourdieu, "the pure aesthetic is rooted in an ethic, or rather, an ethos of elective distance from the necessities of the natural and social world, which may take the form of moral agnosticism..." (p. 5). For Bourdieu, the high quality–low quality debate has a clear definition and is conditioned upon socioeconomic status. However, as Shefrin (2004) observes, Bourdieu's theorization of social class in relation to aesthetic tastes is problematic, for he does not recognize that all people, not only the working class, have access to "bourgeois" aesthetics (p. 264). The problematic aspect of Bourdieu's demarcation comes not only from the consumer's end, but also from the producer's. Artists can come from a proletarian background and still produce "pure" aesthetics. The class divide here does not function as a measure by which to distinguish taste issues.

Further demarcating aesthetics from popularity, Fiske (1986) posits that aesthetics do not intersect with the realm of popularity. In his perspective, the popular is the antithesis of the aesthetic: "aesthetic judgments are anti-popular—they deny the multiplicity of readings and the multiplicity of functions that the same text can perform as it is moved through different allegiances within the social order" (p. 103). Fiske's view of aesthetics is separated from popular culture; for him, aesthetics are divorced from everyday life and possessing an immutable characteristic: "the aesthetic denies the transience of popular art" (p. 103). Given the long-standing dichotomization of popular culture and aesthetics, how do we understand the popularity emerging on the social media?

The crux of this dichotomization is based on the premise that popular music and popular art forms do not qualify as a "pure" art form, which is not meant to be appreciated and liked by the broader masses. If we leave the operational decisions related to the music industry up to a few cultural intermediaries, a problem will arise when a small number of musicians are "lucky" enough to be chosen by the labels to be mass marketed. Social networking sites are considered revolutionary because of their democratic nature; anyone who wishes to be a musician has the opportunity to share his or her music. However, this does not mean that musicians with true talent are required to survive on their own, as in a "survival of the fittest." The conceptualization of popularity on the social networking sites requires one to wrestle with the vexing question of what is considered true quality, value, and talent? Because this question is highly subjective in nature, finding a resolution is not an easy task. To argue that popularity raised on the social networking sites negates quality or worth may be reminiscent of the highly contentious claims of earlier authors. This perspective might further fall into the trap of

universalizing aesthetic tastes and standards, as had been done by Immaneul Kant (1790) through his notion of "disinterestedness." *

In this book, the aim is neither to prove nor disprove the aesthetic aspects of popularity raised on the social networking sites. Rather, I question how popularity on the social networking sites is increased and determined. In doing so, I do not necessarily argue that popular music has a lower standard or quality when juxtaposed with other types of music. As can be seen, it is important to unpack the notion of popularity from multiple vantage points.

According to Stuart Hall (1998) the notion of "popular" is neither simple nor monolithic. Hall (1981) in "Notes on Deconstructing 'the Popular,'" presents several different interpretations of popularity. The most pragmatic meaning relates to the market and commercial endeavors: "the things which are said to be popular because masses of people listen to them, buy them, read them, and seem to enjoy to the full" (p. 446). Hall notes that this definition is "quite rightly associated with the manipulation and debasement of the culture of the people" (p. 446). Yet, Hall finds this definition problematic as it blindly assumes a passive audience base.

The second type of popularity that Hall describes is the one linked to alternative cultures, "the authentic 'popular culture'" (p. 447). Hall explains that while this may seemingly replace the earlier definition with a type of valorization, "it neglects the absolutely essential relation of cultural power—of domination and subordination—which is an intrinsic feature of cultural relations" (p. 447). In arguing the shortcoming of this outlook, Hall states that no popular culture can exist "outside the field of the force of cultural power and domination" (p. 447). While problematizing the first two types of popularity, Hall prefers a third definition of popularity:

> in any particular period, at those forms and activities which have their roots in the social and material conditions of particular classes; which have been embodied in popular traditions and practices... what is essential to the definition of popular culture is the relations which define "popular culture" in a continuing tension [...] to the dominant culture. (p. 449)

The third definition of popularity is the one that justifies the aim of this book because it focuses on the transient definition of popularity, which exists in between the top-down and bottom-up forces of power. Hall argues that this conception of popularity should be treated as "a process: the process by means of which some things are actively preferred so that others can be dethroned" (p. 449). In short, popularity is not static in its meaning, but it can be decided collectively and can also be a highly fleeting concept. However, popularity in the digital field of

* The notion of "disinterestedness" is based on the difference between liking something vs. finding something beautiful. For artworks to be defined as beautiful, an objective universal standard must exist, as distinguished from subjective personal inclinations; Kant insists that pleasure should be detached from the judgment of tastes.

cultural production functions as a condition to the rules of the field. This aspect needs to be elaborated upon as it echoes Bourdieu's notion of the field.

According to Bourdieu (1993), "the field of cultural production is the site of struggles in which what is at stake is the power to impose the dominant definition of the writer and therefore to delimit the population of those entitled to take part in the struggle to define the writer" (p. 42). In the digital field of cultural production, a similar logic influences the ordering process. Anyone entering the digital field of cultural production is susceptible to the ordering process as the result of the advent of prominent partnerships with the mainstream industry. As the mainstream industry participates in the hybrid field created by the social networking sites, a more pronounced and systematic way of setting up the hierarchy of artists appears.

Hearn (2010) asserts that the rating and ranking system predominates the social networking sites, but she also raises questions that are similar to those in this book, such as who determines how reputation is measured, who selects the people participating in the measurement system, and who benefits from the rating systems? In short, the rating process itself is sometimes disguised as a form of self-empowerment, such as when we are led to believe that in expressing our likes and dislikes, we are participating in a collective community. For Hearn, "insofar as measurement systems constitute that which they measure, when we rank, rate or feedback, we are not only finding ourselves in the list, we are giving ourselves up to it" (p. 435). In the case of musicians, the expressions of audiences' preferences cannot necessarily be seen as succumbing to the agenda of mainstream industry.

However, the troubling issue is tied to a growing need to prioritize musicians much the same way as Billboard; the partial pre-configuration of the digital field comes from the imposition of what constitutes the worth of artists. The ranking chart here intersects with Bourdieu's (1993) idea of position taking. Bourdieu notes that the status that the producers of symbolic goods obtain in the field is "related to the specifically cultural hierarchy of degrees of consecration. Such a position implies an objective definition of their practice.... Whether they like it or not, whether they know it or not, this definition imposes itself on them as a fact..." (p. 131). In a similar sense, the music chart was established to define an objective standard about artists' work. Nevertheless, the need to create a hierarchy has a strong economic motivation. Shepherd, Wicke, Oliver, Laing, and Horn (2003) state that the music chart is almost a guarantee for album sales as it functions as an "extra channel of promotion" (p. 536).

The authors further explain that "charts offer a means of substantiation within the recording industry, as they act as a yardstick by which the success or failure of certain releases can be measured" (p. 538). It is not necessarily problematic that the industry uses the chart as a way to predict a song's commercial viability, but it is troubling that these charts, according to Shepherd et al., are manipulated.

Although various attempts have been made to increase the accuracy of the charts and to avoid rigging, there have been continual reports of manipulation; thus, the charts do not operate as a reliable system that represents the consumers' penchants. Similar problems extend into the digital field of cultural production where various services exist to improve the ranking status of musicians in the charts. Akin to the manipulation of the chart system by the major recording industry, the strong desire to increase popularity has engendered the creation of social protocols. Jenkins (2006) highlights the importance of the protocols by drawing on the work of Gitelman (2006). Jenkins states that

> a medium is a set of associated "protocols" or social and cultural practices that have grown up around that technology. Delivery systems are simply and only technologies; media are also cultural systems... Protocols express a huge variety of social, economic, and material relationships. (p. 13–14)

Protocols are of particular importance in reference to participatory culture: "as long as the focus remains on access, reform remains focused on technologies; as soon as we begin talking about participation, the emphasis shifts to cultural protocols and practices" (Jenkins, 2006, p. 23). The social protocols primarily exist to provide advice on how to gain popularity on the social networking sites; often, such recommendations come in the form of various paid services and self-help books (Suhr, 2010). In the following chapters, I will explain how the conceptualization of the social networking sites as a type of digital cultural production further applies to specific sites. It is important to know that while each social networking site has characteristics unique to its own digital field, various important themes are currently emerging as representative and indicative of a certain time period (the years 2003 to 2011) in the history of the social media.

MySpace as a Digital Field of Cultural Production

MySpace has an interesting history, and its impact is enormous. This book is being written at the critical juncture where MySpace may face ultimate failure, the implications of which are worthwhile discussing. In this chapter, I will outline the trajectories of MySpace since its inception and will explore various aspects of the site ranging from the users' perspectives to the promotional pointers from experts. In reading the explanation of MySpace's features, one should keep in mind that the descriptions include both the previous methods of communication and the most recent changes that have been made.

MySpace began when Tom Anderson, a musician with a film degree, paired up with Chris DeWolfe, an Xdrive, Inc., marketer, to create a website where musicians and fans could interact and engage in music sharing and casual discussions on music. Between the website's launch in January 2004 and 2010, MySpace has grown into a gigantic conglomerate. On July 18, 2005, News Corporations bought MySpace for approximately $580 million dollars (Newscorp, 2005). In 2006, MySpace had almost 100 million members, and it ranked as the sixth most popular website on the U.S. internet in terms of page hits (Cote & Pybus, 2007, p. 88).

MySpace has two separate kinds of profiles that are determined by whether one is a regular user or a musician. For regular users, the main features are related to the ability to post personal information, including general interests, pictures, videos, and background music. The musician profiles provide an additional feature so that several music tracks can be uploaded free of charge. The musician

pages also allow users to input biographies, gig schedules, pictures, videos, general information, blog entries, and comments. Musicians can even sell individual music tracks. While the music profiles have sample songs for viewer listening, the profiles also provide an outlet for compact disc sales and the promotion of concerts and tours, as well as links to personal websites.

In addition to a simple commentary feature which allows musicians to brand themselves, another aspect of prime importance is MySpace's effort to branch out in order to become more of "a lifestyle brand," a plan developed by DeWolfe (Businessweek, 2005, para. 23). This has been accomplished through a series of new site features and programs. In early 2006, MySpace introduced a new feature called MySpace IM, an instant messenger program that uses MySpace screen names. One year later, MySpace created MySpaceTV, which functions similarly to YouTube. MySpace launched the MySpace News Show in April of that year. In July 2007, a new function allowed users to share their current moods by using emoticons, which are icon faces exhibiting a variety of moods. MySpace announced MySpace Karaoke in April 2008, a program which enables users to upload audio clips onto their profile pages (MySpace, n.d.).* As this series of updates indicates, MySpace is attempting to attract and engage users through a variety of programs. Whether it is through the creation of a brand or the application of diverse site functions, MySpace has created a blurred boundary between work and play.

The Digital Fields of MySpace

MySpace is divided into three subfields: mass-produced production, small-scale production (restricted), and the hybrid field that is an overlap between the two. For instance, in the section titled "Top Artists," users can view three different categories of artists, organized and ranked by record label affiliation: Major Label, Indie, and Unsigned. However, in 2011, another new ranking category titled "Overall" was added. Here the artists are ranked side by side within their own categories on the music page. This illustrates an even level of exposure granted to unknown, as well as well-known, artists. It is, however, unclear whether or not the artists listed in the top ranks have been categorized solely based on the popularity gained on MySpace. Nevertheless, viewers have equal access to music produced by amateurs as well as by "professionals"(musicians signed under major or indie labels).

From One Subfield to Another

According to Jeff Howe (2005), numerous music bands have become successful due to MySpace and other community sites, such as purevolume.com. Some of

* Although these features have been updated on MySpace, some of them were discontinued, such as MySpace Karaoke.

the bands that have risen to commercial stardom are Fall Out Boy, My Chemical Romance, Reliant K, and Silverstein, to name a few. Colbie Caillat is a prime example of an unknown artist becoming extremely popular. Whitney Self (2009) notes that within eight months of Caillat's initial site postings, she was the number one unsigned artist on MySpace; this eventually led to her contract with Universal Republic Records and her debut album, Coco, in 2007. (This charted at Number Five in Billboard)

In another article, Caillat praises MySpace's role in the success of her career.

> The great thing about MySpace is that you can build up an army of fans and then when you go to a record company, there's no point in them trying to change what you do because it's already been tried and tested. (Cited in Kilgore, 2007, para. 5)

While there are also stories of musicians being discovered outside of the social networking sites (such as performing on the street or at a music venue), the difference between being discovered on MySpace, as opposed to a real-life context, is the role played by the charts. While musicians in actual venues can also document their fan bases by keeping track of the audience attendance at each concert, the popularity of Caillat and other successful MySpace users is more visible because of the site's unsigned musicians' chart. This is the most obvious way to distinguish Caillat from others in the eyes of the record labels executives.

With this in mind, how are musicians who belong to the field of mass production, such as those affiliated with a major record label, involved in the field? For musicians who are already being supported by a label, the goal is not necessarily to be consecrated into the industry. The initial consecration occurs when unknown musicians generate buzz online. For established musicians, the game plan and strategies often pertain to strengthening the cultural capital they have already obtained. Thus, many mainstream musicians also utilize MySpace and YouTube as an important source of marketing. For example, singer-songwriter James Blunt, who is signed to Warner Brothers Records, released his album on MySpace (Contactmusic, 2007). Anyone could download his album for $9.99, and in addition to downloading, the purchaser also received a CD album in the mail.

Another example is Lily Allen who also utilizes MySpace as a means of marketing new albums by performing in MySpace's "Secret Show Series" (Ayers, 2009a). Allen is also reported to have performed in Tokyo for another of MySpace's "Secret Show Series." As revealed in the above examples, MySpace does not just cater to independent artists, since it clearly embraces and aids mainstream artists who are signed to major record labels. According to Van Buskirk (2008), MySpace has joined forces with three of the four major American record labels. Although MySpace Music will remain a separate entity, it will be owned in part by the other

labels. MySpace is not the only social networking site that has established partnerships with the mainstream record labels.

There are also cases in which musicians who were part of the subfield of mass production transfer to a different field. In short, artists who are signed to major record labels can be transformed into indie artists by signing with the MySpace Record label. Concepcion (2008a) reports in Billboard that Christina Millian, whose recording contract with Def Jam Record terminated in 2006, will sign a new deal with MySpace Records. This is a prime example of MySpace's hybrid field where it functions like a field of mass production in terms of discovering and offering recording contracts but operates on a smaller scale than major record labels. However, this is not to assert that this hybrid field operates in the same way as independent record labels, since the nature of indie labels and the hybrid labels are slightly different. Hybrid fields have much more open access for undiscovered and everyday participants than independent records, where more exclusivity occurs in terms of the selection process of signing potential artists.

Working in the Digital Field of Cultural Production

Previously, I introduced the phrase "immaterial labor" and explained how this term could be applied as a way to discern the exploitative aspects of the digital economy. With this framework in mind, how can one exert immaterial, affective, and free labor on MySpace? Cote and Pybus (2007) describe "immaterial labour" on MySpace by concentrating on the "social and cultural component of labour" (p. 89). They focus on explaining the immaterial activities on MySpace by highlighting "the composition, management and regulation of the activities of its users" (p. 90). While Cote and Pybus do not specifically examine how musicians work on this site to increase the value of their works, this chapter delves into such processes by exploring the major methods of communication and exposure utilized by musicians on MySpace.

MySpace operates via two types of major communication between musicians and users: one can directly send a message to other members (similar to email), or one can befriend other users (meaning, one becomes a part of another person's friends list) and leave comments on their comment sections. Besides inviting someone to be a friend or requesting to become the friend of other members, MySpace users can also post blog entries for others to read, and viewers can respond by leaving comments on the blog sections. Moreover, if one wants to make an announcement about upcoming gigs to a group of designated friends, MySpace provides a bulletin board section where anyone can freely post information.

In true MySpace fashion, I created a blog on my MySpace profile, inviting musicians to write about their thoughts on fame, popularity, rating systems, etc. Despite my effort to strike up a discussion and inspire responses, only four people

voluntarily responded to the post (of course, this statistic was directly linked to the size of my network, but with a group of approximately 5,100 friends (as of November 2009) and 26 regular readers of my blog, there was a noticeable lack of interest in this topic). Five additional responses were the result of directly emailing several MySpace users. Despite the low number of responses, the eight comments were thoughtfully conceived at the time of research, which ended in May 2008. Among these responses, three of the voluntary responses came from non-musicians. Nevertheless, most of the comments substantiated my thoughts on the presence of immaterial labor on MySpace.

In answering my blog posting, Jennifer Richman (a singer-songwriter) stated: "with MySpace, you get out what you put in. Popularity can be gained at tremendous proportions if you put in the time promoting yourself on MySpace." In agreement, another commentator (a guitarist) mentioned that in order to gain popularity, one must work hard:

> The bottom line is that it takes work to generate interest, in the real world and online. I have friends—musicians—who post their songs and then essentially sit back, mistakenly expecting a new community of ears to discover them and then becoming disappointed when this fails to come to fruition. I've made numerous contacts, friends and acquaintances through this website, a good deal of them through reaching out and responding to those who have made the effort to do the same; using it as a platform for authentic contact, albeit online. It seems to be that the more present you are the more likely people will stumble across your art. (guitarist, personal communication, April, 13, 2008)

Similar to this response, Mat Helm (a singer-songwriter) stated that without working hard (such as, putting much energy into networking), the actual results are minimal:

> As far as the performance issue I was disappointed with the responses, or turnouts I had received from MySpace "friends" in the past. It could be due to the fact that I'm introverted to an extent that I feel it requires too much energy to hold the interest of that many friends, and that the actual value of the art has nothing to gain from being illustrated from a perspective of fame or a position of solitude.

Clearly MySpace popularity and interest cannot be generated through a passive approach toward marketing. The results vary depending on how much work one puts in.

While the musicians recognized the aspect of labor linked to this website, the audience members responded optimistically in reference to the effects of MySpace on the careers of independent musicians:

> I believe that MySpace does help independent musicians gain worldwide popularity and recognition that they might not gain if there was not a media like MySpace. It lets a wider variety of people gain access to a wider variety of music. Where as say in your case your fantastic wide range of music might only get to people that have an interest in your type of music. Here (MySpace) someone clicking around MySpace music may see your profile and take an interest in your music.

With similar optimism, a Japanese musician emphasized MySpace's presence in foreign countries, thereby focusing on MySpace's ability to transcend national boundaries:

> I simply think that MySpace.com is one of tool to let foreign audience listen to my music. There're also some SNSs similar to MySpace.com in Japan. For example "mixi," the most popular one and for Musicians and Audiences, there's "YoroZoo" I also register for. But they consists of almost only Japanese language. So then, it can be only for Japanese. I want more audiences listen to my music who live in other country but on the same planet.

On MySpace, besides one's intentional marketing and promotional efforts, the network bodies can contribute to the increase of an artist's visibility. Here, the notion of "free labour" by Terranova (2004) comes to the fore. Terranova's analysis also applies to MySpace musicians since they are offered free labor through the actions of other users. Without intentionally asking for favors, one way to enhance one's visibility is through being featured as a "top friend." The top friends are the most favored members of a particular user's profile. The display of top friends is usually done in a manner that projects one's personal taste for certain types of music or affiliations. For instance, if the musician is a classical artist such as a string player, he or she may display famous string players of the past and present.

Another example of free labor on MySpace involves having a specific artist's music as a featured element on a non-artist's profile page. When a user likes a certain artist's music, he or she can simply press the "add" button shown in the music selection and have the music played as a background on his or her profile page. When other users visit the site, the music will automatically play while the artist's name and the title of the musical selection are shown; the musician, thus, receives free promotion. However, besides these examples of free labor, musicians must work diligently to gain popularity and visibility. This aspect of work has not only been recognized by musicians but also various websites have established ways to target this dimension of labor by linking it with the increasing of one's friends list.

As in all professional sectors, in the field of digital cultural production, there are ways that users can break the commonly accepted rules. For example, instead of gaining friends by asking to befriend them, a user might find a means to "buy" friends. Several websites have recently been developed to replace this type of labor

through a program that will do the "work" for the artist. One example of this is http://www.thetoolsmith.com, a site that is solely devoted to the acquisition a large numbers of friends on MySpace and the provision of automatic responses:

> Easy Adder is the ultimate MySpace Friend Adder tool to help promote your band, market your product and services, or even run for office. Easy Adder automates the daunting task of adding friends, sending messages, and leaving comments.

Although it is unclear whether musicians are using this software in large numbers, the mere existence of these sites throws into question the popularity gained on social networking sites as a result of democratic process.

Another example of a labor-saving website that is particularly targeted at musicians is a site called Maxplays (n.d.). This site advertises multiple benefits:

- Increase your profiles awareness through Top Artist rankings

- Climb the MySpace charts

- Have more genuine fans take notice and visit your profile

- Generate more friend requests and comments

- Expose yourself to industry executives

- Impress fans, A&Rs, promoters, managers, record labels, radio, other musicians, booking agents, etc.

- Receive MySpace Gold and Platinum Plaques

This site claims that artists can, for a price, gain greater attention from the mainstream media. This happens when their music is being heard by numerous users. While increasing the number of times that a song is played can be accomplished through other time-intensive means, Maxplays offers to simplify the process.

In addition to these two examples, many friend-adding tools are readily available to purchase online. For example, www.friendfrost.com is a website which purports to be "the fastest way to make thousands of friends on MySpace." Furthermore, YouTube also features numerous tutorial videos with titles such as "Get tons of friends on MySpace free!!!" "Get millions of MySpace friends instantly," "How to get thousands of MySpace friends free!" and "1000 MySpace friends added daily—free MySpace friend adder site." As evidenced in these examples, a "friend" is a commodity on MySpace, and the acquisition of numerous friends

leads to gains in social capital. Of course, one should neither blame nor make an issue of the fact that musicians wish to gain more fans for their music. However, we can view these services as a reaction to the valorization of friends on MySpace. The number of friends (i.e., social capital) gives musicians the illusion or, in some cases, a true reflection that their music is indeed being consumed by masses of people. Ironically, this view also betrays the ethos of autonomous decision-making and the subfield of small-scale, independent productions.

Affective Labor and Brand

Affective labor on MySpace does not merely trigger emotional, sensorial reactions; it is also linked to a subliminal desire to fiercely self-promote and advertise one's shows, albums, and artistry, centered around the notion of branding. As Naomi Klein (2000) states, "brands could conjure a feeling" (p. 6). Branding is an essential mechanism in the context of affective labor on MySpace, because, as Arvidsson (2005b) contends, "brands are built on immaterial labour of consumers: their ability to create an ethical surplus through productive communication" (p. 235). In *Brand and Values in Media Culture*, Arvidsson (2006) describes the creation and valuation of brands. In his explanation, Arvidsson emphasizes that it is not the actual commodity that makes a brand, but the consumers that create the meaning of the brand which means even if one creates a brand, what makes the brand valuable is directly related to consumer involvement. In short, if consumers collectively associate a specific brand with an idea, a certain set of values is created. However, brands can only have an actual value when the importance of brand association is collectively internalized and materialized.

Another account of associations between value and branding is presented in the article "The Logic of Brand" by Arvidsson (2005a). Here, he delves into the relationship between brands and labor by stating that "brands are a mechanism for the transformation of affective energies into valuable forms of immaterial labor" (p. 22). Although brands are physical forms that are materialized through the carrying of a significant value, the processes related to the creation of a brand are inevitably linked to immaterial and affective labor. Essentially, it is through these immaterial and affective forms of labor that values and meanings are acquired.

In order to brand oneself, a certain outlet or platform is required so that one can labor immaterially and affectively. Arvidsson (2006) states that the internet is an extremely conducive platform upon which to build brands (p. 96). Because of the internet's interactive element, it is easier to cultivate values surrounding brands. At this juncture, it is important to take a look at one particular profile, the one for Tila Tequila whose enormous popularity and branding on MySpace has given her the opportunity to have her own reality television program on the major television network MTV. But who is Tila Tequila? What she does professionally

is not very important, since her stardom seems to hardly relate to what she does; instead, her popularity is linked to the lifestyle and the image she represents. However, the reason why I am devoting attention to Tequila's profile is that one wonders what it is about her profile that has brought her enormous popularity. Many factors are rooted in her popularity on MySpace, but the main source is her success in branding. It is not an exaggeration to say that Tequila has fully capitalized her brand on MySpace.

Tequila's profile (viewed in March 2009) is extremely cluttered with the many facets of her life, yet there is one unified theme. Even though Tequila promotes her music, clothing lines, book, and videos for purchase (which may potentially be confusing for the viewers as consumers), all of her merchandise projects one image, which is the persona of rough sex appeal combined with the opening line on her profile: "the baddest bitch on the block." Thus, Tequila's brand is what she embodies: sexual aggressiveness, as articulated in her label, "the baddest bitch." The type of image Tequila projects is not of my concern here, but rather I am interested in the tactics she uses to build her persona to gain a certain aura that is inextricably linked to branding. To this end, it is interesting to note that Tequila uses the free labor of fans to heighten her façade as a "celebrity."

This is clearly exemplified by Tequila's phone message box; she invites her fans to call a toll-free number and leave messages for her. The display of her fans' voice messages is integral to the maintaining and building of her image as a "celebrity." The exhibiting of examples of how her many fans adore and idolize her adds value to Tequila's brand—whether or not that value holds quality is an irrelevant issue. Although her profile feeds off of countless visits from her MySpace fans, it is interesting to note that her message box is also used as a platform for self-promotion by other MySpace members. Because Tequila's profile page is visited heavily on a daily basis, some MySpace members leave messages, trying to promote their own music: "Come check us out for new songs up! Add us and leave us your thoughts on them!" This occurrence demonstrates an interesting paradox: Tequila hopes to maintain her status through the aid of her fans, while her own page sometimes becomes a platform for other MySpace users to promote their own music.

Brands are created as the result of efforts linked to immaterial, affective, and free labor; in this context, brands can be regarded as a form of materialized cultural capital. For example, regardless of the quality of her music, Tequila's social capital has engendered cultural capital through various mediated discourses. After her popularity soared on MySpace, Tequila was featured in *Stuff* magazine. With her public image on the rise, MTV offered her a reality television show called "A Shot at Love with Tila Tequila." This was a provocative dating show about a bisexual woman's quest to find love, and it included both male and female contestants. The content of the show is not as critical for this study as is Tequila's ability to capitalize on the fame generated from being on MTV and her decision to market her

bisexual appeal by writing a book, *Hooking Up with Tila Tequila: A Guide to Love, Fame, Happiness, Success and Being the Life of the Party*. As the title suggests, this book echoes the concept of the reality show and is heavily marketed on MySpace. In a sense, Tequila has been able to merge the mainstream and grassroots media outlets and to build her brand. The labeling of MySpace as a grassroots media outlet will be challenged and problematized at the end of this chapter, with special focus being given to the discussion of cultural, social, and economic capital. Nevertheless, as can be seen from this small case study of Tequila's stardom, even if she receives only minimal publicity from her album release and music, the outcome of her branding is definitely permeating the various media outlets.

Social Protocols from the Experts

Adopting and applying the tips from self-acclaimed experts is considered a manifestation of the social protocols (Suhr, 2010). For the purpose of this study, these tips are not necessarily analyzed under the assumption that all musicians follow or practice them; however, the tips are important as they show the rules of the game. They imply that there are certain techniques and protocols to be mastered in the field of social networking sites. When someone has "figured out" what works for them (or when a musician finds mass popularity on a website), the relevant experience is then translated into a universal tip that supposedly provides an advantage in the field of social networking. Through the analysis of these tips, not only do we get a sense of the dynamics of the digital field of cultural production, but we also receive insights into the efforts entailed in establishing the norms in the field. As Bourdieu (1993) states, "the meaning of a work (artistic, literary, philosophical, etc.) changes automatically with each change in the field within which it is situated for the spectator or reader" (p. 30–31). The rules change over time and are, by nature, short-lived or destined to become obsolete.

Various books have been published to aid musicians in gaining more fans on MySpace (Vincent, 2007; Jag, 2008; Weber, 2007). Here, I will examine a book specifically written for online music promotion titled *MySpace Music Profit Monster: Proven Online Marketing Strategies for Getting More Fans Fast!* by Nicky Kalliongis (2008). According to the back cover of the book, the author is "a veteran music industry professional that's worked with the likes of the legendary Clive Davis and L. A. Reid and with artists as diverse as Aretha Franklin, Avril Lavigne, Outcast, Pink and Prince." After establishing the author's credentials as an "expert," the book explains how the author can help you to 1) make the most of your MySpace page; 2) utilize MySpace, YouTube, Facebook and Squidoo in concert for maximum online presence; 3) get people to visit your site and listen to your music; 4) increase traffic to your site; 5) write and circulate an effective press release; and 6) attract media, radio stations, record labels and fans and much more.

While the book promises to provide various tips on the topics stated above, what constitutes the author's actual advice? Examples of affective labor are evident when the author emphasizes tapping into the "caring" dimension. While the earlier section of this chapter introduces the concept of "buying friends" on MySpace, Kalliongis (2008) makes it clear that there are two issues that relate directly to increasing the number of friends and fans:

> Use the invite system to create personalized invitations. Most people appreciate an email that means something instead of a generic email that everyone receives. While this will take more time, it is worth doing in order to cultivate an invested friends list. You're not simply trying to amass the most friends, you're building your audience one fan at a time. (p. 48)

As can be seen from this statement, there is an element of affective labor in the effort made by a musician to befriend the audience members and to then turn them into fans. Although fans actually support the artist, not all friends become active fans. On a related note, the labor of adding friends is also highly emphasized by Kalliongis. In an earlier section, I introduced a few fee-based websites that aid musicians in instantly adding friends. However, Kalliongis teaches how to accrue friends manually:

> If you want to add more names to your friends list, placing an "Add me" button in a comment on a popular profile with a large friends list is a powerful way to get a large amount of new friends. You can use any picture you want to draw attention, and when a new friend clicks on it they will be asked to accept you as a friend. Podcasting from your blog or MySpace page is a good way to increase your fan base. A podcast is exactly the same as a blog, but with audio as well. To create a podcast, you need to upload your songs or other audio content to your web site or you can host your podcast to your MySpace blog or page by pasting your podcast. (p. 57)

It is important to note that the laboring tips recommended in this quotation are very time-consuming and require a mastery of certain techniques. A successful user of this advice must be able to converge various media outlets and be savvy with all kinds of customizing tools. Although learning and adapting to technology is important in one's labor, Kalliongis highlights the more interpersonal aspect of labor, which is the art of social networking.

In addition to dedicating time to making one's profile appear more attractive, Kalliongis focuses on the social protocols of MySpace. The interactive dimension is very important, as MySpace's central function is social networking. This point is echoed in the testimonies by musicians, all of whom emphasize that one cannot just make a profile and wait for others to approach you. Work must be put into being socially pro-active on the website. Kalliongis mentions this same point:

Now that you have a complete MySpace profile, it's time to look at how to inter-act on the MySpace network. This is very important because the amount of time you spend marketing your music will determine how popular you become on MySpace. MySpace marketing is all about getting your name out there and mak-ing "friends." While you shouldn't expect this to extend to real life, a "MySpace friend" is a friend to appreciate. Every user you can get on your friend list will show others that your page is worth exploring. (p. 69)

This aspect is extremely important and resonates with other social networking sites as well.

The social networking tips given by Kalliongis (2008) should be examined further in order to understand the types of key components he is addressing, since some of them seem contradictory. For example, he states that while it is important to befriend others in a real, manual manner, "you shouldn't be concerned with the personalities of the people on your friend's list. A friend is a friend and in the world of MySpace, the more you have the better you'll be received" (p. 69). The implication of this advice extends further than its obvious emphasis on the equation between the number of friends and the perceived popularity and value. In essence, Kalliongis seems to be saying that the specific people who consume one's music are not all that important, a perspective that completely ignores and dismisses the quality of audience members.

While it seems clear that what matters the most is the number of friends rather than the quality of friends who actually "appreciate" the music, it is impor-tant to examine whether these types of labor actually yield the promised outcome in a rewarding way. Hardt and Negri's (2000) understanding of immaterial and affective labor highlights the promising aspects of cooperation and social interac-tion: "the only configurations of capital able to thrive in the new world will be those that adapt to and govern the new immaterial, cooperative, communicative, and affective composition of labor power" (p. 27). In general, their outlook on immaterial and affective labor has been viewed as "benign" (Thompson, 2005, p. 85). However, these laboring processes may not only have positive results.

Some scholars, such as Gill and Pratt (2008), are dissatisfied with the notion of affective labor, since all work possesses affective dimensions and challenges: "if all work has affective dimensions then what does it mean to say that any particu-lar job involves affective labour" (p. 15). For these scholars, the puzzling aspect about affective labor is rooted in the conceptualization of the affect itself: "affect appears largely in its more pleasant guises—solidarity, sociality, cooperativeness, desire—and, importantly, as (largely) always-already transgressive" (p. 15). Gill and Pratt argue that the implications of the emphasis on affirmative feelings are troublesome, especially taking into account contemporary capitalism that does not acknowledge the existence of other types of emotions such as "fatigue,

exhaustions and frustration... fear, competitiveness, the experience of socializing not simply as pleasurable potential, but as compulsory means of securing future work" (p. 15).

As the earlier examples of MySpace indicate, the affective dimension is, to some extent, deceptive; Kalliongis seems to recognize this, since he clearly disregards the quality and emphasizes the quantity of friends. Even if one proactively projects a positive image and sends out invitations, at the end of the day, the labor is only productive insofar as it fulfills one's goal of gaining popularity. Moreover, Kalliongis does not address how this type of affective labor of befriending others may result in rejection and failure. Although one may extend invitations to numerous users, there may be many people who disregard the messages.

Perhaps in an effort to prevent this type of outcome, MySpace's communicative mechanism includes various devices that encourage users to not ignore such messages. Earlier I mentioned that the function of requesting friends has been enhanced by the attachment of a comment box next to this tool. Without personal messages, one may be less inclined to pay attention to the multiple friend requests that might accumulate in one's message box. However, despite developing a way to encourage MySpace community members to acknowledge one another's messages and thus improve the networking process, there are also ways in which one can reject all messages and friend requests from specific users by putting one's profile setting into a default mode.

While there are positive and affirmative aspects to affective labor on MySpace, it is also important to recognize that negative emotions can happen despite one's labor. Thus, as Gill and Pratt (2008) assert, "these (unpleasant) affective experiences—as well as the pleasures of the work—need to be theorized to furnish a full understanding of the experience of cultural work" (p. 16). Similarly Hesmondhalgh and Baker (2008) contend that immaterial and affective labor is problematic, especially in the context of the creative industries. They also criticize Hardt and Negri for failing to specifically address the immaterial and affective labor that takes place in the cultural sector:

> at some point in an account of the labour undertaken in a particular sector, such as the cultural industries, it will also be necessary to consider what is specific to that sector. At no point do Hardt and Negri offer even a hint of assistance in this respect. (pp. 99–100)

After pointing out Hardt and Negri's shortcoming, Hesmondhalgh and Baker turn their attention to a particular case study from the creative industries: the reality television programs related to talent competitions. In examining the talent program *Show Us Your Talent*, Hesmondhalgh and Baker explain that much of what is involved in this competition is emotional labor:

managing the emotional responses of others... is also integral in talent shows. This applies not only to the performance itself but also to the contributor's walk on to the stage (trepidation, nervousness, excitement) and the post-performance chat in the green room (joy, disappointment, frustration, anger). (p. 108)

What this suggests is that the affective labor described by Hardt and Negri is not all-encompassing in the sense that not only affirmative and positive emotions are linked to such endeavors. Hesmondhalgh and Baker reveal how, in the creative industries and especially in talent shows, the pressure to win the show can often be emotionally draining and overwhelming; this can undermine the fun and happy times that often actually happen on such occasions (p. 112).

From this case study, we can locate MySpace within the larger landscape of the culture industries, where the focus is on one's talent and the methods for displaying one's talent in such a manner that people become fans. The following recommendations by Kalliongis (2008) underscore the pressure and delicacy of dealing with social networking issues:

I'd like to point that over-dressing your email can leave the user under the distinct impression that they're a recipient of a mass-marketing campaign, so make sure you "personalize" your correspondence in some small way.... Be sure to add a little humor and self-deprecation. It loosens their guard and makes them slightly more willing to give your work a listen. Nobody likes an ego, so make sure the message isn't only about you....You ARE looking for friends after all. (pp. 75–76)

However when all else does fail, and one ends up being unsuccessful with online social networking or if one does not have the time to gather many friends, there is an alternative. One can purchase a MySpace profile, which is sold for prices up to $25,000 (p. 69).

The similarities between television talent shows and MySpace are that both require a toughness to overcome personal emotions and a need to ingratiate oneself with others. On the television shows, one must learn to control one's anger and frustration, and to put on a cheery face at all times to convince program producers and staff members that one is cut out for the competition (Hesmondhalgh & Baker, 2008). On MySpace, one must learn to deal with negative experiences, even if one is not getting the type of attention that one desires to receive, and one must become accustomed to soliciting others' support: "The idea of disguising yourself as a friend so that users open your mail without the pretences of spam and manufactured words is good as long as you let people know who you are" (Kalliongis, 2008, p. 75). This process of befriending others could potentially be draining, as one makes an effort to make as many friends as one can, only for the sake of becoming popular online. The negative emotions that are commonly displayed on talent programs are also evident when angry MySpace users rant about

the website's ranking system. Negative emotional responses do occur from time to time on MySpace in the midst of the hard work that is being exerted. (Often this is expressed by the use of emoticons.) In the next section, I will explore the online ranking systems and analyze the negative toll this type of system has had on one particular MySpace user.

The Ranking: The Ultimate Cultural Capital

If this labor is deemed to be immeasurable, what kind of measurable value can be attributed to immaterial and affective labor? According to Bourdieu (1993), "the art trader is not just the agent who gives the work a commercial value by bringing it into a market; he is not just the representative, the impresario, who 'defends the authors he loves.' He is the person who can proclaim the value of the author he defends" (p. 77). With this in mind, how do MySpace musicians gain cultural capital? Unlike the traditional way of winning recognition through hiring intermediaries to promote one's talent and potential, the judgment of value on MySpace is left to the network bodies. Hence, the network bodies step into the roles previously played by corporate executives and artist and repertoire scouts, who traditionally shaped the careers of artists. While this development has been celebrated as a true democratic revolution, an interesting assumption arises at this juncture. One may now think that majority support is what grants and legitimizes an artist's value—hence, it can be logically thought that the ranking system on MySpace is an indicator of artistic value.

According to Jack Bratich (2010), "judgment culture often takes the form of rating communities...judgment, a form of divergence with its special linguistic weaponry, is not a cultural norm" (pp. 64–65). MySpace epitomizes the judgment culture, as rating and ranking are an integral part of the music communities. Mark Sweney (2008), in "MTV and MySpace Band Together," reports that MTV will soon feature the most voted MySpace musicians' video on the MTV2 website. A show called "MySpace Chart" will also be aired on MTV2. This program will feature the voting activities of fans, and the top five artists chosen by the fans will receive a free promotion. Because MySpace's fame seems to be a ticket to larger-scale renown, popularity on MySpace is not taken lightly. Nonetheless, corruption could exist in the process of climbing up the charts. On MySpace's forum, under the topic titled "Unfair ranking system on MySpace's music chart," one MySpace user expresses his skepticism and doubts about the ranking system and explains how unjust aspects of the chart system have made all of his hard work futile:

> I have worked extremely hard to accomplish what I have with my music, and I was very pleased with the rewards that I reaped some time ago, but now I feel as if all the pain-staking labor I have exerted in creating my music is 100% pointless.

Your unfair, impartial ranking system and music charts have destroyed my ability to promote myself on your website; furthermore, they have discouraged me from writing more music or posting it on your website. Once again, my question is, what are your criteria for selecting and ranking bands for your music charts? Also, why have I suddenly disappeared from the charts, even before I changed my genres to see if I could notice a difference. (Jadeius-the-Vdead, 2008)

Clearly, this user is advocating a close investigation of the process utilized in the ranking system. Interestingly, this user's skeptical post has received only a few dismissive comments: "Quit your bitching it's really not that big of a deal. I don't even know anyone who actually looks for bands to listen to through the charts" (Mackensen, 2008). As reflected in the statements by other members in the community, this user's complaints may be perceived as frivolous and reactionary; however, the ranking process is not to be taken lightly.

On January 21, 2011, Billboard launched "Billboard Uncharted," which is a ranking system for so-called "undiscovered talent" (Billboard.biz). Uncharted is unique in the sense that unsigned musical artists have never had the chance to appear on a Billboard chart before now. As Toynbee (2000) explains, in the 1940s, the Billboard charts were based on the airplay of musicians as well as the direct sales of records. In 1958, Billboard started a "Hot 100" hit parade. This chart purportedly symbolized democracy, and the Billboard chart was especially significant to the Rock and Roll music genre (Toynbee, 2000, p. 19). Ironically, the social networking sites do not differ greatly from the mainstream music industry, since in both frameworks, the ranking chart determines the career path of musicians.

Unlike the Billboard chart on which airplay and album sales determine the viability and popularity of musical artists, the measuring indicator for Uncharted is based on multiple social networking sites' statistics and songplays. According to Billboard.biz,

The Uncharted ranking is based on Billboard's own Heat Score, a formula of online exposure incorporating streamed plays, page views and fans according to MySpace Music as well as sources tracked by online aggregator Next Big Sound, including YouTube, Facebook, Twitter, Last.fm, ReverbNation, SoundCloud, iLike and Wikipedia among others. (Billboard.biz, 2011)

With this in mind, the complaints of the one unhappy MySpace user regarding the charts are worth considering. The ratings and ranking on MySpace are indicators of a specific musician's value in terms of the mainstream industry's standards.

In response to my personal blog post, however, only one non-musician member questioned the rating system, although no distrust in the actual process of the ranking system was actually expressed. Instead, the poster argued that the rankings were determined solely by the MySpace users.

The rating system seems to be rated by the people who use MySpace, so if someone comes across a concert pianist and they don't like that type of music they may rate it low. Is that fair? I would have to say no, just because they don't like that type of music they may give it a low score, not because the music is not well performed, but simply because they don't like the piano. (Deutschland, 2008)

This user attributes the unfairness of the ranking system to the wide variation in people's taste in music; he does not indicate skepticism toward the entire operation of the ranking system. Can the ranking system fairly reconcile and weigh a wide variety of tastes in music? To this end, it is important to recognize that MySpace's chart is also organized by genres or categories; hence, a person's disinterest or animosity toward a certain style of music will not count among the votes that accumulate in the chart of specific genres.

Another respondent to my blog posting, David Helfrich (a rapper), asserted his belief that the ranking system matters in the general success of a musician's convergence into mainstream media outlets:

Certainly—the music industry looks at MySpace "stats" (such as views, friends added, comments etc...) and takes that into consideration—so as with any form of popular culture (particularly in America)—people will do whatever they can to attention grab—be it via sexy photos, flashy layouts, or any element that grabs the popular culture. (Helfrich, 2008)

While the ranking system seems to function as a means to discern the popularity of independent musicians, the record labels also acknowledge the importance of the ranking system for signed musicians.

According to Neyland (2010), Billboard recently launched another ranking chart, which is based on the statistics of social networking sites for artists working in the field of mass production. Social 50 charts provide statistics on unique page views, numbers of fans, and streams of songs on sites such as Facebook, YouTube, Ilike, MySpace, and Twitter. This is an interesting development for the social networking sites and the music industry, but it is not surprising since the popularity generated by the social networking sites is perceived as a strong indicator for the potential success of artists.

Despite the value that the ranking system may hold, not all musicians use MySpace as a platform to measure the likelihood of success as set forth by the social networking sites and the industry alike. While some responses to my blog post acknowledged the importance of statistics and ratings, Mat Helm (a singer-songwriter) claimed that the value of MySpace lies in its collaborative aspects:

MySpace may serve as a springboard for an artist who has trouble releasing their art for critique or may result in a major increase in unit sales for one who has built a recognizable name. As far as being a tiny part of the communal universe

of artists, I do not feel competitive and personally use MySpace to work out musical ideas in order to gauge responses from listeners, to correspond with compelling artists from other parts of the world and listen to what they're doing, and to be sought out by other musicians who may be interested in crafting instrumentation for my compositions. (Helm, 2008)

Helm states that although he does not rely on MySpace to build his career, he does recognize its contribution to the building of networks with other musicians who may be interested in collaborating on musical projects. His statement is in line with Pierre Levy's (1997) idea of art in an age of "collective intelligence": "the accent has now shifted from work to progress. Its embodiment is manifested in moments, places, collective dynamics, but no longer in individuals. It is an art without a signature" (p. 123). Although Levy believes that cyberspace art has no signature, many artists on MySpace beg to differ. Collaborative aspects on MySpace do not necessarily suggest that one's art or individuality is lost through a fusion with others' ideas.

Craig McGorry (a jazz musician) echoes Helm's response in regard to the collaborative and networking elements of the MySpace experience:

The main value I have found with MySpace has been the interaction with other musicians. It serves as a cyberspace business card. I have my own website, a MySpace account, and now a Facebook account. Most of the interaction on MySpace has been with musicians I meet saying "Hey what's your MySpace site?" This is so they can hear how you sound and figure out how serious a player you are. But I meet most musicians I know either from other musicians, playing situations, or by posting ads on Craigslist. The Craigslist responses are the ones where typically the responder typically asks for your MySpace address and offers theirs as a "resume" of sorts. (McGorry, 2008)

According to McGorry, his MySpace page essentially functions as a resume, a commonly shared communication space amongst musicians. In addition, he finds connectivity and the opportunities to perform with others as the "value" that comes out of MySpace. Thus, collaboration in the musicians' community is a highly valued asset, and MySpace provides such opportunities by promoting connectivity with other musicians.

The MySpace phenomenon has become a bridge toward potential convergence with the mainstream media outlets, and users claim that it has also attributed to the rise in independent (unsigned) musicians' sales and success. In his response to my blog, Helfrich affirms the way in which MySpace benefits independent artists who want to skip the labor or cost of building a website:

Perhaps an unrecognized advantage of MySpace is its benefit to the artist who does not want to pay for a website—and has little to no html skills/connects to build an aesthetically pleasing and functional site. MySpace allows the unknown

artist to post music and easily give their work instant access to a greater community/audience—and thus has been instrumental in exposing fans to breaking artists. (Helfrich, 2008)

As revealed by these statements, one cannot necessarily conclude that the teleological aim of MySpace participation lies in mainstream acceptance and popularity; yet at the same time, one cannot completely dismiss the fact that the desire to amplify one's popularity and success on MySpace and to hopefully gain access to the mainstream outlets is a contributing factor to MySpace activities. The site's major problem, however, has more to do with these type of fame-driven activities as a collective whole, since the overall popularity of the site could paradoxically lead to its decline and over-saturation.

The Demise of MySpace's Heyday

MySpace may still be considered worthwhile by some users, but in mid-2009, it was already entering a state of decline. In the article, "Rumors of the Decline of MySpace Are Exaggerated," John Biggs (2007) discussed the controversial rumors about the decline of MySpace in reaction to the rising popularity of Facebook. At that time, Biggs argued that MySpace was not being threatened. Two years later in an article titled "MySpace Shrinks as Facebook, Twitter and Bebo Grab Its Users," (March 29, 2009) David Smith reported that "MySpace had 124 million monthly unique visitors last month, a decline of 2%, according to the marketing research company comScore. Facebook, by contrast, racked up 276 million unique visitors, an increase of 16.6%" (para. 5). Smith further explained that the reasons for MySpace's decline were linked to the increasing number of employee resignations at MySpace. According to Ryan Nakashima (2009) in *Huffpost Media,* MySpace reportedly cut 30% of its staff in order to increase efficiency and to more closely resemble the makeup of the Facebook staff. MySpace is definitely aware of its rival Facebook as revealed by the hiring of former Facebook executive Owen Van Natta by News Corp. as its new chief executive.

Although MySpace's diminished popularity did not occur overnight, it is important to note that this development was neither sudden nor unforeseen. Six years after its founding in 2003, MySpace was experiencing a gradual decline in membership, resulting in a loss in popularity, and a devaluation in the eyes of its users and others. As a discrete group of users, musicians have long argued that popularity generated on MySpace can help launch or enhance their professional careers. Thus, there has been an increase in the various services that assist musicians in quickly attaining popularity. Despite attempts to cater to musicians and to stay relevant in the current cultural climate, MySpace's declining popularity is revealed in a report by News Corp. president Chase Carey which announced that the company had experienced a drop of $70 million in advertising revenues (Boris, 2010).

As perhaps further evidence of MySpace's decline, my personal profile e-mail account is currently filled with countless spam and advertising messages. In the month of April 2009, a random review of the e-mail subject lines included the following announcements: "Last call for tickets to detour: NYC's premiere Film Noir & Arts Festival @ Galapagos in Dumbo Brkyn, Thurs April @ 7:30 pm"; "Hey I'm playing a show in New York"; "Bride has new stuff"; "Tania Stavreva Piano Recital at Yamaha Artists Services, Inc 05/08/09"; "Discover Sound- Join our online community"; "Download the new silent disorder EP now"; "Sin.sex. art. detour: NYC's premiere Film Noir & Arts Festival"; "booking: live shows, photo shoots, and more." As the titles of these MySpace messages clearly indicate, few of the emails filling my mailbox were actually personal in nature. (Prior to 2006, these types of spam efforts were rare.) Thus, contrary to the experts' recommendations on effective means for social networking on MySpace, the striving for popularity mitigates interactivity on the website, and this in return impacts individual artists' efforts to promote themselves.

The spam mails and overtly ubiquitous promotional efforts on MySpace were mentioned by site user, Craig McGorry. He explained that similar to craigslist. com, a commonly used classified website used by musicians to network, MySpace might be experiencing a debilitating problem of over-saturation:

> I'd like to comment on Craigslist. About a year or two ago, I could get about 1 gig a month from that site. However, in the last year or so, it has become so saturated, that I haven't gotten a single gig from that site. I think that when someone posts looking for a "Jazz Band for Cocktail Hour" or some kind of event, they receive an overwhelming amount of responses. This is because it is difficult to find paying jazz gigs. It may be different for pop music (actually, about 8 months ago I did get a pop gig and made some money. This was through a posting on CraigsList). I wonder if MySpace has a similar saturation effect. With CraigsList, I know that it's helped created a commoditized situation. If I want to charge someone $150 per musician for a trio gig for 2–4 hours, they can probably find someone to do it for much less. $150 per musician is not even that high a price for a skilled group of musicians, but many students and professionals are all in the same boat looking for gigs. They all have MySpace accounts and can look good "on paper" (on either?). So, it seems to have leveled the playing field, but maybe in a negative way. (McGorry, 2008)

As the above commentary reveals, MySpace may be suffering from the same problems that plague CraigsList.

The Renovation of Field and MySpace's Future

In 2010, MySpace announced a new plan to rebuild and rejuvenate the popularity it once had. The change suggests a serious urgency to save the fate of MySpace, and the attempt involved prominent visible changes, such as a drastic re-design

of the MySpace logo. One new plan is to merge with other social networking sites, including Facebook. Merging with Facebook would mean that the users of MySpace could import any information posted on Facebook (Kar, 2010). According to Kar (2010), MySpace will introduce a feature that resembles Facebook's "Like" button; when users like something, they can click a "thumb's-up" button to express their support of something. Also, similar to Facebook's and Twitter's updated status features, MySpace now allows users to express what mood they are in and to share their current status. However, besides these changes, a more noteworthy development on MySpace is its attempt to shift attention back to the musical artists. The section called "For Artists" is an additional section on MySpace which has several functions related to the primary functions of record labels. Artists can now sell their music directly on iTunes, Amazon, Cdbaby, and Tunecore; they can also publish their tour dates and sell tickets.

Furthermore, MySpace offers statistics on fan members. This last feature, titled FanReach, provides a comprehensive graph that shows the number of fans in each city. This feature is the result of a partnership with Reverbnation, a social networking site devoted to providing tools for musicians, labels, management, venues, and fans (Reverbnation.com). Not only does the graph document MySpace's fan base, but it also provides a comparison with other social networking sites, such as YouTube, Facebook, and Twitter; furthermore, the graph allows musicians to write customized emails to fans. This automatic setting is useful since musicians no longer need researchers to help them plan when and how to make buzz. This setting also helps musicians to gauge their popularity in conjunction with the other social networking sites. Thus, MySpace's new efforts are becoming cooperative in focus and are no longer geared towards competing with the existence and popularity of other social networking sites, namely YouTube, Facebook, and Twitter, although it is true that to some degree, all three of these sites have different roles when compared to MySpace. MySpace's new direction, then, seems to be one that embraces the unique features of the other social networking sites and strives to converge with them. The goal is to make MySpace the primary station where musicians can keep track of their fan bases.

MySpace's new features and updates, thus, indicate a willingness to remain current and to the forefront of musicians' activities. Previously MySpace was centered on the heated competition for accruing friends. As of 2011, despite MySpace's effort to provide a platform for independent artists, grassroots activities seem to still be of secondary importance, since the promotion of the mainstream entertainment industries dominate the site's front page. This is clearly intentional since the site is heading in a new direction; a *NY Times* report quoted the president of MySpace as saying that the focus of the site is "social entertainment" (Helft, 2010).

Reflection on the Digital Field of MySpace

On January 13, 2011, MySpace went through a serious downsizing by cutting 46% of their employees (Oswald, 2011). There was much speculation that News Corp is trying to sell MySpace (Oswald, 2011). Finally on June 29, 2011, MySpace was sold to the advertising network Specific Media for approximately $30–40 million (Boorstin, 2011). The goals of this company may possibly hint at the direction that MySpace may be headed. According to Boorstin, Specific Media is one of the largest online ad networks in the country; the company monitors the browsing history and demographic information of internet users to customize ads for them. Furthermore, the reports of Justin Timberlake's (a famous pop singer) involvement in the efforts to restore MySpace's current standing are interesting to say the least (Nakashima, 2011). From all indications, MySpace seems to be progressing towards greater entrenchment in the mainstream corporations' interests in profit maximization. Such an agenda may find difficulties retaining a grasp on the grassroots or bottom-up activities of musicians and fans. The interesting issue is that while MySpace's course has shifted away from its initial approach, this change in direction will most likely strongly impact MySpace's effectiveness in discovering rising talents and increasing the popularity of musician users. Despite the existence of the music chart that distinguishes between unsigned, indie, and major artists and separates out the overall ranking (which combines all three categories of artists), MySpace's content now thrives primarily on reports and news coverage of mainstream entertainment. Although it is fair to say that the future role of MySpace in the discovery of underground musicians is still unclear, given the objective of the company which bought the website, it seems unlikely that MySpace will actively aid in the representation of grassroots musicians.

YouTube as a Digital Field of Cultural Production

YouTube is of critical importance to today's musicians and the music industry at large. While MySpace once functioned as a place where musicians could interact with their fans and increase their fan base, YouTube provides the opportunity for users to increase fan bases via video postings. Thus, the site functions as a testing ground for musicians and offers useful, alternative marketing tools for the music industry. Hence, being able to network on YouTube is one of the "must learn" tactics for becoming a successful online promoter (Kallongis, 2008). Many YouTube users have reported that popularity generated on this site can directly help launch a successful career. YouTube has, thus, frequently been touted as a place where people can easily see the fruits of their labor. One objective and non-celebratory study of YouTube is presented by Jean Burgess and Joshua Green (2009) in their book *YouTube: Online video and participatory culture*. Similar to their line of argument, in this chapter, I will illustrate that YouTube is neither a utopia nor a dystopia for signed and unsigned musicians.

What Is YouTube?

YouTube was created by three former PayPal (an online service through which money can be sent and received) employees in mid-February 2005. The unique feature of YouTube is that this site not only displays movie clips, television clips, and music videos from mainstream culture, but it also makes accessible contents

created by amateurs, such as videoblogs and short original videos. In October 2006, Google, Inc., purchased YouTube for US $1.65 billion. The videos on You-Tube can be accessed by unregistered users; however, by registering, users are allowed to upload unlimited numbers of videos. In the second year of YouTube's operation, more participatory and feedback features were added. In July 2006, YouTube announced that its daily viewer total now numbered more than 100 million, and in June 2006, 2.5 billion videos were reportedly watched. By August 2006, YouTube claimed to host about 6.1 million videos, and its user accounts topped 500,000 (YouTube, n.d.). YouTube's popularity has soared ever since its creation. For example in Great Britain, YouTube was the most popular video website in November 2007; in 2008, YouTube was consistently ranked as one of the top ten most accessed video sites in the world (Burgess and Green, 2009, p. 2).

Crossing of the Subfields

YouTube is of critical significance to unsigned aspiring musicians who wish to increase their audience base. One example of this is Esmee Denter, a young You-Tube sensation from the Netherlands. Caroline McCarthy (2007) reported that Justin Timberlake, a former boy band star, signed Denter to his new record label in 2007. According to the article, Timberlake founded Tennman Records in a joint venture with Interscope Records, a major record label. The popularity Denter won on YouTube has resulted in a recording contract, but she will also gain more fame by touring with Justin Timberlake as an opening act.

Sometimes YouTube popularity and stardom can be accidental or at least reported as such in the rhetoric of various press outlets. For instance, the singer-songwriter Zee Avi uploaded her music to YouTube, purportedly without the intent of winning a contract with a label. The artist explained her ambitions in an interview with Billboard magazine: "I went on there without any expectations or intentions for it to be a marketing tool, because I've never perceived YouTube to be that... I saw it as an outlet for entertainment and for me to share my music" (cited in Herrera, 2009, para. 2). After signing up for an account in 2007, her channel soon attracted subscriptions from thousands of viewers. Fan labor was actively exerted. One prominent fan, Racounteur's drummer Patrick Keller, sent a clip of Avi's "No Christmas for Me" to White Stripes manager Ian Monotone. Monotone signed up with her immediately as a manager and eventually signed her to Brushfire Records. Her song "No Christmas for Me" became a single on Brushfire Records' holiday compilation album. On May 19, 2009, Avi released her first solo album. Stories like this one help build the hopes of many aspiring musicians. Whether Avi wanted this to happen or not, this case reveals that the popularity of YouTube is not tied solely to the enormous number of people who

use the site. The issues of popularity are also inextricably linked to the hype surrounding the "accidental stardom" type of discourses.

A similar series of events occurred to the group Straight No Chaser, a 10-man a cappella group, which became popular on YouTube and eventually signed a contract with Atlantic Records. One of the members of Straight No Chaser, Randy Stine, describes their experiences as follows:

> Initially what happened was that he emailed me on YouTube, with some kind of vague username on YouTube," says Stine. "And I kind of thought, "Who's this guy, Craig from Atlantic?" When he called me on New Year's Day this year, I'm sitting and Googling his name, trying to figure who I'm talking to exactly. I'm thinking, "Am I being punked? Is this a fake call?" (cited in Novikov, 2008, para. 4)

Stine further explains that when he realized that Craig was not a fake but instead the CEO of Atlantic Records, he answered the phone call, which eventually resulted in a contract and a five-album deal. Like Avi, there was no apparent intention or ambition from the band's end. According to one of the other members, the contract was completely unexpected: "Randy put our video on YouTube—just for fun, just so we could relive the glory of our days. We did not expect it to lead to a record deal" (cited in Novikov, 2008, para. 7).

Although the list of unsigned musicians acquiring record contracts is extensive, pop sensation Justin Bieber's case is particularly noteworthy because not only was he signed to a major record label, but he has become enormously famous and is now a household name. According to *ABC News*, Bieber started to post homemade videos showing him playing music already at the age of 12. However, Bieber's goal in posting the videos was not to score a record contract. Instead, he wanted to share his singing talent with family members who could not attend Bieber's local talent shows. Since uploading his videos, Bieber's YouTube viewer numbers grew exponentially, which encouraged him to post more videos. Consequently, the buzz that he was creating on YouTube attracted the attention of music industry insiders to Bieber's commercial potential. Eventually, Bieber found a manager who introduced him to the performer, Usher. Although Usher signed Bieber to Island Def Jam Recording, others, including Justin Timberlake, reportedly also sought to sign Bieber (Adib, 2009). Bieber's rise to enormous fame sounds so simple and seems to be a matter of luck and talent. However, it is important to note that creating buzz online resembles the way that publicity was generated in the past. On YouTube, creating buzz is equated with large numbers of views. To some extent, the narrative of Bieber's path to stardom echoes the assumption that as long as one is talented, one will somehow always receive recognition and be discovered.

Nevertheless, not every artist gains fame on YouTube through unintentional luck. The rapper Soulja Boy knew exactly what he needed to do to get noticed and become famous. Soulja Boy gained enormous online attention after joining YouTube. He relayed this account to Billboard:

> I was one of the first artists to have a YouTube account, if not the first. I joined two months after the site launched... I faked it until I made it. I acted like I was a celebrity. I was signing autographs, taking pictures, but I had no record deal. I was living the life of a star, but I was just a regular kid then. (cited Concepcion, 2008b, para.5)

Soulja Boy knew how to create the persona of a "celebrity" before he was even one. After he had countless people following him on YouTube and MySpace, he landed a record contract with Collipark/Interscope Records. After he signed to the label, his sales records soon matched his enormous popularity on YouTube. When Soulja Boy released the single "Crank That," it sold 3.9 million digital copies, and was considered the third biggest song download since 2003. His debut album, "SouljaBoy TellEm," sold 943,000 copies. According to Nielson RingScan, his single "Crank That" has tallied a total of 2.4 million sales (Concepcion, 2008a).

Besides the musicians mentioned here, there are other instances of musicians getting record deals through exposure on YouTube, such as Bo Burham (Kahn, 2008) and Phatfffat (Concepcion, 2008b). Considering the descriptions above, it is difficult to describe YouTube's fame as simply sheer happy accident or carefully constructed marketing strategy. If musicians decide to use YouTube as a way to share their music for fun, the popularity generated on the site can be understood as based on "accidental" stardom due to personal talent; if the site is utilized as a promotional tool, the popularity could possibly be viewed as a result of labor. While musicians can become popular via calculated efforts to showcase their music or through mere chance and luck (and a degree of talent), another interesting case deserves close attention in the context of popularity on YouTube.

Popularity in the YouTube environment can be earned when a video goes viral. In contrast to Justin Bieber's story, Rebecca Black, a thirteen-year-old girl, seems to be going down the same path as Bieber; to date, she has received over 113 million views (Russian, 2011). Similar to Bieber, she has gained national mainstream exposure, and her song was also charted by Billboard. Furthermore, she was a guest star on the Jay Leno show. So far, it seems as though Black's career may mimic Bieber's, but Black's story has a grimmer aspect. Although she is enormously popular, her popularity is not the result of her talent, rather the opposite. Her notoriety has given her national fame. In terms of the concrete number of views, Black has become famous, but it is the viewers' attitudes towards the music that has attracted the spotlight. YouTube has a function that permits the expressing of likes and dislikes of songs, and according to Wikipedia, Black's one upload-

ed song has garnered 87% dislike of total ratings (Friday, Rebecca Black Song, n.d.). Thus, Black's fame is interesting because it is not supported by the general public's likes but is rather built on animosity. Furthermore, Black has been cyber-bullied and has even received a death threat that was the focus of an investigation by the Anaheim, California, Police Department in April 2011 (Russian, 2011).

On a paradoxical note, Black was nominated for MTV's O Award, along with Lady Gaga and Justin Bieber. The O Award honors digital music that has received wide exposure on the web (Sweetbeat, 2011). Moreover, Black was invited to appear in Katy Perry's music video, "Last Friday Night" (Stahler, 2011). Given the contradictory dimension of fame, YouTube's popularity cannot be consistently or logically interpreted. Popularity seems to have an irrational dimension that cannot be correlated with people's tastes in regards to music.

Working in the Digital Field of YouTube

Because YouTube's popularity provides opportunities for mainstream exposure and fame, there has been an increase in the number of self-help books on the subject of how to become popular or successful on YouTube (Miller, 2008; Ying, 2007; Weber, 2007; Levy, 2008). With the help of these books, independent cultural producers can follow certain steps and protocols to gain popularity on YouTube. Similar to other social networking sites that focus on music production and networking, YouTube allows for social networking (Lange, 2008)—this, in and of itself, is considered a serious type of labor. Laboring is often time-consuming and requires great attention to details, but most importantly, all of the labor that takes place demands a social component. Kalliongis (2008), the author of *MySpace Music Profit Monster*, advocates such endeavors:

> The most important way to increase your exposure on social networking sites like Youtube is by being a constant presence online. Join as many groups as you can, leave comments, and post new video, broadcast live, and give fans a reason to want to return to your page. (p. 126)

Thus, participation in the discussion carried out in the commentary section of a website is one of the vital ways that one can increase and build one's fan base (Lastufra and Dean, 2009, p. 134). The online promotion strategies on YouTube do not only rely on blatant and obvious tactics to gain people's attention. Similar to MySpace, on YouTube, making "friends" and being polite to each and every one of them is crucial. One must master the "social protocols" on the social networking sites in order to win the true interest of the fans. In this way, the linking of one friend to another functions as a form of free labor.

The key component to musicians' social networking practices on YouTube is the combined efforts of immaterial and affective labors and the way in which they

drive the free labor of audience members. Besides commenting on each other's pages on YouTube, users can gain more popularity by responding to each other's videos through the creation of other videos. Basically, by tracking website visitation (hits), one can learn much about the viewers who could be transformed into fans. One further way to propel the free labor by viewers is by staying active within the community. By "borrowing" and collectivizing the free labor of audience members, immaterial labor is generated. This idea echoes Andrejevic's (2007) elaboration on surveillance and i-commerce in the digital age. Andrejevic explains that although on the surface, the interactive media seem to invite harmless interactivity from the audience members, in the end, users come to a site for a variety of motives. The monitoring of users is justified by the following rationale: "if watching workers helped make them more efficient, monitoring consumers [is] an integral component of managing the 'problem' of distribution... Might a comparable method be developed for managing a dispersed mass to make them prolific and 'productive,' not just as workers but also as consumers?" (Andrejevic, pp. 74–75). This question relates directly to our current discussion.

As Andrejevic's statement illustrates, monitoring one's audience is highly useful in understanding and building potential fan bases. This strategy can also be applied to YouTube, where one can surf around the comment section and analyze the types of music preferred by other users. Based on the information gathered, one can then make recommendations directly to other users or invite them to subscribe to a particular YouTube channel. Although exploring YouTube may seem like a pleasant pastime, this activity offers many opportunities for gathering information about the site users. At this juncture, the question arises as to how to interpret these collective activities and networking endeavors, all of which are driven by a desire to harness mass energies and to focus them toward the acquisition of fame.

On YouTube, in order for a musician to gain popularity, one does not just act as a personal "agent," but he or she also becomes a recruiter of multiple "agents" who represent the mass networks. Therefore, one must accrue as many viewers as possible just like on MySpace. As mentioned above, musicians can create their own YouTube channels from which they can broadcast videos. Viewers can sign up to become regular viewers of a specific individual's videos. The more viewers acquired, the higher the exposure and popularity for the musician in question. Increased viewership can ultimately attract the attention of the record labels. However, in order to achieve this, one must exert immaterial and affective labor. These forms of labor also become a pillar for the free labor of fans. By learning certain tactics and mastering the process of befriending people online, laboring for free becomes seemingly natural and fun for the artists/recruiters.

Nevertheless, there are other broader issues to explore in the overall process of befriending. In order to become an independent brand, one must learn to relate

to the massive channels of networks; this is paradoxical because standing out on one's own seems almost impossible in a society of control in which wide-scale networking is required. Thus, on YouTube, a logic similar to that on MySpace is employed. The key to this kind of networking is to understand that in convergence culture, one must tap into the accessibility of others. This does not merely apply to working with the large social networks, but it requires social networking with agents to help foster the emotional labor of complimenting favorite artists' music and inviting others to join in. The ultimate teleological aim of this kind of labor is to distinguish oneself from others by creating a celebrity status online.

YouTube as a Field of Mass Production

Thus far, I have demonstrated how unsigned, independent musicians can achieve success on YouTube by following certain social protocols offered by the experts. At this juncture, I will explore how the signed musicians can benefit from YouTube. The site has multiple roles when it comes to aiding signed musicians since it allows them to preview albums, interact with fans and to regain or increase popularity. Gary Graff (2007) states that Def Leppard's front man, Elliot, informed Billboard that the band no longer needed to preview their upcoming albums on the road because of YouTube. Instead of physically previewing the album, the band uploaded upcoming singles on YouTube. Similarly, some artists, such as Monica, also use YouTube as a way to directly interact with their fans by releasing statements about upcoming albums (Crosely, 2008).

In addition, YouTube is a place for once popular recording artists to regain their popularity and increase album sales. According to a Billboard (2008) article titled "April Fools Gets Rickrolling," British dance pop sensation Rick Astely's 1987 song "Never Gonna Give You Up" became popular again when Astley posted a video of himself in a funny dance performance. The article reports that the video utilized the "rickrolling" method, which is defined as "tricking internet users into clicking on a link but instead redirecting them to [another link]" (Billboard, 2008 para. 3). The end result of this was that sales of the song increased twofold.

While the signed musicians described above were famous prior to the inception of YouTube, this was not the case with the band OK Go. Although signed by Capital Records, the band was not very successful until the year 2006, when it filmed a homemade, low-budget music video of four band members dancing on a treadmill. In the *USA Today* article "Blend of old, new media launched OK Go," Kevin Maney (2006) describes in detail the journey that OK Go took to attain massive popularity through the use of YouTube. If the video of treadmill dance by OK Go has indeed "[become] a cultural milestone—the YouTube Age version of Michael Jackson's moonwalk" (Maney, 2006, para. 1)—understanding the trajectory of this band's journey is important as it sheds light on how signed but

unpopular bands use YouTube to create fame. This begs the following question: what is the hype and how did YouTube help to achieve such success?

Clearly there are countless videos on YouTube vying for viewers' attention, but OK Go's plan to use YouTube was not entirely accidental. According to Maney, Capital Records was involved in the distribution of the video as part of a viral marketing strategy. The video was choreographed by the band singer's sister, and according to Damien Kulash, a band member of OK Go, the band decided to videotape the routine in the backyard of one of their houses "just to see what it looked like" (cited in Maney, 2006, para. 20). This took place right before the start of the band's second tour.

Interestingly enough, the video, which was solely made and directed by band members and the singer's sister, got into the hands of the CEO of Capital Records, Andy Slater. Although the band filmed the video without informing Capital Records (thereby technically violating the song's copyright), Slater told *USA Today* that he decided not to pursue legal action because he "thought it was the band exercising its right to have some sort of homegrown punk ethic, and [he] embraced it" (cited in Maney, 2006, para. 25). While Slater's decision to not pursue legal recourse might be perceived as an implied endorsement of the video, the senior vice president of marketing at Capital Records explicitly wanted the video to be posted on various video sites, such as ifilms. He was the one who gave permission to post the video online.

In the meanwhile, OK Go created a different marketing strategy by having Kulash hand out DVDs of the video to kids that "looked the nerdiest" (cited in Maney, 2006, para. 29)). Kulash informed the kids that the DVD was not supposed to be out in public, and that if their record label found out, the band would be in trouble (cited in Maney, 2006, para. 29). Kulash told *USA Today* that the day after he handed out the DVDs, the video was everywhere on the internet. This occurred during the year that YouTube was launched. The article reports that "the timing was unintentionally perfect" (Maney, 2006, para. 31). At the peak of its popularity, the treadmill video on YouTube was watched more than one million times within one week's time. As a consequence, OK Go started to make major television appearances: Good Morning America, The MTV Music Awards, The Colbert Report, and J.C. Penney ads. The video was even spoofed on "The Simpsons." To top it all off, OK Go even won a YouTube "Oscar" for their video (Nichols, 2007).

Analyses of OK Go's YouTube popularity were reported in many news articles (Ultimateguitar, n.d.), but the article "OK Go Chart Shows Growth from YouTube" deserves some attention since the author created a graph to analyze the correlation between album sales and YouTube exposure. According to the article, the statistics showed that in the two weeks prior to August 17, 2006, OK Go album sales rose to nearly 2,500 from 457, and the sales of the track "Here We Go"

skyrocketed from 43 to 3,600. The article attributes the significant increase in the album and single sales to "YouTube exposure and the resulting press" (Coolfer, 2006, para. 2). While the article focuses on YouTube's role in OK Go's market success, one should be wary of the carefully constructed marketing strategy behind the YouTube campaign. As Jenkins (2009) also notes, "in a hybrid space like YouTube, it is often very difficult to determine what regimes of truth govern different genres of user-generated content. The goals of communicators can no longer be simply read off the channels of communication" (p. 122). Although the OK Go video concept was somewhat accidental (since it was definitely home-made), its success cannot be viewed as completely unexpected, since the record label and the band wanted the video to create a buzz on the internet. What is important to note in this case is that gaining popularity on YouTube is not a simple matter; there can be many marketing practices wherein major corporations hide their true identities behind amateurs hired to create grassroots content as in the case of LonelyGirl 15 (Burgess & Green, 2009). *

Given these various methods for increasing popularity, another factor needs to be explored in order to better understand how YouTube functions to impact the mainstream music industry as well as the grassroots activities of amateur musicians. In the next part of the chapter, I will explore various problems that YouTube has encountered with the major record labels, and will attempt to outline this conflict's consequences and implications.

The Conflict between the Subfields

On December 20, 2008, Greg Sandoval reported that Warner Brothers Records had pulled its videos from YouTube after choosing not to renew its licensing agreement with the website. Warner Brothers Records is not the only label demanding that its videos no longer be played. According to O'Brien (2009) in *New York Times*, YouTube had to withdraw various videos from its German site after a falling out with GEMA, an agency that represents numerous songwriters, composers, and music publishers. The previous contract had lasted 17 months, but when GEMA raised its fee to 1 euro (1.3 U.S. dollars) a video, the contract renewal negotiations failed. Three months prior to this event, YouTube had a similar experience with the Performing Rights Society, a British agency that provides artist representation.

The YouTube—Warner Brothers dispute has angered many musicians who are signed to Warner Brothers. Mike Masnick (2008) reports that Amanda Palmer,

* Lonely Girl15 case was a phenomenon on YouTube; Bree posted various videos about her troubled relationships with her parents, but it was later revealed that the stories were disingenuous. According to Burgess and Green (2009), "LonelyGirl 15 violated the ideology of authenticity associated with DIY culture, while at the same time being wholly consistent with the way YouTube actually works" (p. 29).

who was signed to Warner subsidiary Roadrunner, was unhappy about the current state of affairs between YouTube and Warner. In the article, Palmer clearly stated her opinion that Warner Brothers' actions did not materially protect the artist's rights. Furthermore, she claimed that if YouTube had surrendered to Warner Brothers' demands, the artists would not have gained any benefits from the deal. The removal of videos of all songs associated with artists contracted with Warner Brothers Records not only angered artists signed to Warner Brothers Records, but also led to the deletion of some amateur musicians' videos.

According to a *New York Times* article by Tim Arango (2009), Juliet Weybret, a high school sophomore, posted a video of herself singing the song "Winter Wonderland" on YouTube in December 2008. Weeks later, she received an email notification from YouTube stating that her video had been removed due to the fact that Warner Brothers owns the copyrights to that popular Christmas song. Weybret is not the only aspiring singer to whom this has happened. A staff lawyer for the Electronic Frontier Foundation reports that "thousands of videos disappeared" (Fred von Lohman, para. 4). Among the videos that vanished were some that only used copyrighted songs as background music and for other non-commercial purposes, such as sign language videos. Warner Brothers explained that the wholesale video removals were due to YouTube's inability to distinguish copyrighted material pirated in professional videos from amateur, non-commercial videos.

In light of the full-fledged battle between Warner Brothers and YouTube, non-performing YouTube users, aspiring musicians, and even professional artists signed to major labels feel that their outlet to express their art and showcase their talents is being taken away. The angry voices of musicians protesting YouTube's removal of their original videos are rising (Wauters, 2009). YouTube may still be considered a haven for independent musicians, but the division between the video site and the major labels has caused deep anguish for some aspiring artists. Even when YouTube made a settlement with the major labels, the artists signed to the major labels complained that they were not receiving additional royalties. In the article "Musicians waiting on a YouTube payday," Sandoval (2008a) reports that some musicians are not seeing the results of the financial deal that was made between YouTube and its four large music label partners.

The dissonant voices of unhappy YouTube users may soon become even more agitated. In an *L.A. Times* article, Dawn Chmielewski (2009) reports that Universal Music has forged a partnership with YouTube, which has resulted in the creation of a new site (Vevo.com), where viewers can watch a variety of videos from Universal Music's artists. Soon after, Sony signed up to join the same deal (Sandoval, 2009). Although Warner Music and EMI have not yet signed contracts, negotiations to do so are underway (Sandoval, 2009).

As these news reports suggest, YouTube's continuing battles with its major label partners are affecting many independent artists, as well as artists signed to the

major labels. Gehl (2009) presents a complex view of the site and its problems in "YouTube as archive: Who will curate this digital Wunderkammer?" Gehl argues that unlike the common belief that YouTube is democratic, YouTube's structure resembles that of the traditional corporate media outlets: "its lack of a centralized 'curator of display' actually sets the stage for large media companies and entrepreneurs to step into the curatorial role" (p. 43). Gehl's point here is an important one to consider for several reasons. Firstly, his arguments compel us to think about the democratic characteristics of YouTube. Not everyone who uploads a video will have a chance to share his or her posting. This reality is discussed in detail by Jenkins (2009):

> YouTube's utopian possibilities must be read against the dystopian realities of a world where people have uneven access to the means of participation and where many are discouraged from even trying. If YouTube creates value around amateur content, it doesn't distribute value equally. Some forms of cultural production are embraced within the mainstream tastes of site visitors and the commercial interests of the site owners. Other forms of cultural production are pushed to the margins as falling outside dominant tastes and interests. (p. 124)

Jenkins argues that even if a video is uploaded and is given an opportunity to be shared with others, the way in which the video receives exposure is an issue that needs to be addressed. In addition, constant vigilance and surveillance are growing issues on YouTube; these are causing alarm and creating an anxious environment for the YouTube users who wish to upload their videos.

It seems that in the end, YouTube might eventually function no differently from the mainstream media. This is ironic in the age of convergence culture. As the mainstream corporations continue to dominate the participatory media, individual practices and endeavors to gain attention are becoming not only fierce but also unpleasant. Burgess and Green (2009) have noted this new reality: "some of the most active members of YouTube social network have expressed discomfort with the interjection of corporate players into a space they experience as community generated" (p. 5). In the next section, the skeptical view expressed above will be contrasted with the various competitions that are being held on YouTube. The nature and procedures of these competitions will once again complicate the binary views of YouTube; nevertheless, a common thread will be picked up in terms of the inevitable role of the mainstream music culture in the collecting and organizing of competitions for amateurs.

The Hybrid Field of YouTube

YouTube's hybrid field comes into play when the site functions as an intermediary between the mainstream industry and the artists. Basically YouTube is playing two

sides of the fence; the site helps the undiscovered artists by creating opportunities for musicians, while also catering to the needs of the mainstream industry. Typically, the hybrid field is particularly pronounced in the competitions the site holds. The reward for each competition is different but there is one commonality which often entails partnerships with major corporations: increased exposure.

In 2006, YouTube teamed up with Cingular and ABC to promote new unsigned bands in a competition called the YouTube Underground. Unsigned artists were invited to submit their original music videos, footage of live concerts, or their best songs or most creative films between October 2 and 18, 2006. The winning clips were to be featured on *Good Morning America*, and the clips would also be turned into a Cingular ring tone. This competition may have not been widely known, but it is significant that although the competition was limited to "underground" talent, the reward had nothing to do with being an underground artist. Rather, the award provided mainstream exposure and used this exposure as a way to motivate musicians. In addition, one should note that the media convergence was not limited to just the YouTube community but involved several different media platforms: ABC, YouTube, and Cingular (television, internet, and cell phone company).

On a similar note, Hasty (2008) reported that for the 50th Grammy Awards show, YouTube held a competition for unsigned instrumentalists to perform on stage with Foo Fighters. String, woodwind, and brass players were invited to submit 60-second audition videos of performances of the Foo Fighters' song "The Pretender." These videos were judged by Grammy-affiliated judges, who ultimately chose forty-five finalists. After that, the voting was opened to the public on YouTube, and the result of the voting was the selection of three finalists. Once again, YouTube coordinated a national event, providing an opportunity for musicians to gain prestigious mainstream exposure; not only did the winners share the stage with a popular band, but they also gained the honor of being chosen by Grammy-affiliated judges.

Another interesting development with YouTube is the extension of their competitions to the classical music genre. YouTube established the first YouTube Orchestra by extending invitations to all musicians to submit audition recordings online. Anyone regardless of location could become involved with the YouTube Orchestra by submitting audition videos for consideration. The entries had to be received by January 28, 2009, and each submission had to include two pieces, one of them an original piece titled "The Internet Symphony" composed by Tan Dun specifically for this project. The second piece could be chosen by the contestant to demonstrate individual musical skill and talent. The contestants were then judged by musical experts affiliated with the London Symphony Orchestra, Berlin Philharmonic, San Francisco Symphony, Royal Concertgebouw, Hong Kong Philharmonic Orchestra, New York Philharmonic, and other renowned orches-

tras around the globe. After the experts narrowed the applicant pool down to the semi-finalists, the YouTube community at large then voted on the finalists. The finalists were invited to a three-day classical music learning summit followed by a performance opportunity at Carnegie Hall.

The noteworthy aspect of this competition is the fact that it strove to combine the classical music genre with experimental perspectives in the hopes of discovering talented musicians around the world through the utilization of YouTube's crowdsourcing* methods. Various media outlets provided press coverage for the YouTube Orchestra. Many articles were written about the groundbreaking method of auditioning musicians around the globe. Aspen Steib (2009) in "YouTube Orchestra Wows Carnegie Hall" quotes YouTube's marketing manager Ed Sanders on the topic of the goals for this competition: "We hope this is game changing in the sense it redefines audition space, it brings people closer together and lets them collaborate, transcending geographical and linguistic boundaries" (para. 4). On the day of the final performance, Carnegie Hall's seating space was 90% occupied.

Another growing trend on YouTube involves competitions that apply the free labor of fans and musicians. Often these types of competitions are sponsored by major record labels. For example, in the Ben Folds competition, the Sony/BMG record label released the following statement:

> The very unique Ben Folds is inviting all college singing groups and musically inclined individuals in the U.S. to submit YouTube footage of a Ben Folds cover song. The ten videos with the most YouTube views will be featured on BenTV when the all new BenFolds.com website launches in mid-August. (Sonybmg-music, 2008)

Although the competition was advertised for everyone, it seems clear that the goals of the competition were to disseminate Ben Folds' songs as widely as possible and to promote his new website. Thus, the motives for these types of competitions frequently involve the promotion of a particular musician's future career plans, such as upcoming albums, websites, and tours. In a similar way, Def Leppard also used YouTube as a way to interact with fans. Ayers (2009) reported that Def Leppard will invite fans to submit their favorite videos of the band's songs on YouTube. The reward for winning the competition is two concert tickets and an opportunity to meet the band members backstage.

Besides working alongside mainstream record labels, YouTube is also used by music software companies to promote their products through contests. On son-icstate.com (a website that caters to electronic musicians), the announcement of the "Notion Music YouTube Competition" was made. The description of the com-

* Crowdsourcing is a concept that is rooted in the ideology that "labor can often be organized more efficiently in the context of community than it can in the context of a corporation" (Howe, 2008, p. 8).

petition is worthy of examination, as it points to a few important features of the contest:

> NOTION Music has kicked off the inaugural PROGRESSION YouTube Competition, an online contest inviting composers from around the world to write and perform their own compositions their PROGRESSION guitar-based program music composition program, as their backing band. The competition, which will be judged in summer 2008 by a combination of selected artists, is designed to give new composers the chance to demonstrate their talents for a chance to win NOTION Music software and a NOTION Music endorsement. (Sonicstate, 2008, para. 1)

Obviously the competition used the crowdsourcing method to attract talented audition performances. The irony here is that corporations have started to use this method as a savvy marketing strategy. In the following description of the "Notion Music YouTube competition," the managing director of Notion Music, Kris Karra, listed the motives and benefits of this competition:

> We believe there is a huge amount of undiscovered talent out there and we want to give up and coming musicians the opportunity to showcase their skills. We can provide the means to inspire aspiring musicians to create their own music with the help of professional quality performance software. (cited on Sonicstate. com, 2008, para. 2)

Although the notion of crowdsourcing will be explicated further in the last case study chapter on Indaba Music, it is important to introduce what it means and why such a method is dominating the social networking sites' competitions. Most of these major corporations phrase the competition descriptions to mask their motives; although the competitions are targeted at "undiscovered talents," it seems quite obvious that the sponsors of the competitions use musicians' free labor for promotional purposes. In the end, the reward for the winner is the product he or she is advertising. Without having to hire anyone to develop promotional ideas or campaigns, the sponsor company benefits from the free labor of the competitors.

To this extent, what is the characteristic of the hybrid field? While it could be argued that the YouTube competitions are groundbreaking and innovative since they allow undiscovered musicians to gain more exposure, they are often held to generate greater popularity for the sponsors and to function as advertising campaigns at the expense of the competitors' free labor. To this end, these competitions do not solely benefit "the undiscovered musicians."

Reflection on the Digital Field of YouTube

In this chapter, YouTube was analyzed in terms of several different aspects. YouTube's role in launching unknown musicians' career has been undoubtedly piv-

otal; however, it is important to understand how various reports construct such popularity as opposed to what really is taking place. Many reports valorize musicians' success as resulting from hard work and talent; while this aspect cannot be contested, it is important to parlay YouTube's role in musicians' success with other aspects, since popularity is generated by several factors. As the result of considering a few expert tips, we have seen how popularity on YouTube can supposedly be earned via mastering of certain tricks.

In terms of its democratic aspects, while YouTube offers opportunities for musicians to upload their music videos, the way in which the videos are displayed is somewhat problematic. The presentation issues pertain to the digital politics of being seen. On YouTube, being discovered may happen accidentally; however, this accidental stardom must be placed in juxtaposition to another aspect which pertains to cultural intermediaries. YouTube's editors decide which music can become featured. This means that the subjectivity of the editors also should be considered as factors in the decision-making process. To this end, YouTube's digital field of cultural production can be characterized as follows: 1) the field is controlled by the YouTube editors and the organizers of the competitions to produce a hierarchical culture where gaining "value" as a musician is inextricably related to being a participant in the mainstream industry; and 2) the cultural intermediaries include both the YouTube users and the judges selected for the competitions

However, if a person has already become famous on the mainstream media, then fame on YouTube may occur with little or no effort. This was the case with Susan Boyle, who experienced overnight success after being on the 2009 season of *Britain's Got Talent* television show. As a result of her established fame, Boyle also gained enormous popularity (as measured by the number of video hits) on YouTube. YouTube has a symbiotic relationship with the mainstream media, as revealed by instances such as this. If a previously unknown person becomes popular in the mainstream media, that person can gain worldwide fame with the help of YouTube.

On the other hand, the commercial aspect of YouTube has not always resulted in positive outcomes. YouTube has faced various legal battles over ownership and copyright issues, which has caused the site to delete numerous videos, especially those connected to artists signed by Warner Brothers Records. Although YouTube provides opportunities for average consumers and citizens to voice their opinions and share their music, its actions do not necessarily benefit the average users. YouTube continues to focus on forging various partnerships with major corporations; the recent partnerships with Universal and Sony are clear examples of the direction being taken by YouTube, a direction that indicates the implementation of mainstream ideologies. However, the concern here is not necessarily limited to the rules and regulations that will be imposed upon YouTube, but rather the analysis of how such transitions complicate the notion of free labor.

The success stories related to YouTube have inspired countless aspiring musicians to sign on to YouTube, hoping for similar experiences. There is a discrepancy as far as noting the result of their free labor. In some cases, the musicians do not consider the act of acquiring friends or increasing popularity to be labor, but others admit to working hard to generate and pique the interest of YouTube viewers. For some, it is important to earn some kind of financial return for their efforts. This is a new development in terms of people no longer wanting to work for free, as some reports suggest that musicians are waiting for their activities on YouTube to pay them back (Sandoval, 2008a). This seems to be combined with reluctance to work and to materially profit. YouTube now reflects the new reality; the site no longer functions as just a medium for everyday people to share their videos. This new situation is most obviously exemplified by the various competitions that have been held on YouTube.

One striking aspect of the YouTube competitions was the fact that the rewards were related to exposure in the mainstream media outlets. It seems that YouTube is capable of creating numerous opportunities pertaining to larger cultural events. YouTube's activities transcend the limits of virtual reality, bringing musical events into the actual, physical environment. However, the implications of the YouTube Symphony Orchestra, performing with Foo Fighters, and various other competitions run deeper than the fact that YouTube can organize an event outside of the virtual world. These events intersected with the mainstream culture through the involvement of a famous composer such as Tan Dun, or a popular band. such as Foo Fighters. Both amateur and lesser-known musicians were invited to perform on stage together. The performance space, Carnegie Hall or the Grammy Awards, also symbolizes success for many classical musicians. Overall, YouTube is a major purveyor of a new type of culture, which is neither mainstream nor underground but which combines both in an indefinable way.

Second Life as a Digital Field of Cultural Production

MySpace and YouTube are significant for musicians who participate in the subfields of mass production and restricted production. The rules of the game suggest a high emphasis on the quantitative mechanisms that evaluate musicians. Second Life has a different function, one that highlights live music performances which are a crucial aspect to all musicians' careers, regardless of whether they are signed or unsigned, known or unknown. Patrik Wikstrom (2010) explains that performing music live and embarking on tours used to be the way to promote albums, whereas in the digital age, live performance is no longer a means to achieve successful record sales. Rather the priority has shifted so that it is the recorded music that inspires the live performance. Furthermore, Wikstrom comments that the income stemming from recorded music alone is no longer sufficient; hence, live music has become a major source of income for recording artists in the digital age. To this end, Second Life is an interesting alternative since it offers a platform where musicians can perform, earn an income, and promote themselves in a virtual space.

Second Life is "a 3-D virtual world created by its Residents. Since opening to the public in 2003, it has grown explosively and today is inhabited by millions of Residents from around the globe" (Second Life, n.d.). Second Life is owned by Linden Lab, whose headquarters covers an area of over 1, 577 million square feet (Bonsu & Darmody, 2008). In Second Life, participants create their own avatars, and they can buy and own land, teach classes, create objects, perform, and

participate in virtually all types of real-life activities (Diehl & Prins, 2008). The field of Second Life is similar to the earlier case studies on MySpace and YouTube in that Second Life incorporates mass-produced cultural production and small-scale production (i.e., independent or amateur musicians). However, the fields on Second Life do not necessarily overlap as in the cases of MySpace and YouTube; instead, a clear distinction of fields occurs through a physical demarcation of virtual spaces. Second Life offers concert venues that are used by the mainstream industry, while there are other places where amateur and independent musicians can perform. The rules of the game are also collectively written and problematized in the Second Life forum where the players in the subfields communicate about the approaches that have worked and have not worked for them.

The Subfield of Mass Production on Second Life

On Second Life, musicians are not necessarily becoming involved on the site to acquire direct economic capital; instead, they are seeking to strengthen the capital they already possess. For example, the EMI record label hired Second Life co-founder Cory Ondrejka as a senior vice-president of digital strategy as EMI struggled to make strides in the digital era (Sandoval, 2008). Thus, it's clear that major record companies are reacting to the ever-growing influence of social networking sites. Besides the use of Second Life by new and emerging artists, Robert Andrews (2006) reports that famous musicians from various genres, such a Duran Duran, Suzanne Vega, and Talib Kweli, have performed on Second Life. Actual performances are not, however, the only activities in which mainstream artists participate. Singer-songwriter Regina Spektor (who is signed to Sire Records, a subsidiary of Warner Records) held a listening party on Second Life; Ben Folds launched his new album on the website (Hutcheon, 2006), while the rapper Chamillionaire and the grunge band Hinder have used Second Life as a way to connect with their fan bases through the meeting and greeting functions (Andrews, 2006).

Second Life is also endorsed by major classical recording labels. According to a *New York Times* article (September 18, 2007), Anne Midgette reported that the Royal Liverpool Philharmonic held a virtual concert in the virtual Art Deco hall in Second Life. Universal Classic had also "acquired" land in Second Life, so that visitors could view a virtual exhibition of artifacts related to legendary mezzo-soprano Maria Malibran, who toured Europe to promote Cecilia Bartoli's new Malibran-theme album. The article also reported that in May 2007, pianist Lang Lang performed a live concert as an avatar. Jonathan Gruber, the vice president of new media for Universal Music Group, expressed the following opinion of Second Life's potential usefulness: "We're not 100 percent sold on it. It's experimental. We are interested in making sure that if there are opportunities for us to reach people through a medium like Second Life, we're there for it" (para. 17). The audience

members of Second Life also showed appreciation for this type of opportunity, since it removes the limitation and confinement of one's geographical location.

Universal Classic is not alone when it comes to experimenting and using Second Life as a promotional and marketing tool. The renowned classical music label, Naxo, featured the young Italian pianist Alessandro Marangoni in a concert that took place on February 23, 2009, in the main auditorium on Utwig Sim. On this occasion, Marangoni was interviewed by David Schwartz, a noted American composer, about the pianist's new recording of Rossini's piano music (Naxos, 2009). While Second Life often functions as a promotional tool for already established musicians, it is also a digital field where unsigned musicians can attain economic, social, and cultural capital. Second Life is noteworthy because live performances occur in real time, a function which differs from those available via MySpace or YouTube. The next section provides a virtual ethnographic comparison of how Second Life live performances operate in parallel to real life.

The Subfield of Restricted Production

Musicians in the subfield of restricted production perform on Second Life as avatars; the performances are conveyed live in real time through a streaming audio. The avatars not only move but can also dance. In addition, the avatars can be adapted to resemble the performer in question. To some extent, Second Life's live musical performances challenge the traditional meaning of live performances. While this is considered a relatively new phenomenon in comparison to sharing music online in an already-produced form (as exemplified by MySpace, where musicians network with listeners and other musicians), real-time live performances may possibly change the dynamics of the way in which musicians work on such sites.

To better understand how independent musicians in the subfield of restricted production perform and promote their music on Second Life, I conducted a virtual ethnographic study in order to fully understand the issues surrounding live musical performances, especially in the context of the relations between performers and audiences. Given the fact that all users are disguised as avatars, real-time live performances on Second Life are difficult to analyze without actually entering the site to experience what it is like to be an audience member.

In the month of April 2009, I visited several Second Life live musical performances. My selection of performances was based on the convenience of particular times and days. Because I was already a member of Second Life, I simply logged on and clicked on the "search" button. Inside the search function, I chose my selected dates and typed the words "live music" into the search box. After entering these keywords, I was given variety of selections from which to choose. At this point, I chose the performances based on my availability to devote an entire

hour to the observation of the concert. All told, I was able to analyze a total of ten performances on Second Life.

In Second Life, although I had not taken into account the genres in terms of selection process, it is important to point out that pop and hip-hop music, which usually rely on a backing track for performances, are not prevalent on this site. Many performances on Second Life are mainly live performances. Although live music performances on Second Life may represent specific subgroups of musical styles, I focused my attention on the musicians' laboring practices, and did not necessarily seek to create links between genres and laboring practices.

My first attempt to observe a Second Life performance was not successful; however, although I decided not to view this performance, my experience was significant in that it made me aware of specific cultural issues that exist on Second Life. I entered this first venue approximately two hours prior to the actual concert time. As a newcomer to this venue, I asked about the time of performance. In my attempt to learn more information about the Second Life performance, I was quickly criticized by one of the members, who happened to be the venue performer herself. This person was extremely condescending and challenged me rather belligerently every time I asked a question. It was such an extremely unpleasant experience that I ended up changing my mind about including her performance in my study.

Later, one of the other Second Life members who had witnessed my interaction with the performer approached me in a separate chat-room. He informed me that deceptive activities seem to thrive on Second Life. Since everyone hides behind a self-constructed avatar, a higher-than-usual degree of skepticism exists when dealing with issues of identity and authenticity. Apparently, because my avatar was created a few months prior to accessing this particular venue, the performer in question doubted my genuine desire to learn more about Second Life live performances. She assumed that I should have known all the details and understood the culture of Second Life by this point. However, because I was not an active member in the past, I was unaware of all the technical complexities that come with interacting on Second Life. Although I ended up not attending the concert, this encounter provided me an opportunity to learn about certain protocols and the culture shared by Second Life members. From this point on, I toned down my inquisitive attitude and mannerisms.

The first actual performance that I attended took place on April 6, 2009. The artist, Clairede Dirval, played guitar and sang mostly cover songs from the popular music genre. The performance occurred in a venue called Zenlive at 6:00 p.m. Second Life Time (9:00 p.m. Eastern Time). During the performance, several incidences happened that were worthy of analysis. First of all, the conversations that were pursued in the chatroom were interesting. Here, Second Life members carried on public discourses about the performance or other relevant concerns.

The chatroom was a major way in which the members communicated with one another, but it was also a location in which the performer and audience members could communicate. While the avatars could be made to jump, dance, or walk around at their own volition, in order to communicate directly, chatting was utilized. Observing this particular performer, I could see that Dirval was already acquainted with several of the audience members. My impression was that here existed a community of people who already knew each other, perhaps from previous concerts or as a collective body of fans.

The most valuable information garnered from this concert was the manner in which the performer addressed and paid close attention to the chatroom conversation. In between each song, Dirval continuously referred back to the conversations that were going on in the chatroom. At one point, Dirval did not seem to like the fact that various members were busy chatting with one another about issues unrelated to the actual performance. Because the performer possessed a disguised avatar, she could not show direct emotions and was limited to a restricted number of gestures: 1) she called out the names of the members; 2) she engaged in conversations with the members; and 3) she made jokes in the chatroom. As for the audience members, they showed support by pressing the "applause" button, which produced a clapping sound. On a couple of occasions, one of concertgoers also reminded the other attendees to tip the artist. Each time a tip was given to the artist, gratitude was displayed in the chatroom by the typing of the words "thank you." This also implicitly reminded others to tip as well.

At one point, the performer asked one of the members, "Are you drinking tonight or are you staying sober?" From this inquiry, it was clear that the audience member and the performer knew each other from a previous encounter. Gathering from a variety of exchanges that went on during the concert, it was clear that although the means of communication were limited, the performer made repeated attempts to interact with the audiences by closely paying attention to the chatroom conversation. It seemed as if the avatars' appearances and movements did not matter a great deal; rather, the oral and written communication was the major source of conversation. During the concert, the performer mentioned that one particular audience member needed a drink. After this remark, the audience members joked about Dirval wanting to turn everyone into an alcoholic. Quickly after this commentary, Dirval repudiated the accusation by saying that she just wanted everyone to have a good time. Using this interplay as an example, it is clear that interaction with audience members seem to be important in gaining attention during the performances.

The second concert that I attended was given by Mike 00 Carnell who sang and played the guitar on April 11, 2009. It was at the location called Kijiiji at 2:00 p.m. Second Life Time (5:00 p.m. Eastern Time). The concert did not differ greatly from the earlier concert that I visited. The performer consistently addressed

and took note of each audience member by either saying his or her name or asking for specific song requests. The performer also asked the audience members to vote for the specific venue where the performance was taking place. Apparently, there was a competition on Second Life for the best venue. Although it was unclear whether being voted as the best venue on Second Life affected the performer's popularity or not, voting reminders were sent out throughout the performance.

At one point during the performance, Carnell told the audience members that he did not know a particular requested song by David Bowie, and offered his apologies. Clearly the performer was making an effort to please the concertgoers by playing requested songs along with some of his original songs. This type of interaction was very similar to a certain kind of real-life, live musical concert, where the performers allow attendees to participate in shaping the musical content of the show. In addition to these interactions, Carnell asked the audience to whistle with him. Apparently the audience members could sing along to the songs by using the "whistle" function. From time to time, there were also moments where the breaks and pauses in between the songs created awkward moments. Because there was no real movement of the performer (besides the artificial movement of the avatar acting as if it were playing music), it seemed harder to follow the performer's actions. At this point, I became curious as to why people would attend Second Life live musical performances. I turned my attention to the chatroom where I asked the following question: "Why do you come to live music here?" One of the members soon responded: "cause we don't like to listen to taped performances." Another audience member mentioned that he or she loves the audience members' interaction with musicians. Soon after, another member interjected: "Second Life reflects real life, it's all the same." For this member, a Second Life concert did not qualitatively differ from an actual live concert. Yet another concertgoer added to this conversation by stating that "it is more accessible," thereby emphasizing the convenience as another reason for visit.

The third concert that I attended on April 11, 2009, at the Cocoa Beach Music venue was given by pianist Winters Kanto. This performance started at 5:00 p.m. Second Life time (8:00 p.m. Eastern Time). The performance was supposed to last one hour; however, I was unable to view the entire performance due to a negative encounter with one of the other members. While enjoying the jazz pianist's performance, I realized that my avatar was not moving. Because I was not actively moving my avatar, I discovered that it was hanging its head, making me appear inactive. Although I did not care that my avatar was inactive, someone in the chatroom wrote, "move, you idiot." I was startled by this remark and asked: "Did you just call me idiot?" This person then confirmed that he or she had indeed called me an "idiot." After reading this, I wrote: "I will not move." As soon as I typed this, my access to the concert was taken away. This experience revealed one aspect that distinguishes Second Life from real-life performances. An insignificant

and trivial bickering between audience members usually does not result in the removal of someone from a concert. Apparently though, Second Life allows misbehavior as a reason to exclude members from concert settings. A certain kind of propriety and attitude is advised in the Second Life setting. Not all users have the authority to exclude others from the chatroom; only a few people are empowered to restrict who is permitted in the room (one must be the owner of the shop or performance venue, or otherwise officially affiliated with a location). Obviously, whoever called me "idiot" had such power.

The fourth concert that I attended was on April 17, 2009. It was a performance by Blindboink Parham, who sang and played the guitar at the Blues Fabrik venue. The performance started at 1:00 p.m. Second Life Time (3:00 p.m. Eastern Time). I entered the venue a few minutes early, which gave me an opportunity to chat with the artist briefly. I asked the artist if he enjoys performing on Second Life more than in real life. Although the artist said he likes performing in real life better, he mentioned that they are similar experiences: "people listen, and it's live, no karaoke." This statement should not lead to a generalization of the Second Life performance experience as inferior to actual live performances. Others, such as Grace Buford, an active Second Life performer, actually prefer Second Life live performances over other kinds of live events:

> I can go into a club or a venue in the real world and people aren't listening. They're talking, laughing, carrying on. And as an artist, we're all a little bit narcissistic. We've created this work and we want to share it and have an intimate connection," she said. "On stage, you kind of think, "What's the point of me being here?" In Second Life ... you're having that intimate conversation with the listener. (cited in Sutter, 2009, para.30)

Despite the differences of opinion in terms of preferences, the key issue is not necessarily which type of performance is better or worse. Rather it is important to recognize that both have advantages and disadvantages connected to them.

During Parham's performance, I observed how he interacted with the audience members. Once again, the method of reaching out to the audience members was similar to the earlier performances that I had observed. This performer also called out the audience members' names and greeted them one by one. He had a poster on the stage which displayed a direct link to his professional homepage, MySpace page, music shop, and group-add. The poster also provided information about the performer's work and background. His merchandise and music information were just a click away.

During the performance, Parham mentioned that his CD was for sale and that free guitar lessons were available on his website. One of the concertgoers repeatedly encouraged the other concertgoers to tip the artist and the venue, and also thanked them for doing so. This gesture was consistent with the other con-

certs that I had observed; thus, I inquired what this person's role was. After briefly chatting with the person, I learned that every venue hires a person to promote the venue and to encourage the audience members to tip both the venue and the performer. While the performer encourages others to tip the venue and him/herself, another person usually runs the venue. This person helps facilitate the flow of the concert; sometimes the manager assists newcomers, like myself, to learn more about the artist and the venue.

The fifth concert that I observed also took place on April 17, 2009, at 4:00 p.m. Second Life Time (7:00 p.m. Eastern Time). This concert was held at the D2Tk venue, and it was a live musical performance by Damian Carbenell (he sang and played guitar). At this point, I was accustomed to the general etiquette and culture of Second Life live musical performances. Unlike my initial mishap, I now related well with the audience members, and I felt like a part of their Second Life community. People at this venue seemed to be much more open to my presence, which may have been because I was becoming more adjusted to the culture of Second Life. I casually chatted with other audience members and joined in praising the artist's talent. When I showed that I was enjoying the concert by writing positive commentary in the chatroom, one member even sent me the list of requested songs. In the listing were five original songs and other popular cover songs. This member also made the following announcement to the audience members: "If you want to join Damian's group, the Carbenell street team, just IM me." By joining Damian's group, one can receive updates about the artist's upcoming shows and other events.

Throughout the concert, the artist repeatedly addressed the concertgoers by either calling out their names or asking if they were having a good time. He also reminded them to "hit up that tip jar." In appreciation, Carbenell dedicated a number of songs to the audience members. From this concert, it was clear that "casual" chatting and interaction functioned on Second Life as a means of promotion. This was essentially a form of affective labor, but more importantly it showed how conformity was required as a prerequisite for participation; while positive comments were rewarded with attention, negative comments, and dismissive or inactive attitudes were punished with marginalization and expulsion.

After the concert, I asked how the performer had gotten started on Second Life. At one point, the owner of the venue, noticing my interest, kindly invited me to wait around after the show to chat with her. When the show was over, she asked me to get on "voice-chat," which is another way to communicate on Second Life. Just like the telephone, people can talk to one another using their real voices. Although I did not have voice-chat set up on my computer, I was able to hear the owner's voice while I typed my responses to her and another member who participated in the conversation. We casually discussed how performers get started on Second Life and how popular the site has become. The owner said she was often

asked for interviews by students doing research papers on Second Life. She also told me that the site is no different from real life in that many people use it as a way to actively start music-related careers, such as becoming promoters or managers. The owner even cordially invited me to perform on Second Life, should I ever be interested. I thanked both the owner and the other member for being kind to me, especially since my previous experience as a novice Second Life member had not been so pleasurable.

The sixth performance that I attended also occurred on April 17, 2009, at the Pond Live Venue at 5:00 p.m. Second Life Time (8:00 p.m. Eastern Time). The concert was given by Shannon Oherlihy, who sang and played the guitar. This performance did not begin punctually due to a series of technical problems. During the delay, the concertgoers chatted with one another on issues not necessarily connected to this performance. When Oherlihy was finally ready to perform, the audience members showed support by clapping and paying compliments to her voice and music. Although the actual performance was short in duration, I was able to observe how audience members react when artists have technical difficulties. They were mostly patient and remained in the performance room until the end of her show.

The seventh performance I attended was on April 17, 2009, at the same venue by Donlizard Hunt (he sang and played the guitar), and it started at 6:00 p.m. Second Life Time (9:00 p.m. Eastern Time). Just like every other performance, the artist acknowledged everyone in the concert venue by calling out their Second Life names. At this venue, the voice-chat function was activated, which bothered some audience members. One of the audience members asked those talking to pursue their conversation in a private setting. During this performance, the artist called me out for not dancing. I told the performer that I did not know how to make my avatar dance. Another audience member kindly told me to click on the ball next to her arm. After I clicked the ball, my avatar was suddenly dancing in sync with the rest of the girls. When I started dancing, the artist noticed right away and commented on the fact that I was now moving. Throughout the performance, the artist invited the concertgoers to check out his website for upcoming shows.

The eighth performance I attended was on April 17, 2009, at the venue Massine I, and it was given by the performer Astronimus Randt at 7:00 p.m. Second Life Time (10:00 p.m. Eastern Time). In this performance, the artist played a variety of instruments (violin, flute, guitar, and keyboard) and sang. He played cover songs, as well as his own original music. In the chatroom, one member distributed the performer's MySpace page. It was apparent that this person was playing the role of assistant or manager. In between each song, Randt usually called out the names of audience members, but he also made comments about the music industry. For example, he observed that the music industry has changed in

a major way in recent times and that now he gets to perform in a virtual world to an international audience. He then added, "That's the way I like it." Without my asking any questions about his experiences as a live musician on Second Life, Randt revealed that he enjoyed this experience and appreciated the change in the music industry. From his testimony, it was clear that Second Life live concert opportunities were opening doors for many independent musicians. One of the audience members agreed with this performer by typing "Fuck MTV." Aside from this discussion, an unrelated conversation was going on in the chatroom, which was lewd in its content. Two of the audience members seemed more interested in exchanging sexual innuendos between one another than in concentrating on the concert.

The ninth performance I attended was on April 18, 2009, at the Pond Live Music venue. The concert was by Iriskaye Siamendes, and it started at 2:00 p.m. Second Life Time (5:00 p.m. Eastern Time). This performance was similar to a karaoke performance, since Siamendes had a pre-recorded track and sang on top of it. She sang only cover songs, and the genres of music were country, blues, and pop. During the performance, Siamendes announced her merchandise for sale, such as T-shirts. She also mentioned that her manager was present. At this point, I asked in the chatroom who the manager was. Siamendes responded to my inquiry, and referred me to her manager by typing his name. The manager contacted me, and I asked if he was Siamendes' manager in real life as well. The manager responded that he is her boyfriend, and on Second Life, he helps her book and run her shows by sending out notices and assisting with anything that she may need.

From this example, it was clear that free labor may be offered by people with whom a performer is connected in real life. The manager/boyfriend, however, told me that having a manager on Second Life is not necessary if one wants to start up as a performer. To this end, Siamendes added that simply talking to people at a venue may lead to opportunities to perform as a musician/singer. She also stated that she started singing on Second Life in July 2008, and since that time, her circle of acquaintances has grown tremendously. Through these informal chats, I was able to better understand how Second Life live performances happen and to gauge the enjoyment that the performer receives by performing.

The last performance that I attended was on April 18, 2009, at the Pond Live Music venue at 5:00 p.m. Second Life Time (8:00 p.m. Eastern Time). The concert was by Glaisne Osternam, who sang and played the guitar. On stage, there was a poster that announced, "Join Glaisne's fan club here." As was the case with the seventh performance, this performer interacted with me by recognizing my movements. I initially watched the performance from afar and later decided to move to the front by the stage. The performer immediately commented on my change of position. Osternam also responded to the audience members' song requests. When an audience member requested a Jeff Buckley song, the performer

apologized for not knowing it, but then told the requester that he would look it up. This performance did not differ significantly from the other nine performances in terms of the interaction between the performer and the audience members.

Working in the Digital Field of Second Life

After attending a total of ten concerts on Second Life, each an hour in duration, I began to understand the common trends and patterns inherent to the site's live music venues. There were at least three ways in which immaterial, affective, and free labor was exerted. Firstly, all of the artists paid close attention to their audience members. Each artist addressed the audience members directly during the concert. The performers called out the names of the concertgoers and/or responded to the chatroom conversations. When I asked questions, most of the artists politely and promptly responded to them.

The interaction between performers and audience members constituted a form of self-promotion; any curious inquiries about or interest in the artists were always answered and addressed with care, while tangential comments seemed to be neglected. Sometimes a performer joined a conversation to reprimand the audience members and to call attention back to the performance. To some extent, the artists may have an easier time performing on Second Life, because unlike real live performance venues, the audience members cannot talk to each other loudly, thereby distracting or insulting the performer.

On Second Life, affective labor is highly visible through the interactions. The members of the community can share their experiences and discuss social protocols on the Second Life Music Community Forum under the posting title "What do I do during the shows?" Here a new performer to Second Life asked for advice about social protocols, and numerous users responded to the newcomer. The advice resonated with the data I had gathered from the field study:

> Talk to the people in the audience, as in directly, one to one. Get some patter happening between tunes, not just words to fill up space but talk to people. It's much easier to do that in SL compared to RL so long as you don't turn off the display of names above people's heads.

> The stage show doesn't mean much. People go to venues because they like the person running it, they like the act, or both. It's more fun with an elaborate stage show, but it won't change too much how many people come to your show. I've tried everything up to a stage that materializes out of the floor while it shoots fireworks and fog. I even built one early on that would shoot flaming cannonballs out over the audience. It's fun doing that, but it'll eat a lot of time that would be better spent working up your act...Call back all the stuff yer mama would tell you: don't mumble, blah, blah... Those are real people out there— Entertain them! (What do I do, 2008)

Considering these tips, it is clear that Second Life live performers can interact frequently with audience members despite the obstacle of not sharing the same physical space as them. Slightly different advice was provided by another member:

> Some performers go as far as greeting each audience member and thanking them individually for tips / donations. Personally I feel that's unnecessary: a good old "Welcome to the show, great to see you here' and a "Thank you for your donations' at the end of the show feels better for me so long as it's sincere and not rote formula. (What do I do, 2008)

Another member openly disagreed about the manner in which the performer should show appreciation to the audience members:

> I disagree about the blanket thanks for the donations. I'm always disappointed when that happens. People love hearing their names. It makes them happy and it's one of the reasons they tip. Is it so much to ask to thank them by name for choosing to give you money they didn't have to give? I've heard some artists go around the room and mention by name every person there, which can get a little tiresome. Otherwise, good advice here. One of the real tricks is learning how to connect and chat with your audience with a 20–30 second lag between what you say and when they hear it. That takes some getting used to. You have to acknowledge applause you haven't heard yet and trust it's forthcoming. (What do I do, 2008)

Although there were differences of opinion in terms of how to approach interactivity between audience members, given the advice above, musicians should individually thank their listeners and work hard to build their online fan base. This is handled much more delicately than in face-to-face live concerts, where non-verbal communication can also contribute to creating artistic aura. The mastery of such delicacy is what epitomizes the digital labor.

Secondly, it seemed important to have at least one person who acted as a manager or assistant in the venue. This person was either the owner of the venue or someone hired by the artist or the venue. This manager had several roles. During the performances, the manager repeatedly reminded the audience members to tip the performer and then expressed gratitude to those who did. This person also invited the audience members to join the artist's fan club or so-called "street team." (When a person joins the street team of an artist, he or she receives notifications of when and where the next performances will take place.) Finally, the manager played the role of a groupie and an avid fan. After each song ended, this person always cheered the artist by making loud clapping sounds, bravos, or other types of pre-recorded cheering sounds. However, one should not presume that this labor is free. These individuals are usually compensated, as are the artists performing on Second Life. Each artist who performs on Second Life can earn tips, which come in the form of "Linden dollars": 260 Linden dollars equal $1.00 US. The

performances occurring in these spaces may appear to be simple leisure activities, but they actually require serious labor that is merely disguised as fun and pleasure.

The third type of immaterial labor is displayed through Second Life performers' active involvement in the site community. Unlike many live performances where the backstage separates the performer from the audience, on Second Life, there was no backstage; rather, the artists created close relationships with the audiences by hanging around after the shows. Although not all performers mingled with their audiences, a few of them lingered after the shows, either attending the next performance or just hanging around to chat with their friends.

While Second Life activities thrive off of various examples of immaterial, affective, and free labor by the musicians, some scholars claim that these types of labors are being exploited. Contrary to the celebratory outlook of musicians' experiences, Tom Boellstorff (2008) explains the concept of creationist capitalism by stating that "workers are not just sellers of labor-power, but creators of their own worlds" (p. 209). In his anthropological analysis, he describes the thriving of creationist capitalism on Second Life in the context of an annual contest for residents to produce the best machinima in Second Life (p. 210). The winners' films then became promotion tools for the virtual world: "it is the cultural logic of creationist capitalism that renders intelligible a state of affairs where consumers labor for free (or for a nominal prize) to produce advertising materials for a product they have already produced" (Boellstorff, p. 210).

As the above description indicates, Second Life is a place where grassroots creativity is oftentimes sacrificed for the promotion of major corporations' marketing agendas. Demetrious (2008) in "Secrecy and Illusion: Second Life and the Construction of Unreality" argues against the utopian construction of Second Life as a community populated by empowered participants: "In Second Life, the hegemonic use of ideologically invested discourse serves to camouflage traditional power relations between its producers and consumers" (p. 4). Demetrious further criticizes the purportedly deceitful aspects of Second Life by citing Tony Walsh's article "Who really owns your Second Life?" (2006). In support of Walsh's point, Demetrious argues that even though residents on Second Life may think that they have much control and freedom for the customization of personal avatars, in the end, the ownership of each account is retained by Linden Lab.

A similar line of argument is pursued by Samuel Bonsu and Aron Darmody (2008): "[What] Linden and owners of other user-generated MMOGs do so successfully is mobilize unpaid consumer labor and convert the intangible fruits of the ethical economy into actual revenues" (p. 359). Given these contexts, how do we wrestle with the Second Life's musicians' activities? Musicians on Second Life receive a number of rewards in terms of economic and social capital. John D. Sutter (2009) in "Artists Visit Virtual Second-Life for Real World Cash" reports that the Second Life phenomenon is becoming increasingly popular among both

professional and amateur performers. Sutter points out that while the music industry is crumbling in an era of economic recession, Second Life musicians are thriving well by making "real money." Sutter (2009) reports that one Second Life musician (Cylindrian) made approximately $10,000 (including CD sales) over the course of one year's time. While major recording artists mostly use Second Life as a way to generate buzz around their upcoming albums or to promote themselves, for independent musicians, the site is a place where moderate incomes can be made.

Nonetheless, although Second Life musicians can acquire economic capital, one should not assume that every musician on the site makes enough money to earn a living. Furthermore, it is important to note that the subfield of Second Life is not autonomous from the mainstream industry or the capitalist frameworks. A key example of this is the way in which the music venues are operated. Second Life music venues are like actual, physical venues, as they can rise and fall in popularity; they can go bankrupt or suffer under poor management. Although membership on Second Life is free, fees are associated with the operation of the venues. To own a venue, the potential owner needs to buy the "land." Thus, these music venues do not just operate without any financial obligations. On Second Life, there are detailed explanations about the process of purchasing the land and about the service fees. To provide a clearer picture, I examined one of the popular Second Life music venues, Molaskey's Pub, and analyzed the venue's operations and how they affected the musicians' efforts to gain economic, social, and cultural capital.

Molaskey's Pub

Molaskey's Pub is a well-known and active music venue on Second Life. According to the website, it is "an Irish style pub featuring live acoustic music on Sundays, Mondays, and Thursday. It has played host to some of Second Life's most popular musicians and also offers a beach, darts and winter ice-skating rink" (Second Life, n.d.). Although I had not previously visited the pub to observe its live music concerts, the possible demise of this once popular pub caught my attention. Despite its earlier great success, in 2011, the venue was struggling to stay in business. Thus, I conducted a mini case study of the pub and its struggles. I focused on efforts to maintain the venue's viability among musicians as a platform for acquiring economic and social capital.

According to New World Notes, a blog devoted to Second Life, Wagner James Au captured the stories surrounding the potential closing of Molasky's Pub. With the possibility of the venue closing, many members of Second Life offered commentaries on the issue.

> Sadly this rot is spreading all over SL. Many popular venues and businesses are folding up because the economics no longer work. Odds are no one will step in

and if they do they'll either fail or never reach the former status. What is needed is some form of stimulus like a price cut in the tiers. (Like that will ever happen).

Contrary to the reigning logic of Second Life, which posits that businesses have good odds at being successful, the pending closure of Molaskey's Pub raises a contradictory and pessimistic perspective about the Second Life economy.

> Very sad. However, the first thing a venue owner will tell you, myself included, is that venues do not make money. I only host one big event a month due to the funding. The money to hire artists either comes from my store sales or out of my RL pocket. So, why do we do it? The love of SL live music and the artists.

Given the testimony of experienced users and venue owners, the actual economics of Second Life live performances are not propelled by the creators of Linden Lab but by the supporters of restricted cultural production. Clearly, the motivation does not lie in making profits but in intrinsic rewards.

Another user provided comments regarding the economic situation on Second Life and its exploitative dimension:

> Nothing makes money in SL these days, not just venues. That is what happens when a Pyramid scheme runs out of new people to prey on, and Molaskey's is a place that you can look at and point to and say this was done the right way and still not able to afford these sim prices, it is sad really, and needs to be looked at long and hard by the Lab. Need to lower tier, get the economy going again, get at least a percent of the population making some money again. Linden Lab is becoming the equivalent to the dictatorship that just takes billions from their country, while 99% of it's people are starving. They need to cut prices or finally figure out how to grow the user base again, soon.

In accordance with most of the commentaries, a different user argued that maintaining a venue is expensive and further stated:

> Music venues in Second Life have never been money makers and most don't break even. Katy, Nasus, Apple and Mia kept Molaskey's open as long as they did as a labor of love. It is a sad day indeed when I think of Second Life without my personal "Cheers."

The cynical views on the economic dimension of Second Life and its potential to provide a profitable venue for musicians as well as the venue owners continued:

> Never heard of it. Another win for LL's Commerce Team. If they don't want you seen you don't get seen. The destination guide is pretty much useless and is not maintained. I tried using it today and landed in the air falling until i landed on a private skybox. Apparently LL has no resources to deal with maintenance and upkeep of the dest guide. And the events system? LL allows the same people to repeatedly violate the rules making it unusable.

Finally late in the discussion, the co-owner of the Molaskey's pub chimed in and offered an explanation regarding the situation:

> As co-owner of Molaskey's Pub and producer of the music program, I was always motivated by my love of the music. I always operated under the philosophy that you can't expect the people who attend the shows to support the program. That business model has been proven, time and again, not to work in SL. Therefore the option was to develop the surrounding lands into a commercial/residential area with rents designed to be competitive while covering the tier, with a little left over to supplement the music program.

It is clear from the statement that while there is an agreement about the shortcomings of Second Life's business model, the pub co-owner's motivation for running the venue came from intrinsic rewards. She also stated that the pub's owners do not have the time to put in the work that is needed to successfully operate the venue; they have real-life commitments pertaining to their careers that require their attention. The co-owner, however, expressed optimism that the venue could be operated successfully by someone else who had more time to devote to it.

Following these statements, a musician on Second Life raised several important concerns regarding the failure of the economic system, blaming the site's unfair business model and the inability of the venue owners to balance their personal careers and Second Life ventures. The musician also criticized the site users and audiences in part for the failure. The exploitation does not solely concern mainstream corporations exploiting the everyday users but is also generated by the actual users of the venues. As the musician stated, "the real problem IMO is people have come to expect live music for free. Which is not just in Second Life but all over the web. As a musician that has a lot of investment in equipment, studio building and time I can tell you that it is not a profitable venture either." This comment reflects the fact that while Second Life's business model is flawed and may not always be beneficial to the musicians and the owners, the audiences and fans are not free of culpability. Despite the pessimism linked to the future of Molaskey's Pub, the venue survived, and the saga continues. According to a press release on the pub's Facebook page on April 18, 2011, the owners sold the venue to Dreams Riler and her company Higher Ground Music. While this small case study on Molaskey's Pub had a happy ending with the saving of a venue that musicians and music lovers greatly enjoyed, a number of interesting developments and insights exist that help in understanding the nature of this incident.

The digital field of Second Life is contingent upon the digital economy. Despite various claims that the venues are operated solely for the love of music and that musicians perform for just the same reason, by ignoring the economic aspect, the intrinsic rewards are not fulfilled. This seemingly contradictory reality is explored by Ursula Huws (2010):

On one side of labour, there is the urge by the individual workers to do something meaningful in life, to make a mark on the world, to be recognized and appreciated and respected, on the one hand, and, on the other, the need for a substance income, the ability to plan ahead and some spare time to spend with loved ones. This is often expressed as a contradiction between a drive for autonomy and a search for security. (p. 519)

In short, although musicians may not always be primarily working toward gaining economic capital, the digital field of Second Life is defined by capitalist frameworks. Earlier in the chapter, various critiques of Second Life noted how the site is exploiting its users with misleading promises that workers can use the site to build their own careers. However, given the testimonies of some users (although they do not capture the entire gamut of sentiments or experiences of Second Life users), it seems clear that the winners and losers are determined by the rules by which one chooses to play. If the culture of Second Life's digital field convinces the game players (the musicians) that performance itself is great and the intrinsic rewards should be enough for the musicians, there are no losses. However, if users assume that gaining cultural and economic capital is important, then musicians may not be winning in the digital field of Second Life. While the goals and intentions for entering the site's digital field vary, the implicit rules or assumptions are sometimes subtly imposed from mediated discourse which focuses on the sanguine potential of Second Life.

According to Daniel Kreps (2008), Nashville blues musician Van Johin was signed to a Reality Entertainment Label as a result of performing frequently on Second Life. The article reported that a scout had been visiting Second Life for several months before signing Von Johin. Another artist who was signed to a major record label used Second Life as a way to market and release an album on eBay. Todd Leopold (2007) reported on *CNN* that Michael Penn, who had been signed and later dropped by both RCA and Epic Records, created his own label, Mimeograph. After going through a tumultuous journey with the major record labels, Penn told *CNN* that he is enjoying the freedom of being independent, and is practicing his artistry by actively participating in the Second Life music scene. Thus, the example of Michael Penn is a positive reinforcement for musicians who seek to have control over their career without relying heavily on cultural intermediaries.

Towards Winning Cultural Capital

Finally, in this last section, I explore how musicians gain cultural capital. Social capital is a precondition to cultural capital; on Second Life, however, because music communities operate as live music platforms, there are no popularity ratings or charts. However, on other sites devoted to analyzing Second Life's musical activities, various attempts have been made to rank the musicians. On http://moolto.

ning.com, the ranking of Second Life musicians through voting is illustrated. The website exclaims "tell all your friends to join Moolto and come vote for you!" After voting occurs, the artists climb the charts based on the following rule: "0 vote, lose 2 positions; 5 votes, lose 1 position; 10 votes, stand still; 15 votes, gain 1 position; For every 5 votes more, you gain another position!" The reward for winning is "their video featured on the Moolto website; An article on MORE—Moolto Online Publication (more than 10,000 monthly readers); An AV makeover package from some of SL's top designers sponsored on Moolto.com."

Besides this competition, a number of other competitions exist which are worthy of examination. One of these is the RMG Idol Competition, which has the slogan, "live music competition that propels Second Life artists into real life." According to www.rmgidol.com, the goal of this competition is to help great talents on Second Life to transfer into the real-world music industry. In short, the aim is to become a part of the mainstream music industry; this is based on the assumption that the digital field of Second Life is not an end unto itself but a means to finding other, broader opportunities. The first-prize winner received an independent recording contract with Halogen Records and distribution on an upcoming compilation CD from the company. Other awards included exposure outside of Second Life with a great emphasis on the "reality" aspect. Besides the lucky winner, the five runners-up were also promised various publicity and promotional packages.

Another important competition is the Second Life Anthem Contest. The motto behind this contest reflects the problems detected by the various scholars who have examined the digital economy. The website slanthem.com states that the founder of Second Life, Philip Rosedale, made the following announcement: "I'm not building a game; I am building a country." This statement inspired Dr. Richard Gilbert, a psychologist of the virtual world, to raise this question: "What country does not have an official anthem?" Thus, a competition is being held to find the best anthem for the "country" of Second Life, and the grand prize winner will release a professional recording on iTunes after working with Grammy winning songwriters. Furthermore, the grand prize winner will receive $50,000 Linden dollars and HD Machinima during a live Second Life performance. The second- and third- prize winners will each receive $25,000 and $10,000 Linden dollars. The winners will be determined by public voting procedures, but prior to that, a group of judges will evaluate the submissions and will select the finalists that will be posted on the website for the public voting.

Examples such as this strengthen various perspectives that mega-conglomerate social networking sites, such as Linden Lab, are developing a variety of ways to provide opportunities to musicians, while the musicians work to build the Second Life nation, a nation represented by the everyday people, reinforcing the country's aggregate of everyday citizens. This is similar to the goal of MySpace's founder to

build "a lifestyle brand." Besides the contests mentioned above, many other contests exist, such as the Second Life Music Video Contest. The process of ranking artists further occurs in various blogs, such as nwn.blogs.com, which invite users to vote for their favorite Second Life musicians.

Reflection on the Digital Field of Second Life

Similar to MySpace and YouTube, Second Life's users include both mainstream and unsigned musicians. While the activities of mainstream musicians and independent musicians do not intersect in a concrete, visible way, the overall digital field of Second Life is controlled and configured by Linden Lab, and such control affects the small businesses on Second Life. However, while the economic gains and losses within the business model of Second Life are of concern, the other baffling problem pertains to musicians' and the business owners' attitudes toward self-gratitude. Is it merely enough that musicians are given opportunities to perform on Second Life when one considers the limited or lack of financial support? The same question can be raised to the owners of Second Life spaces: should one operate a venue because of a love of music or with a goal of increasing profits? Of course, the answers to these questions vary depending on an individual's value system, time, and other nebulous factors. In an ideal situation, gains in both economic and cultural capital will yield satisfaction, but the situation becomes more tricky when one's hard work on Second Life profits the mainstream industry more than the musicians or the venue owners. However, I am careful to point out this asymmetry in profit management because other immaterial gains are clearly present on Second Life.

From an independent, unsigned musician's viewpoint, Second Life's live performances provided an outlet that was truly liberating in terms of a minimized amount of the politics required for procuring performance venues. Booking a gig seemed pretty straightforward, as it only entailed talking to the owner of a Second Life music venue and requesting a time slot. The presence of signed musicians on Second Life does not limit in any way the opportunities for unsigned musicians to perform. Actually, the success being generated by unsigned musicians is motivating some signed artist to learn more about the Second Life scene. As Robert (2006) states, "the big names, however, are following in the footsteps of members of Second Life's growing unsigned music scene. To many amateur artists, the virtual world represents a good way to build a following" (para.11). Often these artists are contractually linked to major record labels, such as Naxo, BBC, and Sony.

Nevertheless, it is important to understand that the differences between the use of Second Life by major and unsigned musicians are grounded in the site's tip-driven economy. Second Life amateur performers work in order to earn tips and increase fan bases while signed musicians utilize the site as a promotional

platform. In other words, Second Life performers have to "hustle" to get a gig and to cultivate audience approval, whereas signed musicians already have a significant fan base acquired through mainstream media exposure. Thus, Second Life becomes yet another alternative marketing strategy for already established musicians, while unsigned and independent musicians have discovered that a greater emphasis is being placed on increasing individual online exposure.

In addition to performing and marketing, many Second Life contests have been held to attract musicians to the website. The main rewards for participating in the contests have been exposure, increased networking connections, and periodic collaborative opportunities with professionals in the mainstream music industry. These rewards sound desirable to aspiring musicians, but they mutually benefit both musicians and sponsors. Because winners are often determined based on the number of votes, the contests have become a convenient method to advertise or strengthen the Second Life brand (or other commercial brand) through the free promotions done by participants. Overall, Second Life's activities do not seem to have as great an impact as MySpace or YouTube in terms of their potential to promote the discovery of unknown talents by cultural intermediaries. This is most likely due to the fact that the accessibility of MySpace and YouTube is much higher than that of Second Life. Nonetheless, the issues that have both plagued and characterized MySpace and YouTube, such as ratings, rankings, and the tension between empowerment vs. exploitation, are still actively present on Second Life.

Indaba Music as a Digital Field of Cultural Production

In the previous chapters, we examined how various social networking sites allow users to gain fans, perform live in real time, sell records, and showcase music videos. In this chapter, I explore a new development in social networking sites for musicians and the music industry by studying the digital field of cultural production that focuses on online collaboration between musicians. Although Indaba Music may not be a household name (yet) like MySpace or YouTube, the site is drawing the attention of the music industry as a whole. One of the founders of Indaba Music, Matt Siegel, has been featured as one of 30 "power players" in the music industry under the age of thirty (Billboard Staff, 2010). The digital field of Indaba Music offers a unique hybrid field where new and old types of cultural intermediaries play a prominent role in the consecration of the arts.

Indaba Music was founded by Matthew Siegel and Dan Zaccagnino in April 2007. In an e-mail interview, Zaccagnino explained how he and his friend came to establish Indaba Music:

> Matt [Siegel] and I met in college, where we founded a student-run record label together. As we got closer to graduation, we knew we wanted to have the label continue under student management so we started thinking about other ideas. We were fortunate enough to hook up with Mantis Evar, who had years and years of experience in the music industry, and Jesse [Chan-Norris] and Chris [Danzig], who had great technical skills, and we got to work building a platform for artists to collaborate with one another. (Zaccagino, personal communication, March 13, 2009)

As reflected in this story, Indaba Music was created by two Harvard University students, who were not affiliated with any major record labels or corporations. Zaccagnino further described how Indaba Music differs from other types of social networking sites:

> First, it is a social network focused on musicians, engineers, producers, and anyone who touches the creative aspects of music. It wasn't designed as a destination for fans, although happily there are lots of interesting content to explore, and many fans do visit the site. Second, it is a collaborative platform where people are actually creating music together. They exchange instrument tracks, build on one another's work, give each other feedback, and so on. (Zaccagnino, personal communication, March 13, 2009)

Unlike other social networking sites, Indaba Music's major activities are oriented around collaborative production. This site was not solely created to help artists gain fans and build large followings. Rather, its purpose was to offer easy access to collaborative opportunities with others, to function as a resource to help meet artists' musical needs, and to provide a feedback forum for peer groups of musicians.

In my personal correspondence with Zaccagnino, I learned about the process involved in the choosing of featured artists. Zaccagnino stated that the factors that determine featured artist status are both quantitative and qualitative in nature:

> Mantis Evar, who is the EVP of Artists and Community at Indaba Music oversees the selection of featured artists and sessions. The criteria are both qualitative and quantitative. Quantitative in the sense that the more music you have on your profile, the more sessions you are involved in, the more you tell us about yourself the easier it is to learn about you and feature you. It is qualitative in the sense that we find and pick members of the community that we admire, whose music we enjoy, and who are actively making Indaba Music a better place every day. We are mostly musicians ourselves so it's easy to get us excited when we hear and see things that we like! (Personal communication, Zaccagnino, March, 13, 2009)

Although the judges are mostly musicians, they do not necessarily share the same taste in music. Despite this divergence in preferences, Indaba music imposes the staff members' collective taste onto other members through the competition and judging process. Indaba Music is not only driven by the tastes of a select body of judges, like other social networking sites, such as MySpace and YouTube, Indaba Music utilizes a rating system. A five-star rating standard shows how each composition and performance is perceived by others in the network.

Two of the significant features of this social networking site are the recording platform, console, and the competitions. Console's basic purpose is to promote collaboration between musicians. When a musician wants to collaborate with

someone else, he or she can simply upload a track and add music to the already-existing program. In a traditional recording process, musicians must record various layers of tracks in order to create a final piece. The complexity of this process depends on the type of music being recorded. For example, in the case of recording a piano solo, all that is required is one track of solo piano (unless one desires additional technical interventions, such as the addition of reverberation or the application of an equalizer, a function that can sharpen sound quality). However, if a pianist wants to invite a singer to sing on top of the piano music, then two tracks are required. Console functions like a virtual recording studio, since it can be shared with others around the world via the internet: "the Indaba Session Console is an online digital mixer that allows you to mix and edit audio in your web browser from any computer. It includes standard digital audio workstation features such as looping, panning, cropping, and mixing down" (Indaba music collaboration, n.d.a).

Console is similar to Pro-Tools, a commonly used recording software, and is relatively user friendly. Any member can upload a track on Console and invite others in the Indaba Music network to collaborate on the project. According to Harmony Central, Console offers other features, such as "looping, automated pan/volume and the ability to export session tracks and information directly to ProTools, Logic, and all other desktop audio applications" (Harmony Central, 2007, para. 2). In addition to all these features, Harmony Central reports that those collaborating on a track can chat with one another in real time and also "save multiple mixes of the session" (Harmony Central, 2007, para. 2).

On July 9, 2009, Indaba Music announced the launch of an advanced version of Console: Console 2.0. The upgraded version provides an array of functions similar to that of Pro-Tools. Console 2.0 has many new features that the earlier version lacked. For instance, in addition to editing and mixing functions, one can now record music directly and import hundreds of audio samples from the Indaba library. Eliot Van Buskirk (2009) explains the new advantages of Console: "the key to Indaba's breakthroughs in several key areas (improved audio quality, real-time effects, offline mode, and non-destructive editing) was its switch from running on Flash, which hampered some audio features, to Sun's new JavaFX platform" (para. 4). As Buskirk indicates, Indaba Music focuses its efforts on promoting collaborative opportunities for recording musicians. When a group of individuals decides to collaborate on a project, each person can lay down either voice or instrumental lines; all of the collaborators are involved in making early, pre-recording decisions about ownership and pricing (Ziv, 2008). In addition, during the time of composition and deliberation, Indaba Music can manage the transaction records, noting which members have the rights to particular tracks (Ziv, 2008).

Console is groundbreaking since anyone with recording and internet capabilities can create music from any location in the world. Indaba Music musicians

also speak of the collaborative outlet as a major source of value. Through an online survey, I attempted to study the opinions of musicians on their experiences with Indaba Music; only seven musicians responded. While four of the responses were irrelevant in terms of the survey's focus, the rest of these responses directly addressed my survey's content.

> I joined recently—effect of a Colbert Bump. I found several great musicians to collaborate with and just finished a project with Patton M. from Korea that I was very pleased with. I'm in Southampton NY and although I have other collaborators, time and geographical constraints most often interfere with projects. To be able to find collaborators and actually get work done is fantastic. Now I see that a lot of people seem to think that this is a place to promote themselves and I guess to some extent that is so, but it's missing the point. Feedback on how listeners experience the music is very pertinent, but to actually collaborate is where it's at. (Indaba Music project, 2009)

Another member of Indaba Music responded to the above posting, echoing the earlier remark.

> Sounds great I too agree with [name omitted]. Collaboration requires an extension of self, and an open mind. As a musician/producer, I want to think as far outside of my normal boundaries as possible. In doing so, I try to put myself in the shoes of the other artist that I am collaborating with. Since joining Indaba, I've been humbly asked to become a leader of the group Hip-Hop's Finest, as well as met several like minded artists. I also see this site as a way to gain exposure and help others to gain exposure through collaborating, not only with musical ideas, but with creative business ideas. I've only been a member since December 08 and already I'm involved in producing a series of compilations. Let me know what you need from me and I will try to make it happen. Thanks. (Indaba Music project, 2009)

As can be seen from both members' testimonies, it is clear that the collaborative tool on Indaba Music has been favorably received by at least some users who claim that it provides a chance to sharpen personal musical skills. More than gaining popularity or exposure, these two musicians value the way this site provides a platform for them to exchange musical ideas; it also fosters creativity through easy access and functionality.

Various online magazine articles have been written about Indaba Music's unique collaboration tools; most of these articles have praised the website's innovations. For example, Michael Smith (2007) states: "While Radiohead and Madonna openly challenge the industry's current distribution scheme, websites like Indaba challenge the industry's current, lackluster system of developing new talent. Looks like there is another wagon in the ever-growing circle of industry change"(para. 19). In *Electronic Musician*, Marty Cutler (2007) also lauds the

website: "I can't say enough about how web-based collaboration has helped me to realize ideas that have been in my head for years" (para. 38). David Chartier (2009) provides yet another positive commentary: "The entire Indaba Music experience is impressive and refreshingly devoid of silly games and other social networking nuisances" (para. 7). In addition to these published reports, the *Discovery Channel* featured a story on Indaba Music's virtual collaboration framework. Despite the preponderance of Indaba Music's positive reviews, adopting a neutral position is necessary in order to provide a balanced perspective on the site's role in the virtual world.

Unlike the collective act of contributing to the construction of knowledge or developing solutions to problems, musical e-collaboration has multiple implications in the overall context of the music industry. Firstly, the traditional notion of the music band may be changing. Band members no longer have to share the same space to jam and create separate musical parts. Because collaboration can occur at any location that has internet access and at any hour of the day, collectivism no longer connotes "togetherness" in a physical sense. It now signifies decentralization and dispersion. Being able to collaborate with talented individuals anywhere in the world means that the notion of e-collaboration applies to a disembodied form of creativity, where concrete physical proximity has become less significant. Indaba Music's collaborative software is currently used by 200,000 musicians all around the globe (185 countries), and the upgraded version of Console is predicted to draw more musicians who want to directly record and create music (Van Buskirk, 2009).

Despite this new trend toward collaboration, Zaccagnino firmly believes that the collaborative tools on Indaba Music will not replace the traditional form of collaboration in which musicians gather in one room to jam and record simultaneously:

> One thing that we believe in strongly about online collaboration is that it will certainly never replace what it's like to be in the same room with another musician—nor should it. Indaba music is about creating new opportunities that wouldn't otherwise exist, not about replacing other types of collaboration. We cannot assume that this type of collaboration will be the only type of collaboration existing in the future, but it is clear that this will be the prevalent form of collaboration affecting the landscape of the music industry. (Zaccagnino, personal communication, March 13, 2009)

With the rise of online collaboration tools, one can predict that soon internet-savvy musicians will be searching for the next generation of producers. This type of collaboration will help musicians to empower themselves and to affect change; by not yielding control to the record label executives, a musician can be self-reliant in terms of seeking and finally choosing solutions for a specific

set of needs. Although any user can search for collaborators on Indaba Music, a successful search requires labor and dedication. One must invite others to join a particular session, and then actively network in order to see who may be truly interested in a specific project. While the site itself provides direction to users seeking collaborators, users must be active in order to be best served by the functionality of the site.

Lastly, the final implication of the new Console technology relates to the extension of online collaboration into real-life situations. Zaccagnino describes this phenomenon:

> We have seen bands form from meeting on the site and then go on to play live shows; we've seen auditions held online for real world opportunities, and we've even see major artists like Yo-Yo Ma invite people from the site to record with him in the studio. (Zaccagnino, personal communication, March 13, 2009)

As indicated above, e-collaboration does not only exist in the virtual world, since it can easily intersect with the physical world, thereby transforming the way in which musicians find one another to collaborate. E-collaboration can shape real-life collaboration in a way that does not replace the older form of collaboration, but instead enhances face-to-face interactions through the testing ground of the virtual recording studio.

The Hybrid Field on Indaba Music

One of the core elements of Indaba Music is the site's cooperation with the mainstream and non-profit companies, a trend that epitomizes Jenkins' notion of "convergence culture." In the interview with the author, Zaccagnino explained the motivation behind the partnership model:

> We often work with major artists, labels, management groups and so on to run innovative marketing campaigns for them, while creating great opportunities for the artists in our community. More often than not, they approach us and want to engage our community... We plan to continue pushing the boundaries here so that we can increasingly provide a valuable marketing service to major artists while providing unprecedented opportunities to independent artists. (Zaccagnino, personal communication, March 13, 2009)

Competitions on Indaba Music are, thus, created with two purposes in mind; not only do the competitions aid in the promotion of prominent mainstream artists, they also provide independent musicians with opportunities to share their talents and skills with a wider audience.

The mainstream-grassroots partnership model is solidly taking root on Indaba Music, according to its founder:

We are always open to working with different organizations and do so already in many ways. Whether that's partnering with companies who can provide additional services to our members, working closely with major brands to run innovative campaigns for them around music, or having brands sponsor the campaigns that we run for major labels and artists. In the coming months there will be many exciting features and opportunities that will come as the result of partnerships with other companies. (Zaccagnino, personal communication, March 13, 2009)

Innovative opportunities to collaborate with mainstream musicians and major brands are common activities on Indaba Music, but one particular question can be raised at this juncture: can partnerships with major label artists occur without the exploitation of lesser-known musician's free labor?

During my interview with Zaccagnino, he stated that because the executives and founding members of Indaba Music are all musical artists of some kind, their business model strives to put the needs of the artists first:

I think being an artist affects the decisions that we all make. Almost everyone at Indaba Music is an artist in some way, be it as a musician, mastering engineer, producer, filmmaker, photographer, and more. We are passionate about creating tools that are going to be valuable to musicians. That said, we are also business people who believe that there is a large economic opportunity for Indaba Music and don't see any conflict in those two perspectives. If anything, we believe that our perspectives as both artists and business people position us incredibly well to run a business like Indaba. (Zaccagnino, personal communication, March 13, 2009)

Zaccagnino emphasized that he perceives no conflict between Indaba's focus on both cultivating grassroots activities and converging with major record labels and media outlets. However, Ziv (2008) questions whether or not the current business structure of Indaba Music can long continue to function effectively without any alterations or conflicts. The current model is user-centered, insofar as decisions made on Indaba Music focus on the benefits to the users:

Indaba's users are central to the strategy of Indaba and form their core. Indaba's members interact with one another dynamically, that is both the creators of music and its' listeners continually rearrange their interaction with one another depending on the type of music being created and the changing interests of the listeners. (Ziv, 2008, pp. 598–599)

Even participation on the feedback forum is meant to provide ideas about site improvements to Indaba Music staff. Although Ziv notes that user feedback has been implemented in a conducive and productive way, she also comments that this type of information gathering requires an acute attention to detail. Moreover,

the forum monitors must understand and interact with users as closely as possible, all of which takes a lot of time.

Considering the amount of time and work it has taken to make Indaba Music a user-centric social network, one additional significant function must be considered in order to understand whether or not the focus on artists clashes with the partnerships with the mainstream industry. At this juncture, I will turn my focus to the competitions that are being held on Indaba Music.

Contests on Indaba Music

Indaba Music provides unprecedented opportunities for independent and amateur musicians. Before delving into a case study of one specific contest, it is important to briefly describe the types of contests that have been held thus far, and to explain how the winners were chosen and what the rewards were. The competitions on Indaba Music started with the remixes of music made famous by musicians that are typically associated with major record labels, such as Mariah Carey Remixes, The Roots Remixes Contest, K-OS Studio Access Contest, and John Legend Remixes Contest. For these contests, musicians and producers were asked to remix specific musical pieces with separate stem tracks. All of these remix contests have had different types of rewards. For the Mariah Carey Remixes held in 2008, multiple rewards were offered, including $5,000 cash along with different types of digital exposure. The remixes were also featured on Mariah Carey's top friend list on MySpace for a month, and the remixes were promoted on MariahCarey.com and IslandRecords.com. The competition runner-up received a Digidesign MBox 2, while the top 10 finalists were given autographed copies of Mariah Carey's album, E=MC2.

The judges of the competitions are an important matter, as the ultimate winners are evaluated by the professionals in the field. For the Mariah Carey contest, the judges included Mark Sudack, a co-executive producer of Carey's album and director of marketing at Arista Records; Kerri Mason, the dance and electronic music reporter for Billboard; and Mantis Evar, co-founder of Indaba Music who had 25 years of professional experience in producing, mastering, and recording music, and had previously worked for Capital and Blue Note Records. The background of these judges implied that the winner was chosen according to the standards of professional members of the major recording industry. Nonetheless, this does not mean that the popular vote had no meaning; the 10 runner-ups were selected by the Indaba Music community at large. Due to the limitations of this book, I cannot go into great detail about each competition's rules, awards, and judges. Nevertheless, this one example does show a common trend in the Indaba Music contests: the musicians are judged according to the standards of the major recording industry.

However, not all judges of the competitions are affiliated with the music industry. On February 3, 2009, Zaccagnino made an appearance on the television series, *The Colbert Report* (Van Buskirk, 2009). Not only did this opportunity increase Indaba Music's exposure, but Zaccagnino announced yet another high-profile collaboration opportunity for musicians: a remix of Colbert's show segment into any musical style. Although Colbert jokingly warned the audience to not remix his interview segment, this warning instigated a viral online marketing campaign for *The Colbert Report*. As fans tuned in to the show, they heard a musical track which functioned as a viral marketing advertisement. Although the winner of the Indaba Music competition did not receive a monetary reward, Indaba Music posted a statement on its website explaining that the winner would be chosen personally by Colbert, and the prize would be "the look on Stephen Colbert's face when he hears how jaw-droppingly, ear-poppingly fresh your remix is!" This competition exemplifies the addition of non-monetary rewards to the norms linked to e-collaboration.

At this juncture, we must take a closer look at one of the Indaba Music competitions in order to learn more about the nature of the competitions for which the judge and cultural intermediary is a renowned artist. When a prominent musician, such as Yo Yo Ma, judges a competition, what is the impact on musicians laboring to win the competition? What concerns about the competition process exist? Hesmondhalgh and Baker (2008) assert that competitions invoke negative emotions, such as panic, anxiety and nervousness. In line with this argument, a kind of "panic" mode developed during the Ma competition.

2009 Yo Yo Ma Competition

In October 2009, the announcement for the Yo Yo Ma competition was publicized on the Indaba Music site and on National Public Radio. Contestants were invited to listen to Ma's pre-recorded track "Dona Nobis Pacem (Give Us Peace)" and to compose a counter-melody or other form of variation. Upon completion of this task, each contestant was asked to record and then upload the track to Indaba Music for Ma and others to hear. Each entry would be available to the entire community to hear and would automatically be placed into the competition ranking system. Every contestant's personal profile, on which pictures and other music could be uploaded, could be easily visited by clicking on the user's name as it appeared next to the entry title.

Musicians and vocalists of any genre could participate in this competition. During the competition, musicians were invited to share their thoughts about the experience and to raise any issues or questions on the forum particularly created for this competition.

Between January 1 and January 10, 2009, I examined the entire discussion board devoted to the Ma competition and reviewed a total of 500 relevant responses. In doing so, I qualitatively categorized the messages based on a few emerging themes. The discussion focused primarily on two facets of the competition: the voting system and self-promotion. The first theme of voting pertained to the competitive and stressful nature of competitions such as this. The second topic of self-promotion was analyzed by linking it with the concept of immaterial, affective, and free labor to answer the following questions. How do musicians and fans labor to gain more exposure and votes? Are there any common strategies that are used by the majority of musicians? Unlike the earlier case studies of MySpace, YouTube, and Second Life, no specific tips have yet been written for Indaba Music musicians. This may reflect the relatively new and experimental nature of this site. However, it is important to keep in mind that this could change in the future.

At the conclusion of this particular competition, the winners were chosen by Ma after a week-long period of listening to the 354 submissions. The winner was announced on the National Public Radio program "All Things Considered" on January 16, 2009. Instead of choosing one winner, Ma selected two winners, claiming that the experience was like comparing "apples and oranges" (NPR, 2009). The winners were Toshi O, who had composed a heavy metal version of the classical piece, and Kevin McChesney, who used hand bells to complement Ma's track. The winners of this competition were announced on Indaba Music with comments and explanations provided by Ma. In addition, Ma chose five runners-up and gave each individual personalized constructive criticism. This aspect of constructive criticism reflects the fact that Indaba Music's community represents more than just a competition framework—it also allows for professional feedback opportunities, which could potentially serve as a platform for discussion about the aesthetics of music. Understanding the political dimension of the competitions is extremely crucial as it provides valuable insight into how the competitive dynamic alters the cultural values tied to virtual music performance.

Voting Mania: Is My Vote Being Counted?

The first theme that rose out of the discussion board pertained to the practice of voting. Many musicians wanted to make sure that their efforts to gain votes would pay off in a verifiable, concrete way. Some musicians questioned why their status remained unchanged even after their friends and family members voted for them; this caused others to wonder about the accuracy and fairness of the competition.

> I would love to enter this contest, however Indaba etc. must realize that if you have a simple open voting system like this, the winner will invariably just be he who spams the most. Sorry but that is just how the web works. A better alterna-

tive would be to give the whole community 5 votes and have them vote for their favorites. Or elect a panel of judges. A new voting system needs to be adopted, I love making music but won't bother entering contests like this if the system is solely based on number of hits. Otherwise, it just goes to the biggest web spam hustler. Edgar Meyer would lose this contest himself, because I highly doubt he is the kind of guy who wants to stay up all night copying and pasting spam emails on MySpace. You need to fix this. (Yo Yo Ma contest, 2009)

While thanking other members for clarifying the voting procedure, another member posted the following comments:

Thanks for the reply, Mantis Evar! Yes, i had been using the "sort by votes" option up to now, but i thought that in such an open contest, the option of seeing how the voting evolves and what percentage of votes are allocated to each submission would be very enlightening, or entertaining at the least :-) Perhaps it's not of such great importance. Anyway, may you have a Happy new year everybody! With health, love and joy, Theodor. (Yo Yo Ma contest, 2009)

Clearly for this contestant, the contest was a unique opportunity and not one plagued by any voting problems.

On the other hand, the voting procedure was one of the top concerns for other users.

I don't understand what is happening with my ranking. It seems that the more my friends and family vote for me, the lower my ranking goes. Also when they go to is no widget and they can only post a comment at the bottom of the page. I think I am losing out on votes or the 60 plus ahead of me have way more friends than I do. LOL. (Yo Yo Ma contest, 2009)

Some members, such as the ones below, were straightforward and honest about their discontentment with the voting and critique procedure:

I really don't like the voting procedure here. People should be able to select their friends and not have to browse through endless, amateur submissions before they get to the one they want. (Yo Yo Ma contest, 2009)

Does every submission get listened to, or only a certain range such as the top 20 or 40 submissions? I hope it's the former, since voting can be easily manipulated to make you number one regardless if it is number one material. Cheers everyone, and good luck! (Yo Yo Ma contest, 2009)

As exemplified by this statement, many musicians were unsure whether their votes were truly being counted.

In an interesting digression, one user made the point that without the voting system, Indaba Music cannot attract traffic. Thus, voting functions as a way in which Indaba Music increases its activities and presence.

Amy S. You raised a good point. I think that the voting is only a way for Indaba to get hits. Then again, Indaba is a good site, so it does not bother me. Objectivity in voting is nearly impossible, because who could possibly listen to all submissions, then decide. That must be too much even for Ma. Additionally, Widgets or not, voting seems to be cumbersome, if not impossibly complicated for some. Many friends have asked for more info how to vote. What about people voting for themselves? I did, because I had to understand how the process works, to get my friends to vote. They should have a 5 star system, where people rate submissions. But I am not sure how to make that fair. Well, good luck to all. (Yo Yo Ma contest, 2009)

This member noted that the ratings seemed to be problematic; however, this musician did not believe that an objective voting system could be easily established.

It is interesting to note that in this competition, although the votes were problematic for some, the outcome of the competition was not based on the actual number of votes. The ultimate decision was made by Ma. Here we begin to see a shift in the role of social networking sites in music production. Unlike MySpace and YouTube, where the number of viewers and ratings matter a great deal, Indaba Music seems to strive for a power balance between popularity and expert criticism. This model of social networking does not necessarily result in increased popularity for individual musicians.

Although the popular votes were only influential in the selection of the top ten finalists for recognition, it is important to note that the cultural intermediaries in this particular social network were peer musicians and fans, as well as accomplished artists. On MySpace, YouTube, and Second Life, the body of cultural intermediaries is mainly restricted to fans and listeners. (At times, Artist & Repertoire (A & R) scouts may search these sites for new, rising acts; however, in most cases, the A & R scouts do not grant record contracts, unless there are large numbers of listeners.) Nonetheless, as noted above, Indaba Music employs a different model for the discovery and recognition of talent.

One positive aspect of participating in the Indaba Music competitions is the awarding of honorable mentions by professional, accomplished artists or experts in the music field. In the Ma competition, Ma provided constructive comments to the five runners-up. His comments were posted on the page devoted to the competition, where the winners were also announced. Ma explained why the two winners were chosen. For Toshi O, Ma stated: "I thought this piece was virtuosic, well-constructed, and most importantly, fun! The structure is very well thought-through yet it has the spontaneity of improvisation, and that combination is very hard to do." Kevin McChesney received the following praise from Ma: "This is a lovely, very impressive arrangement, especially harmonically. The intricacy is stunning. It's also performed impeccably well, and handbells are really difficult to play." As indicated by this specific event, Indaba Music has created a community

in which musicians can receive feedback from experts in the music industry, and this advice can be applied to help further their skills and careers.

Voting clearly creates an alarming and anxious environment for musicians, which is reflected in the fervent conversations that appeared on the Indaba Music general discussion forum. These discussions reveal much in regards to the newly emerging social protocols on the social networking sites. While musicians now have a collaborative platform through which they can share their music in a democratic fashion, the problem of voting was considered controversial in terms of its methodology:

>The thing is that you can pay companies that will build your friend list for you. You know, send out requests and all for a fee. So if a person is getting their votes primarily from their mammoth friend list then it could be said that they paid their way to the top if they indeed used such methods to build their MySpace, Imeem or whatever. Now I would say that is a bit unfair. But since it's not against the law what can you do? Don't get me wrong. What I am saying in no way excuses all of the whining and belly aching that I heard in both comps. Seems there are a lot of prima donnas that think they're too good or talented to lower themselves to picking up the phone and asking their cousin to vote for them. Forget them. They don't deserve to win. But there are some truly hard working people who want to win the right way but have to compete with folks who have 100,00 plus "friends" on a website. What to do? (Yo Yo Ma Contest, 2009)

According to this individual, musicians should stop being arrogant and should actively work at promoting their own work. The perspective that good work will survive on its own without any additional effort is completely dismissed by this musician.

While this user suggested an alternative to the current voting process, many other members actually rejected the entire voting system. This viewpoint is exemplified in the following quote:

> In my opinion there should not be a voting system at all. If an artist wants a bunch of free remixes to choose from... let them take the trouble to dig through the pile and listen to each and every one of em. After all, it's in the best interest of the artist to pick the most suitable candidate. (Yo Yo Ma Contest, 2009)

Following this commentary, another posting clarified and confirmed the current voting procedure.

> You guys make really interesting points—most of which we've been sharing with the artists we're working with. You'll see for example that in the K-OS program he's going to pick winners from all the entries—his selections will have nothing to do with the voting. However, voting will still enable the community to show which ones they like. Different contests have different objectives though, and we

try really hard to meet all of them every time we launch one of these programs. Keep the feedback coming. (Yo Yo Ma Contest, 2009)

This statement describes the mutable nature of the cultural intermediaries; at times, they are composed of the mass network, and at other times, they are reduced to one single judge, who is often an established artist. While the discussion forum contained heated postings on this topic, another member, a teacher by profession, candidly confessed that he or she has increased personal popularity rankings by asking students for their votes. Despite the fact that this member recognized that this practice is unethical, he or she argued that voting inevitably results in political games:

> Honestly, I agree that there should not be a voting system. I plan to enter a contest soon and I asked my students to vote for me, which is wrong. They should be able to vote for whoever they feel is the best musician. They shouldn't vote for me just because they are my students. However, I know that those whom I will be competing with will indeed have family members and friends voting for them, so it provokes the same preparation from me. (Yo Yo Ma Contest, 2009)

After this posting, another member actually defended the described behavior, claiming that it was the "smart" thing to do: "You BETTER get your people behind you if you want to have a shot at winning here. The voting system is most likely here to stay. People need to just accept that and learn how to play the game" (Yo Yo Ma Contest, 2009).

As indicated by all of these examples, it is clear that voting creates a new type of politics and a stressful environment for those entering the contests. Similar to the culture of the major record industry, in which the Billboard rankings are viewed as a measure of one's success, the voting on Indaba Music is considered a standard against which to measure one's value as musician. Nonetheless, it is important to note that Indaba Music is a microcosm of musicians, since it was specifically designed for professionals and amateurs in the field, not necessarily for the broader category of fans.

In this vein, another member made an important point in regards to the role of voting in the selection process. Instead of spending time focusing on one's craft, voting-driven competitions can distract and deter musicians from perfecting their skill and craftsmanship. Instead of creating music, musicians in such competitions must also become their own personal promoters. For the commentator quoted above, self-promotion adversely affects the quality of the music being produced. Instead of being judged for one's work, the final result at least marginally reflects one's ability as a marketer. This observation leads to the next theme: the rise of self-promotion. How do musicians labor to gain increased exposure and votes for the competitions?

Towards Winning Cultural Capital

The self-promotion efforts on Indaba Music are active, as one would logically expect. The recognition from an already established and acclaimed artist, such as Yo Yo Ma, is interpreted as an indication that a musician really has "what it takes." This recognition adds an air of legitimacy to one's craft and professional efforts. A type of brand association develops (in this case, the brand is Yo Yo Ma), thus heightening one's perceived value. Although no monetary compensation is involved, the association with Yo Yo Ma was in and of itself extremely desirable. This aggrandized the brand of Yo Yo Ma to a certain extent, since musicians entered the competition because of the renown tied to Ma's name. An article in the *Yale Daily News* featured one of the contestants in the Ma competition, Kevin Olusola, a student at Yale. The article first opens by emphasizing Ma's status and importance:

> James Taylor, Alison Krauss, Diana Krall—these are but a few of the world-famous musicians who have collaborated with Yo-Yo Ma, the celebrated cellist who will perform next Tuesday at the 44th Presidential Inauguration. Kevin Olusola '10 would like to see his name added to that list, and he is nerve-wrackingly close. (Jannise, 2009, para. 1)

In terms of the desired association with Ma, the competition winners were not the only ones to benefit. The overall popularity of the competition also mattered to a certain extent. The Yale article reflected this nuanced truth; Jannise (2009) did not just address the winning of the contest, but also recognized the value of popular votes:

> Olusola's submission, which has garnered enough online to put it in second place out of over 350 entries, combines his own cello playing and beatboxing with Ma's recording. But no matter: Whichever submission Ma likes the best will win, regardless of votes. Tomorrow at noon, the winner will finally be announced. (Jannise, 2009, para. 3)

Commentaries by other musicians also added value to Olusola's entry when they were cited as legitimate critiques of Olusola's performance:

> A contestant named Jack Dermody sent Olusola a message that read: "Your sounds sailed around my house like some heavenly gift ... I won't be surprised if you win." Another contestant, professional composer Raffi Bandazian, told Olusola he "loved" his submission and that it "made [him] smile the whole time." (Jannise, 2009, para. 9)

Although receiving exposure in a college newspaper cannot be interpreted as pivotal in a musician's future career, this article revealed that the perceived value of this competition was not solely tied to the final selection of winners. The overall

heightened value of entering the contest with the possibility of collaborating with Yo Yo Ma was seen as significant.

Throughout the contest, many musicians explained how hard they worked to submit their materials and what the opportunity meant to them. However, inasmuch as the reward for the Ma competition was non-monetary, the notion of immaterial labor (Hardt & Negri, 2000) is useful in analyzing the competitors' laboring practices. For musicians, the act of self-promotion was done intentionally. However, some members of Indaba Music criticized the self-promotion that took place on the contest discussion board. This consequently incited discussions on the negative aspects of marketing. Significantly, the key difference between grassroots media outlets and mainstream media outlets is the labor that a performer must exert on self-promotion. In the instance of this particular case study, many Indaba Music members promoted themselves on the discussion board. While the immaterial, affective, and free labor of Indaba Music musicians is very similar to the labor linked to the other social networking sites discussed in previous chapters, slight differences do exist.

Firstly, the kinds of labor are similar in that the immaterial labor on all of the sites consists of actively promoting oneself, although on Indaba Music the solicitation on others' profiles does not occur. The self-promotion efforts also possess an affective dimension. Many users expressed their gratitude towards Indaba Music for their opportunities and also showed respect for others' submissions. For instance, one user stated:

> I would just like to say hello to everybody, and Happy New Year! I'd also like to extend my gratitude to the Indaba staff, and say how thrilled I am to be able to be a part of all this. I hope many of you will take a moment to listen to my submission, as well as those who, like me, got theirs in only very recently. (Yo Yo Ma contest, 2009)

Although this competition did not inspire much promotion of other musicians' work, free labor by various members did occur:

> [name omitted] version is as gorgeous as she is! If you haven't had the pleasure of doing so please check it out. (Yo Yo Ma contest, 2009).

Unlike MySpace and YouTube, free labor by non-musician fans is relatively infrequent on Indaba Music. This may be due to the nature of the website, whose membership is solely composed of musicians. Everyone who signs up for Indaba Music is a musician, ranging from the professional to the amateur. However, Indaba Music is not an amateur-friendly place as many of the competitions expect the entry of recordings to be professionally mastered. Often the organizers of Indaba Music competitions seem to be not looking for "rising talent" but are rather seeking for professional collaborators. Perhaps for this reason, on Indaba

Music's discussion board, the act of complimenting others' work did not dominate the discussions.

On a related note, the act of self-promotion as a form of immaterial labor was often limited to offering critiques and explanations of one's own craftsmanship and methods.

> My submission is layered amplified cellos, played through some stomp boxes (overdrive, delay, and wah) and a Fender Showman tube amp. I wanted to use these tools, which can create so much noise and power, to create something ethereal and perhaps even peaceful. I improvised a bunch of layers, reharmonizing a few sections, then subtracted from there. A last minute project, wish I'd had a little more time... you know, complexity is easy, simplicity is hard. Anyway, enjoy. (Yo Yo Ma contest, 2009)

Although these types of postings were typical on the discussion board, other members criticized this behavior and expressed a strong aversion towards all forms of self-promotion:

> I hate shameless self-promotion, which is why i will make this post so fully shameful: a 5/4 groove, subtle chromaticism, subtle dissonance... what' s not to like? check my song out, folks. let me know what you think. did i mention my 19 month-old daughter thinks it rocks??? pacem out. (Yo Yo Ma contest, 2009)

Other members argued that shameless promotion is an important part of the process and should be pursued unapologetically:

> Unfortunately, all musicians who chose not to hire an agent are bound to spend an enormous amount of time on self-promotion. It is a sad reality. The more time one spends as her/his own agent, the less time is left for composing. That's why the contests like this one are such a great opportunity to do both—to work on some new musical ideas and to exercise self-promotion at the same time. (Yo Yo Ma contest, 2009)

Although self-promotion may permeate the do-it-yourself model of social networking sites, it is important to recognize that gaining popularity was not a primary goal, as much social networking was (and still can be) based on the actual merits of a specific work. However, this evaluation is not meant to valorize and praise Indaba Music as a superior site for musicians, but to distinguish between the different types of laboring practices.

In the previous analysis of increasing popularity on the social networking sites, self-promotion was determined to be integral to success; usually promotion is achieved and propelled by fan labor (Baym, 2007). On Indaba Music, due to the less visible nature of fan labor and free labor, the importance of self-promotion is even greater. This may initially give rise to negative reactions, since such efforts can be perceived as a form of intense narcissism. However, in the digital field

of cultural production, especially in the nexus where the forces of the grassroots culture combine with the endeavors of major corporations, a fierce environment driven by self-promotion is rampant. Not only must musicians spend time creating music, they must also learn to market and promote themselves. This new skill set makes the act of self-promotion unique in the context of the social networking sites, especially those oriented toward musicians.

While some musicians embrace the opportunity to become promotional intermediaries and view this as a natural and inevitable duty, other musicians find this new role to be a waste of time, perceiving it as an unjust and unethical requirement. Being a successful promoter requires skills not typical to most musicians, but instead entails a mastery of techniques related to professional promotional intermediaries. The ethical problem of value comes into play here because promotional intermediaries can be bought and sold like any commodity value.

The issue of self-promotion needs to be analyzed in the specific context of Indaba Music, on which non-musician fans do not carry much, if any, power. Promoting one's work is not necessarily negative in nature; however, this can lead to the emergence of a certain type of social protocols linked to gaining more votes or increasing popularity. When musicians are exposed to an environment where the value of their work is ultimately decided by the act of winning or by a ranking system, a conflict of values can occur. Some people who may not be skilled at mastering the social protocols (or who do not want to devote time to this task) will challenge the system, while others who are adept at it will not find such a system to be problematic. This tension became a central theme in most of the Indaba Music competitions, including the Ma contest.

Towards Acquiring Economic Capital

Although Indaba Music's remix contests may function in part as promotions for newly released singles, the contests do not only focus on remixes of well-known artists. When Indaba Music initially started hosting competitions, original music contests were not available. However, one of the groundbreaking aspects of Indaba Music relates to its function as a bridge between the world of the mainstream media industry and independent musicians. At the moment that I am documenting this phenomenon, it is still too early to understand the implications and ramifications of this functionality. Instead of relying on the popularity of votes per se or the quantitative ratings of users on other sites, Indaba Music has original music contests such the Indaba Music Artist Series.

The Artist Series is typically organized through the classification of genres such as Rock, Country, Jazz, Electronic, Beat, and Soundtrack Music. Musicians can enter the competitions upon paying membership fees. There are three types of memberships on Indaba Music: Basic, Pro, and Platinum. The basic membership

is free for all musicians; at this level, musicians receive 3 free entries to contests per year and 200 mb of storage. Pro memberships are $5 per month, and musicians can enter unlimited competitions and can sell their music on iTunes and via personalized embeddable stores. The storage is 5Gb. At the platinum level, the membership fee is $25 dollars per month. Musicians can put 50 songs on iTunes and receive the 50 Gb of storage. While entering the competitions is not free of charge, Indaba Music has hosted many contests since its inception, and a growing number of mainstream industry companies rely on Indaba Music for promotions and for the crowdsourcing of musicians' talents.

For the Artist Music Series, musicians can submit unlimited original musical performances, and the staff members at Indaba Music handpick the music they feel has the potential to be placed in television programs, commercials, movies, etc. In short, the Indaba Music staff functions as a new type of cultural intermediary, one that operates similarly to the traditional A & R agent or lawyer. Any profits that come out of the music are split evenly between Indaba Music and the musician. In May 2011, Indaba Music initiated another feature that contributes to the system becoming more professionally organized. Every musician now creates a licensing catalog and must agree to the usage of songs. This function is groundbreaking since Indaba Music staff members are now literally acting as agents on behalf of musicians. The growing trend in the digital field of cultural production is on connections with the mainstream industry. These are viewed as a highly valued asset. To some extent, this is not so different from the past when musicians' careers were highly contingent upon and tightly bound to the cultural intermediaries. We now have the same cultural intermediaries but in a different context. To date, it is uncertain how successful Indaba Music's Artist Series will be or how helpful it will be for independent musicians.

As I am writing this chapter, I am participating in the Indaba music Licensing Contest. This will be part my ongoing ethnographic study, and so far, various inquiries about the legal aspects and the rights pertaining to the music have been raised on the comments section of the contest page. Noticeably, the staff of Indaba Music continuously monitors the discussion area where musicians post questions and comments on the contest. The staff members offer timely and detailed responses to the musicians' inquiries and needs. According to Indaba Music, the site offers a non-exclusive publishing agreement, and the composition rights and masters belong solely to the artists. Time will tell if this paradigm will be equally beneficial to both independent musicians and the mainstream industry.

Reflection on the Digital Field of Indaba Music

In this chapter, Indaba music's two major functions (collaborations and contests) were analyzed. The aim of fostering community was emphasized through the

numerous communication methods available to users (blog, chat, messages, forums). User communication now has a new mobile dimension since a software application allows one to connect to Indaba Music via one's Iphone. This means that you can engage in the Indaba Music community from any location that supports a portable device. This functionality was developed to increase efficiency by enabling users to easily connect with one another for collaborative purposes, but at the same time, this highly touted communication method seems to indicate that constant contact with Indaba Music is being encouraged.

While on one hand, one can see that Indaba Music is helping musicians through its site functions, on the other hand, one can also infer that the immaterial labor of musicians is being utilized to drive the programs offered by Indaba Music. Without busy traffic and ongoing member activities, the chances of partnerships with the mainstream industry are less likely to occur. Likewise, without high-profile collaboration opportunities, the press coverage and exposure of Indaba Music would be seriously reduced. Although Indaba Music does emphasize self-promotion, the act of self-promotion does not entail bombarding others' profiles with e-mails, as on MySpace. Instead, self-promotion on Indaba Music takes two different forms. Self-promotion is done as musicians update their profiles and are otherwise active on the site. Indaba Music strongly encourages musicians to pursue these activities. The other type of promotion occurs on the competition discussion boards where users describe how they created their music and offer critiques of each other's postings. Besides intersecting with the issues of self-promotion and networking, labor on Indaba Music also has a financial component. Thus, fan or free labor does not occur as often as on other social networking sites; however, affective labor is often exerted during competitions when contestants promote their entries.

Finally, despite a great degree of enthusiasm and appreciation, the competitions create a hyper-inquisitive and sensitive environment for the contestants. The founder of the site must intervene from time to time to assure the contestants that the number of votes does not matter, as was the case with the Yo Yo Ma competition for which Ma himself was the one who ultimately decided the winners. Thus, even though the competitions have generated much enthusiasm among musicians, they have also put musicians in a state of anxiety and inspired them to challenge the voting system. A large number of postings on the competition forum addressed the voting procedures and debated the role of voting in ascribing value to musical work.

In understanding Indaba Music's convergence with the mainstream record companies, it seems clear that the competitions on Indaba Music play a major role in drawing people into the network. While Indaba Music functions as a bridge between the promotional efforts of mainstream recording artists and the collaborative endeavors of grassroots musicians, it seems unlikely that this type of part-

nership can continue without any value exchanges or value clashes. As Dolfma (1999) notes, "institutions change when people perceive a tension between what single institutions or an institutional setting stand for, on the one hand, and what in fact results from them, on the other" (p. 80). To this end, although Indaba Music purportedly functions without any clashes with the outside institutions with which it is converging, the site's values could gradually change in the future; it is yet unclear whether the direction will result in more concessions from the record labels or from the independent artists.

Conclusion

In this book, I have sought to navigate the issues related to the digital field of restricted production and its intersection with the digital field of mass production. In this final chapter, I will debunk the all-or-nothing view about the social media revolution's impact on the music industry and musicians, and in doing so, I will attempt to further the understanding of the social media revolution. The goal of this final chapter is to explore the subtle and complex nuances of the social media phenomenon by bringing them to the forefront and further emphasizing the contradictions that characterize the digital field of cultural production.

The first contradiction is the dichotomy that rests in between presence and absence. In the digital field of cultural production, while genuine communication and artist/fan relationships can flourish on the social networking sites, it is important to note that the convenience of connecting with a variety of people instantly creates a dichotomous situation of simultaneously being present and absent. Many self-help tips and online services promise easy means for creating an active social media presence. It is understandable that musicians may take advantage of such tips, since after all, musicians need audiences, and the desire to share is quite natural. However, while one can "easily" attain fans and networks by implementing social protocols, support in the virtual realm may not be as concrete as support in the physical dimension. It is clearly different to have fans who come to your shows, as opposed to large numbers of distant users who are part of a body of many millions of viewers (often in the form of votes, friends,

or "Likes"). Of course, the potential exists for those millions of views, millions of friends, on MySpace or a similar site, to turn into concertgoers or consumers of music. However, adopting the mainstream industry's rule of equating success with the gaining of friends or votes differs from making an effort to raise fan bases through which you can market your music. The latter is a natural and logical goal for independent musicians.

Furthermore, while social media environments create a close proximity between the fans and the musicians, the easy accessibility and availability of musicians create an interesting paradox in relation to the presence/absence dichotomy. According to Goldberg (2004), a veteran of the music industry, the goal for aspiring musicians is to create a mysterious aura in order to impress the A&R agent and to win a contract with the record label: "perception is everything... cultivating a sense of mystique and self-sufficiency creates interests...desperation is the ultimate turn off and the ultimate fear. Bluffing is all about playing it cool and pretending that you don't want what you want" (p. 86). If having a "star quality" and being "mysterious" were important in previous decades, the situation has changed dramatically in the age of the social media. Today having a wide presence seems to be almost a prerequisite for gaining the attention of A&R agents.

The contradiction between presence and absence also extends to the relationship between fans and musicians in a literal sense. Jones (2005) mentions that in the absence of artists, fans are more likely to seek out a means to connect with them, as revealed by the rapid increase in record sales that often occurs after the death of an artist. Similarly, the mediated environment plays an important role in the construction of legacies and stories after the death of an artist (Jones, 2005; Jensen, 2005). This shaping also impacts living artists. As Jensen states, if "posthumous reputation is clearly a contested process, one that is continually being negotiated with and against mass mediation," it is interesting how the social media shape the reputation of artists who are alive and available via a direct mediated interaction.

In other words, if the "unattainable" aspect of the artist makes the artist more desirable, the social media environments operate in a converse manner, because they are created to encourage non-stop accessibility between artists and their fans. As more features are upgraded, the connectivity with the fans blurs the boundaries between the professional and non-professional worlds, between work and play. While one may argue that close proximity with artists is considered a positive development in the music industry, we should take a few moments to reflect on this idea. If what makes the artist relevant today is rampant presence and active participation on the social networking sites, these activities belie the perception that artists should *not* be desperately trying to impress the A&R agents, as Goldberg (2004) has noted. The social networking sites not only impact the music industry and the way in which audiences and fans consume music, but they also

affect the definition and the expectations of artists in the digital age. Inasmuch as the means to connect directly with the fans without the help of the mass media is revolutionary, the de-emphasis on the mystique and privacy of the artist may have other ramifications.

In the social media age, the connectivity between fans and artists is achieved through the demolition of the "invisible" barrier, which paradoxically once helped to create the enviable appeal of "star" and "artist" status. While this gap was heightened through selective exposure via the mass media, in the age of the social media, the ubiquity of independent artists who work to gain the attention of the audiences can potentially backfire and take a negative toll. As the interaction between the artists and the fans becomes commonoplace and as artists are now readily available via the social media, there is a risk that the personal interaction will eventually be taken for granted. It could also become less significant or might reify the interaction between customers and customer service workers. The musicians' need to appeal to the mass audiences via the social networking sites does not only benefit the musicians or the fans, but such activities often become a necessity or a requirement in the competition rampant on the various social networking sites. In order to win, working to gain favor in the eyes of the audience is critical. Thus, we need to ask the following question: How does an emphasis on ceaseless mediated interactivity between fans and musicians enhance or delimit the empowerment of independent musicians? While both benefits and potential shortcomings are apparent, it is important to also keep in mind the ways in which these activities collide with the mainstream industry's involvement in the social media environments.

To some extent, the digital field is also increasingly turning into a pre-configured field, where it has become easy for the music industry associates to discern, categorize, and prioritize the artists of various standings. It has become difficult to build one's professional music career without being a part of the digital field of cultural production, and having such an affiliation essentially implies that one cannot truly escape from the mainstream industry's presence in the digital field. While a heavy emphasis is still placed on the quantitative aspects of the industry, the extent to which such mechanisms continue to hold value is another matter, whose outcomes will only be revealed in time.

The second contradiction relates to the conflicting democratic and undemocratic tendencies in the digital field of cultural production. To understand this contradiction, it is important to examine the context in which the social networking sites, as a form of participatory media, have been considered democratic. The root of understanding the participatory nature of social networking sites can be traced back to Hans Magnus Enzensberger (1974), who distinguishes the repressive use of the media during the early years of mass communication from the emancipatory use of media, wherein interactivity between the producer and the

audience occurs, thus promoting a kind of collectivism (p. 113). Finding impetus in Enzensberger's theory, Denis McQuail (2005) proposes the democratic participatory medium as a way for the "common" citizen to express his or her personal views and opinions (p. 131). Although participatory media purportedly rejects hegemonic control as exercised by media conglomerates, participatory media also stands apart from alternative media in that participatory media includes more than just vocal dissent. Participatory media works alongside media conglomerates to create contemporary cultural content. As Jenkins (2006) states, "sometimes corporate and grassroots convergence reinforce each other, creating closer, more rewarding relations between media producers and consumers" (p. 18).

While the social networking sites discussed here could help build mutually beneficial connections between corporate and grassroots endeavors, a development that is democratic in nature due to the lack of a permission process, another democratic ideal is evident in the free expression of opinions. Any user can voice his or her opinions through the expressions of "liking," by clicking the "like" button that is commonly present on various social networking sites. However, the term "democracy" should not be used in a blind celebratory manner, as the conceptualization of democracy in the digital field of cultural production is contradictory. In terms of voting and other evaluative mechanisms, while these actions can reflect genuine liking of and support for musicians, such mechanisms can function as a convenient way for the corporations to easily tap into the masses for their benefits. When rewards are tied to voting, musicians are required to promote themselves. In doing so, such actions simultaneously work as promotions for products, music, and brand names, and they function as a means to raise traffic on the websites, as seen in the four case studies. On some popular websites, such as www.blog.mtviggy.com, authors often write reviews of independent album releases and highlight the profiles of up and coming artists. Every week, the "Artists of the Week" section asks the readers to vote for their favorite artists among those whom the author has reviewed. The artist with the most votes wins the contest. In this instance, although one has the "freedom to vote," each person can vote as many times as he or she wishes. In this case, not only can the artist with the highest social capital convert it into cultural capital, but also the artist with the most persistent voters wins.

The democratic aspect of the social media intersects with the empowerment of musicians. However, the meaning of empowerment contains a subtle implication of being in control. If the social media have empowered musicians and reified the notion of autonomy, musicians do not need to convince anyone to invest in them and their records. Previously, the primary challenge for musicians involved gaining the opportunity to be "heard." Many musicians worked their hardest to place their demo tapes into the hands of the right decision maker. Nonetheless, even if a demo tape is extraordinary, according to Dan Levitin (1992), the music

labels consider numerous other concrete aspects before making a decision, such as the statistics of followings. Earlier in Chapter Two, I pointed out that the music industry often prefers low-risk strategies when it comes to giving opportunities to newly emerging artists. While major corporations are less inclined to take chances, on the social media, an aspiring musician can and often does willingly finance the launching of an album. In the digital field of cultural production, the demand for professional quality seems to be growing, and there is now more work required of individual artists as the notion of "artist development" is dissipating. Musicians are not only required to finance and produce high-quality music, but they also have to prove their value through popularity. Thus, in exchange for control, musical artists now exert 24–7, non-stop labor, and the boundary between living and working no longer exists.

Although the musician maintains a degree of autonomy, Bourdieu's notion of autonomy is inextricably linked with the concept of "the dominant principle of hierarchization." Bourdieu (1993) states, "strict application of the autonomous principle of hierarchization means that producers and products will be distinguished according to their degree of success with the audience..." (p. 46). In other words, artists who hold autonomy do not operate outside of the mainstream evaluative hierarchy. While musicians with autonomy do not need to play by the rules of the game in the digital field of cultural production, in order to attain autonomy, artists cannot escape the digital field's close relationship with the mainstream industry's presence and activities. Thus, the concept of autonomy should not be confused with the idea of freedom and convenience in building one's career and artistry; while the ability to control and disseminate one's music is revolutionary in the social media environment, in the digital field of cultural production, autonomy is attained in relation to and in contrast with other musicians' work (whether independent, signed, or established). In other words, autonomy is acquired as the result of competing, gaining the attention of other users, and winning the contests often sponsored by the mainstream industry. Artistic autonomy in the digital field does not imply that one stands fully apart, but instead relates to distinguishing oneself from the crowd composed of numerous, interconnected musicians.

The point above further extends to the importance of those in control of the musicians' destinies. Rather than completely escaping all of the cultural intermediaries of the music industry, such as A & R agents, these cultural intermediaries are still influential, and there is yet a strong emphasis on winning the interest of traditional cultural intermediaries. This is evident in the news articles about various individuals being *discovered* by industry associates. In short, many social networking sites now capitalize on the making of "connections" between aspiring musicians and industry associates. The social networking site www.musicolio.com exemplifies how the main activities are driven by networking opportunities with

the industry associates. Another social networking site is www.musiclunge.com, which promotes its ability to connect with the various music industry professionals.

As evinced in the case studies, especially Indaba Music, the notion of popularity contests has spawned the heated debate about quality vs. quantity. The ultimate winners of various competitions are judged by either Indaba Music staff (the site's equivalents of A & R agents) or the companies who have partnered in the contests. Popular votes are still a part of the contest, but they do not determine the winners. The YouTube Orchestra is also driven by popular votes and the cultural intermediaries that determine the winners. The trend here is synonymous to many television talent shows, like *American Idol,* on which both the judges and the voting public collectively choose the winner. Only when they have won votes or have been selected by the judges do musicians finally attain cultural capital. In this context, a few additional implications emerge.

The first one is the abstract notion of potentiality as the issue which refines and propels movement in the digital field. Morini and Fumagalli (2010) define bio-capitalism as the wealth gained not necessarily in a concrete measure but rather on immaterial, intangible levels. Bio-capitalism is hard to quantify and measure. It does not relate to concrete goods or money but rather to the emotional, affective, and intellectual realm of the human experience (p. 235).

Morini and Fumagalli explain the value of bio-capitalism as follows:

> ...first and foremost, in the intellectual and relational resources of subjects, and in their ability to activate social links that can be translated into *exchange value,* governed by the grammar of money. Thus, what is exchanged in the labour market is no longer abstract labour (measurable in homogeneous working time), but rather subjectivity itself, in its experiential, relational, creative dimensions. To sum up, what is exchanged is the "potentiality" of the subject. (p. 236)

This statement characterizes the digital field of cultural production. What is important in the digital field is not just the time that is required for the creative process but the potential to become somebody; this is where the trade-off values lie, which are neither trivial nor exchangeable. To this extent, the digital field of cultural production operates successfully within the logic of the capitalistic framework, although the exchange values are not goods but the abstract, affected, and irrational dimension of a "dream comes true" rhetoric.

Furthermore, the digital field of cultural production is not shaped in such a way that the mere presence of alternative or underground music itself can overthrow the existing music industry. While the active existence of independent music in the digital field can pose a threat to the mainstream music industry, in the end, musicians who have embraced collective beliefs in personal star quality often become integrated into the mainstream music industry. Examples of

this are shown in each case study, from MySpace to YouTube to Second Life to Indaba Music. However, I am *not* making a definitive argument that no successful independent musicians can exist in the digital field. Nonetheless, it is critical to understand that, thus far, the examples of musicians who intentionally reject the mainstream industry and major record labels have not been clearly visible, as personal motives and industry boundaries are often intermingled and obfuscated.

The second important theme that characterizes the digital field of cultural production relates to the methods of achieving success. Has the digital field of cultural production changed the means of achieving success? Despite the rise of independent musicians' activities in the digital field of cultural production due to the new communicative mechanism, when it comes to achieving success (although "success" is an arbitrary concept), I argue that the digital field of cultural production still resembles the combination of the two paradigms (pyramid and talent pool model) widely practiced prior to the social media era.

According to Simon Frith (1988), there are two common ways in which popular musicians seek success. The first one is illustrated by the diagram of a pyramid, which signifies the process of working from the bottom up. This model starts with hard work and determination—one must put in much practice to hone one's skills: "the position at the top of the pyramid is justified because they have *paid their dues* on their way up it" (Frith, 1988, p. 112). Each rung of the ladder possesses "a different set of gatekeepers" or cultural intermediaries (p. 112). Frith notes that musicians achieve success when they interact with audiences, and when they are ultimately aided by record companies, promoters, and press and radio outlets (p. 112). Frith argues that once success is achieved, "stardom in this model is permanent" (p. 112). In this model, hard work and talent will be rewarded in the end, thanks to the combination of the right type of cultural intermediaries and loyal audience members. Yet, Frith notes that "this is an ideological account of success," meaning that the model follows a particular sequence of protocols (p.112). This kind of success is not linked to luck, thereby implying that success is achievable and fame is acquirable only if one works hard at it.

The second model that Frith mentions is "the talent pool" (p. 112). Here, contrary to the earlier model of success, musicians can acquire success by sheer luck: "the process is, from both the musicians' and audience's point of view, essentially *irrational*"(p. 113). Frith notes that "the 'creative' role in this pop scheme is assigned to the packagers, to record producers, clothes designers, magazine editors, etc.; they are the 'authors' of success, the intelligence of the system" (p. 113). In other words, regardless of one's talent or hard work, one's stardom is almost random in nature: "who gets selected for success seems a matter of chance and quirk, a lottery, and success itself is fragmented, unearned and impermanent" (p. 113). The key difference between the earlier model and this model is the relationship between the performer and audience members; in the latter model,

this relationship is mediated by the advertisers and marketers. No close, genuine proximity exists between the audience and the performers, although proximity can heighten the authenticity that matters significantly in the music business.

As described by Frith, these two paradigms for success in the music business are crucial as they intersect with one another in the social networking sites. While there is an aspect of "working hard" as in the first model, there is also an element of luck in the digital field of cultural production. In the digital field of cultural production, musicians work hard to win over various cultural intermediaries. The first step is to have music recorded, whether it be in the demo tape format or professional quality formats (the professional quality of music recording by the unsigned can be quite high). After the music has been recorded, the musicians must find various outlets to showcase their music and create a web presence. In order to create an aura, musicians exert immaterial and affective labor in the digital field. When the musicians have gained large followings, they move up to the next rung of the ladder in the pyramid, at which point musicians can compete in more visible, larger-scale competitions, such as the ranking charts. When someone is consistently positioned high in the ranking order, the chances of a musician being discovered by influential cultural intermediaries, such as music industry associates, are much higher. Once a musician is discovered and signed by a major record label, as was the case with Colbie Caillat, it is up to the public to decide whether the artist will maintain long-term success.

On the other hand, the talent pool model also works on the social networking sites, where the discovery of a musician in the digital field of cultural production happens without much effort, seemingly by sheer luck. Regardless of one's number of fans, musicians can be discovered in a random occurrence. This does not mean that a musician lacks talent, but clearly there are instances when increases in popularity or connecting with the "right" cultural intermediary cannot be explained rationally. A common issue in the discourse of the art world is the unpredictable and irrational occurrence of being somewhere at the right time. No rational or logical analysis can explain the outcome that leads to instant, or even gradual, success. On other occasions, however, success can be hyped up by the mediated discourse, such as the internet press. Examples of this include reports of musicians being signed because of simply performing on Second Life, while Justin Bieber's success has been described as a happy accident. This type of rhetoric is a crucial propellant that creates a chain reaction in the various sectors of the culture industry, as reflected in the examples of books and paid web services that claim to help musicians to become the next famous stars.

With that said, nothing should be considered drastically revolutionary in the digital field of cultural production. A new technology can rise and fall or a social networking site, like MySpace, can come and wither, but what matters is how one gains legitimacy and power to mobilize the masses to *believe* in one's artwork. To

this end, I would like to redirect and refocus our attention to the nature of the art world. The advent of the social media has liberated musicians on some levels while simultaneously raising various new problems, but the most important question or predicament remains constant and holds together the intricate web of art world: "belief." For this reason, despite the age of Bourdieu's (1993) arguments, the following statement still resonates and characterizes the digital field of cultural production: "the work of art is an object which exists as such only by virtue of the (collective) belief which knows and acknowledges it as a work of art" (p. 35). Although for Bourdieu, the artists in the field of restricted production have low economic capital but high symbolic capital, in the digital field, artists in the restricted field of cultural production have low economic capital and limited or no symbolic capital, because the standard of determining or acquiring symbolic or cultural capital still adheres to the mainstream industry's chart system as revealed by the adoption of Billboard's Social 50. This is an ironic development because social networking sites have been considered products of the grassroots media; if someone distinguishes oneself in the social media, the argument is that he or she represents the ordinary consumers' democratic voices and penchants. I am not, however, completely renouncing the possibility that independent musicians can be successful even if they reject the game in the digital field. Nonetheless, it is important to be vigilant about the trends and the ways in which the digital field is being shaped.

Finally, I would like to return to the issues of empowerment and exploitation in the context of digital capitalism. The digital field of cultural production thrives in the framework of the close tensions between various dichotomies: market vs. culture, industry vs. art, commerce vs. creativity. These tensions will most likely continue to survive regardless of the development of other new technology. To some extent, the absence of an escape from the market may be a rather pessimistic reality for some, but this dichotomy cannot be easily dismissed by equating of underground culture with quality (or good) music and mainstream culture with low-quality music. While it is true that the pressure to conform to the market's demands is high in terms of the mainstream industry, in the digital field of cultural production, musicians also work under a similar type of pressure to gain popularity that mirrors the mainstream industry's practices.

The competition for popularity is often rooted in capitalism and commerciality, and as some scholars note, digital capitalism is linked to the possibility of exploitation on the social networking sites (Cohen, 2008; Bonsu & Darmody, 2008; Andrejevic, 2011). Nevertheless, the issue of exploitation is not necessarily or solely linked to capitalism. At this point, we should take a moment to reflect on this important situation; perhaps it is not an issue but rather an inescapable reality. When the process of gaining autonomy lies in the hands of others, exploitation is prone to happen. With or without the advent of the social media,

the exploitation of musicians occurs in one form or the other. Any performance venue can easily exploit musicians using "exposure" as an argument for exchanged returns, or exploitation can transpire on a personal level between an individual producer and an aspiring musician in search of network connections. The authors Christopher Knab and Bartley F. Day (2007) warn musicians that without knowledge of today's business models, they will continue to be exploited.

Among the varied cases and types of exploitation, financial exploitation of aspiring artists is common in the music industry. For example, recording contracts are often worded unfairly to disadvantage musicians. Risa Letowsky (2002) has described various legal cases of famous musicians who filed for bankruptcy as the result of overlooking the details of their recording contracts. Similar scenarios occur in the digital field of cultural production. The varied types of exploitation that impacted artists in the past experienced still exist today. However, for some smart, independent musicians, the expected returns from creating and sharing music is not always tied to financial compensation. Regardless of the criticisms that can be made of capitalism and the mainstream culture industry, the issue of exploitation is aggravated due to the nature of the creative industry, where a great emphasis is placed on intrinsic rewards. Often the joy of "sharing music" is more highly valued than the expectations about financial earnings, a reality that can seem rather inconceivable. In this regard, I do not mean to limit my argument to the problematization of a new type of capitalism in the digital field of cultural production. Instead, I would like to raise awareness of one specific baffling conundrum in the digital field of cultural production: self-appreciating labor. According to Barry King (2010),

> the discourse of creativity surrounding digital labour is an important means for insinuating the ideology of self-appreciating labour to work per se. In this manner, the norms of self-appreciation, especially as promulgated by the media, become the ever-receding horizon and yearned-for utopian prospect for those whose social destiny is confined to the realm of ergometric and especially, fractal forms of service work. (p. 297)

It is essentially this heavy emphasis on self-appreciation in the discourse of creativity that propels the exploitation in the field. In creative work, exposure to music is expected to generate invaluable exchange values which should further create the potential for greater success. The dissemination of the rhetoric of "you can become someone" is not very taxing, but although I have made an effort to distill this logic and rhetoric, the essence of the conundrum persists. In the end, the artist is either discovered by an industry affiliate, as happened prior to the digital era, or one must prove one's value through the quantitative mechanism of raising a large number of views, votes or friends. To this end, another under-examined yet important issue should be noted: the musicians' affectivity. In the

digital field of cultural production, the perpetuation of exploitation is not always related to musicians' inability to calculate the losses and gains; sometimes there is a level of irrationality based on abstract and subjective concepts, such as passion, love and desire (or "paying dues"), which can also play a pivotal role in the act of exploitation.

While I argue that a variety of issues contributes to the fabric of exploitation, such as digital capitalism, the reliance on the "belief" in a collective or a few important cultural intermediaries, and the impact of musicians' incalculable and intrinsic rewards, exploitation in the context of immaterial and free labor is yet fully unresolved. As mentioned in the introduction to this book, this topic can be studied from multiple perspectives. For instance, various musicians touched on the issue of free labor when they demanded to be paid by YouTube, and on Second Life, some of the users expressed that the labor on the site should be motivated by love, as other rewards are hard to come by. On Indaba Music, a transition is occurring in the way in which social networking sites create working relationships with musicians —at this juncture, it is too early to discern whether such relationships can be successful and if other social networking sites will follow the trend by initiating professional partnerships between musicians and corporations. In a similar vein, besides Indaba Music, several other websites exist not necessarily for the purpose of social networking, but to foster professional partnerships between independent musicians. For examples, Pump Audio, Versus Media, and Rumble Fish are website services that focus on licensing independent musicians' music for placement on various media outlets. These sites function as agents between musicians and the media industry.

In exploring the dynamics and conflicts between musicians and the mainstream corporations, the issues of why this happens and who is to be blamed are often framed in the dichotomy of the mainstream vs. grassroots/independent forces, wherein the latter is perceived to be under the subsumption of power (especially in the discourse of the popular music industry as introduced in Chapter Two). Nonetheless, underground musicians do not always resist or reject the presence of the mainstream industry, as often they embrace it as an opportunity for exposure, as a means to make money, and as a conduit to build connections. Nonetheless, Andrejevic (2011) notes that "exploitation is not definable solely in terms of subjective sensibility: it is not reducible to whether or not individuals feel they are the victims of exploitation" (p. 91). If this is true, how and when do outsiders claim exploitation in the digital field of cultural production? While the issues of digital capitalism and immaterial and free labor are becoming more convoluted because of the nebulous boundary created by free labor, mixed motives, and rewards, another important line of inquiry pertains to how our culture wrestles with the labor motivated by love and intrinsic rewards.

If we choose to raise awareness to the possible exploitation of musicians on social networking sites due to digital capitalism or the nature of the contentious art world, what alternate values can we embrace? Do we claim more monetary and concrete rewards as an exchange value to musicians' free labor? This is not a simple matter for artists. For non-artist groups, those who are not laboring for their own brands and individual artistry, stepping away from the exploitation issue is simpler. In a case study of the co-creative gaming industry, Banks and Humphrey (2008) note that once the avid, amateur gamers' leisurely involvement in creating new games became serious "work," they no longer wanted to participate in the process of co-creation. The Auran gamers took up the gaming project as a pastime, but when project deadlines conflicted with the demands of their professional jobs, the amateur game developers were no longer inspired to continue their involvement. To this end, amateur game developers were able to exercise their agencies when they refused to allow their free labor to be expended under the disguise of labors of love.

For musicians, rejecting the nature of the online environment is not so easy since the rewards for "exposure" are often enough of a reason to upload music on YouTube, MySpace, and other websites. However, this does not mean that no agency can be exercised by the musicians, but the exertion of agency will need to become a collective force since a few complaints by one or two individuals on a grand, decentralized social network will have hardly any impact (as shown in the various case studies). However, it is critical to understand that often the instances of exploitation are so subtle and ambiguous that they would be difficult to use in legal cases. The example of Billy Bragg questioning the Bebo social network in Chapter Two is a case in point. Often because musicians have chosen to freely partake in the social networks, the claims of exploitation are often dismissed. Nonetheless, these issues should be explored and studied in the context of moral or ethical frameworks.

Thus, this final chapter recapitulates the dilemma that I have explored in detail. Rather than equating the social media trend with the introduction of "Culture Industry 2.0," I locate this conundrum within the larger landscape of contemporary culture. This issue relates directly to collective outlooks and attitudes: Where do we place the merits of arts? Especially with the rise of the social media and the rampancy of music, has the appreciation for the arts increased now that more music is readily available for free? Musicians and music are freely available; nevertheless, the competition has become fiercer, although on the surface more appreciation for music seems to be occurring. Perhaps it is true that, in the end, musicians have become service workers. Much of what enlivens the debate of empowerment vs. exploitations in the context of digital capitalism pertains to the vexing uncertainty of where the line of demarcation between work and play lies. Although Adorno and Horkehiemer's concern that the arts would turn into

commodities still exists today, another layer of predicament exists in the social media age. If the art sector remains free of commercial and commodity issues, the field will be shaped by the digital economy with its strong emphasis on intrinsic pleasure which, in turn, often profits the major industries.

If the art sector adopts the models of the market and commerce sectors, standards and criteria similar to those that govern the mainstream industry's successful paradigm will undoubtedly be imposed as a dominant mode of evaluation; thus, it may further delimit other evaluative mechanisms (as noted by Bourdieu). This could create a further conflict of interests between grassroots and corporate values. Although for some, this issue may seem rather pessimistic and repetitive, as I conclude our current discussion, I wish to emphasize the urgent need to discuss the subtleties of the issues without devolving into polarization. As shown in all four case studies, the examples of the mainstream music industry's online involvement with musicians ranges from revolutionary to positive to borderline exploitative. While this book only captures a fleeting moment in the social media age through the prism of four case studies on musicians and the music industry, my future research will continue to investigate how the art world's drive for recognition and "collective beliefs" operates in close parallel to the advancements of technology and digital capitalism.

References

Aabye, A. (2007, December 29). *Best of SL live 2008 kick off!!!* Message posted to http://thebestofSecond Life.com/index.php?option=com_content&task=view&id=26&Itemid=2

Adib, D. (2009). Pop star Justin Biever is on the brink of superstardom. *Abcnews*. Retrieved from http://abcnews.go.com/GMA/Weekend/teen-pop-star-justin-bieber-discovered-youtube/story?id=9068403#.TwxCIc2KXsI

Adorno, T., W. (1998). On popular music. In J. Storey (Ed.), *Cultural theory and popular culture: A reader* (pp. 197–209). New York: Prentice Hall. (Original work published 1942).

Adorno, T. W. (2001). *Theodor W. Adorno: The culture industry—Selected essays on mass culture* (J. M. Bernstein, Ed.). London and New York: Routledge. (Original work published 1944)

Andrejevic, M. (2008). Watching television without pity: The productivity of online fans. *Television & New Media, 9*(1), 24–46.

Andrejevic, M. (2007). *iSpy: surveillance and power in the interactive era*. Lawrence: University Press of Kansas.

Andrejevic, M. (2011). Social network exploitation. In Z. Papacharissi (Ed.), *A networked self: Identity, community, and culture on social networking sites* (pp. 82–102). New York and London: Routledge.

Andrews, R. (2006). Second Life rocks (literally). *Wired*. Retrieved from http://www.wired.com/techbiz/it/news/2006/08/71593

Arango, T. (2009). As rights clash on YouTube, some music vanishes. *The New York Times*. Retrieved from http://www.nytimes.com/2009/03/23/business/media/23warner.html?pagewanted=all

Arrington, M. (2009). An embarrassed Warner Music regrets MySpace music deal. *Tech Crunch*. Retrieved from http://www.techcrunch.com/2009/04/14/an-embarrassed-warner-music-regrets-MySpace-music-deal/

Arvidsson, A. (2005a). The logic of brand. Retrieved from http://www.scribd.com/doc/110246/The-Logic-of-the-Brand-by-Adam-Arvidsson?page=1

Arvidsson, A. (2005b). Brands: A critical perspective. *Journal of Consumer Culture, 5*(2), 235–258

Arvidsson, A. (2006). *Brands: Meaning and value in media culture*. London & New York: Routledge.

Arvidsson, A. (2007). Creative class or administrative class? On advertising and the 'underground'. *Ephemera: Theory & politics in organization, 7*(1), 8–23.

Asiann-from Japan. (2008, April, 7). MySpace. Messaged posted to http://blogs.MySpace.com/index.cfm?fuseaction=blog.view&friendId=4089821&blogId=371912935

Ayers, M. D. (2009a). Lily Allen welcomes new album at MySpace show. *Billboard.* Retrieved February 13, 2009 from http://www.billboard.com/bbcom/news/lily-allen-welcomes-new-album-at-MySpace-1003940436.story

Ayers, M. D. (2009b). Def Leppard gets interactive for summer tour. *Billboard.* Retrieved July 2, 2009, from http://www.billboard.com/bbcom/news/def-leppard-gets-interactive-for-summer-1003981636.story

Banks, J., & Deuze, M. (2009). Co-creative labour. *International Journal of Cultural Studies, 12*(5), 419–431.

Banks, J., & Humphreys, S. (2008). The labour of user co-creators: Emergent social network markets? *Convergence: The International Journal of Research into New Media Technologies,* 14(4), 401–418.

Banks, J., & Potts, J. (2010). Co-creating games: A co-evolutionary analysis. *New media & media, 12*(2), 253–270.

Baym, N. K. (2007). The new shape of online community: The example of Swedish independent music fandom. *First Monday.* Retrieved from http://firstmonday.org/htbin/cgiwrap/bin/ojs/index.php/fm/article/view/1978/1853

Baym, N. K., & Burnett, R. (2009). Amateur experts: International fan labor in Swedish independent music. *International Journal of cultural studies, 12*(5), 1–17.

Beck, C. (2009, February, 1). The Indaba voting system. Message posted to http://www.indabamusic.com/forums/5/topics/2673

Becker, H. (1982). *Art worlds.* Berkeley and Los Angeles: University of California Press.

Billboard. (2008). April fools get rickrolling. Retrieved from http://www.billboard.com/bbcom/esearch/article_display.jsp?vnu_content_id=1003783845

Billboard Staff (2010). Power players: 30 under 30. *Billboard.biz.* Retrieved from http://www.billboard.biz/bbbiz/content_display/magazine/features/e3i146f59304cd52ab853707a2918ff0bb9

Billboard.biz. (2011). Billboard launches uncharted, the first ever ranking of undiscovered artists. Retrieved from http://www.billboard.biz/bbbiz/industry/indies/billboard-launches-uncharted-the-first-ever-1004139757.story

Boellstorff, T. (2008). *Coming of age in second life: An anthropologist explores the virtual human.* Princeton, NJ: Princeton University Press.

Bonsu, S. K., & Darmody, A. (2008). Co-creating second life: Market-consumer cooperation in contemporary economy. *Journal of Macromarketing, 28*(4), 355–368.

Boorstin, J. (2011). MySpace finally sold for some $35 million. *Christian Science Monitor.* Retrieved from http://www.csmonitor.com/Business/Latest-News-Wires/2011/0629/MySpace-finally-sold-for-some-35-million

Boris, C. (2010). News Corp to MySpace: Shape Up or Ship Out. Retrieved from http://www.marketingpilgrim.com/2010/11/news-corp-to-MySpace-shape-up-or-ship-out.html

Born, G. (1993). Against negation, for a politics of cultural production. *Screen, 34* (3), 223–242.

Bourdieu, P. (1984). *Distinction: A social critique of the judgement of taste.* London: Routledge.

Bourdieu, P. (1986) The forms of capital. In J. Richardson (Ed.) *Handbook of theory and research for the sociology of education* (pp. 241–258). New York: Greenwood.

Bourdieu, P. (1993). *The field of cultural production.* (R. Johnson, Ed.). New York: Columbia University Press.

Bourdieu, P., & Wacquant, L. J. D. (1992). *An invitation to reflexive sociology.* Chicago: The University of Chicago Press.

Bozung, T. (2008, Febrary 29). Session intent. Message posted to http://www.indabamusic.com/forums/3/topics/160

Brabazon, T. (2005). 'What have you ever done on the telly?' The office, (post) reality television and (post) work. *International Journal of Cultural Studies, 8*(1), 101–117.

Brabham, D. C. (2008). Crowdsourcing as a model for problem solving: An introduction and cases. *Convergence: The International Journal of Research into New Media Technologies, 14*(1), 75–90.

Bratich, J. (2010). Affective convergence in reality television: A case study in divergence culture. In M. Kackman, M. Binfield, M. T. Payne & A. Perlman (Eds.), *Flow TV: Essays on convergent medium.* pp 64–65. New York: Routledge.

Bragg, B. (2008). The royalty scam. *New York Times.* Retrieved from http://www.nytimes.com/2008/03/22/opinion/22bragg.html

Businessweek (2005) The MySpace generation. Retrieved from www.businessweek.com/magazine/content/05_50/b3963001.htm

Burgess, J., & Green, J. (2009). *YouTube: Online video and participatory culture.* London: Polity Press.

Burnett, R. (1996). *The global jukebox: the international music industry.* London, New York: Routledge.

Chartier, D. (2009). Indaba Music: Social networking meets online jam sessions. *ars technica.* Retrieved from http://arstechnica.com/media/news/2009/01/indaba-music-your-collaboration-studio-and-classifieds.ars

Chmielewski, D.C. (2009). Universal music, YouTube forge partnership. *Los Angeles Times.* Retrieved from http://articles.latimes.com/2009/apr/10/business/fi-ct-youtube10

Chloe. (n.d.). Is my-space a dying trend? Message posted to http://answers.yahoo.com/question/index?qid=20080812060415AAp7onz

Cohen, N. S. (2008). The valorization of surveillance: Towards a political economy of facebook. *Democratic Communique, 22*(1), 5-22.

Colman, C. (2007, April 17). Second Life music study: Initial findings. Message posted to http://www.rikomatic.com/blog/2007/02/second_life_mus.html

Concepcion, M. (2008a). Exclusive: Millian signs with MySpace records. *Billboard.* Retrieved from http://www.billboard.com/bbcom/esearch/article_display.jsp?vnu_content_id=1003852976

Concepcion, M. (2008b). Soulja Boy: Soulja of fame. *Billboard.* Retrieved from http://www.billboard.com/bbcom/feature/soulja-boy-soulja-of-fortune-1003924766.story?pn=1

Contactmusic (2007). James Blunt–Warner to sell Blunt album on MySpace. Retrieved from http://www.contactmusic.com/news.nsf/article/warner%20to%20sell%20blunt%20album%20on%20MySpace_1044023

Coolfer (2006). Ok go chart shows growth from YouTube. *Coolfer: Music and Industry.* Retrieved from http://www.coolfer.com/blog/archives/2006/08/ok_go_chart_sho.php

Cote, M., & Pybus, J. (2007). Learning to immaterial labour 2.0: MySpace and social networks. *Ephemera: Theory and Politics in Organization, 7*(1), 88–106.

Crosley, H. (2008). Monica gets busy on sixth album. *Billboard.* Retrieved from http://www.billboard.com/bbcom/news/monica-gets-busy-on-sixth-album-1003922819.story

Cutler, M. (2007). The world is your workstation. *Electronic Musician.* Retrieved from http://emusician.com/tutorials/musicians_online_collaboration/

Demetrious, K. (2008). Secrecy and illusion: Second Life and the construction of unreality. *Australian Journal of Communication, 35*(1), 1–13.

Deutschaland (Vileseck Germany) (2008, April 7). MySpace. Message posted to http://blogs.MySpace.com/index.cfm?fuseaction=blog.view&friendId=4089821&blogId=371912935

Deuze, M. (2006). Ethical media, community media and participatory culture. *Journalism, 7*(3), 262–280.

Deuze, M. (2007). Convergence culture in creative industries. *International Journal of Cultural Studies, 10*(2), 243–263.

Diehl, W., C., & Prins, E. (2008). Unintended outcomes in Second Life: Intercultural literacy and cultural identity in a virtual world. *Language & Intercultural Communication, 8*(2), 101–118.

Dolfsma, W. (1999). *Valuing pop music: Institution, values, and economics.* Delft: Eburon.

Ellison, N. B., Steinfield, C., & Lampe, C. (2007). The benefits of facebook "friends": Social capital and college students' use of online social network sites. *Journal of Computer-Mediated Communication, 12*(4), 1143–1168.

Enzensberger, H. (1974). Constituents of a theory of the media. In *The consciousness industry: On literature, politics and the media* (pp. 95–128). New York: The Seabury Press.

Fiske, J. (1989a). *Reading the popular*. Boston: Unwin Hyman.

Fiske, J. (1989b). Popular discrimination. In *Understanding popular culture* (pp. 129–158). Boston: Unwin Hyman.

Fiske, J. (1998). The popular economy. In J. Storey (Ed.), *Cultural theory and popular culture: A reader* (2nd ed., pp. 504–521). New York: Prentice Hall.

Friday, Rebecca Black Song (n.d.). Retrieved from http://en.wikipedia.org/wiki/Friday_(Rebecca_Black_song)

Frith, S. (2001). The popular music industry. In S. Frith, W. Straw and P. Street (Eds.), *The Cambridge Companion to rock and pop* (pp. 26–52). Cambridge: Cambridge University Press.

Frith, S. (1991). The good, the bad, and the indifferent: Defending popular culture from the populists. *Dialectics, 21*(4), 102–115.

Frith, S. (1987). *Art into pop*. New York: Methuen & Co.

Frith, S. (1988). *Facing the music: A pantheon guide to popular culture*. New York: Pantheon Books.

Garrity, B. (2006). Billboard bits: Dixie Chicks, Rolling Stone, YouTube. Retrieved from http://www.billboard.com/bbcom/esearch/article_display.jsp?vnu_content_id=1003155201

Gehl, R. (2009). YouTube as archive: Who will curate this digital wunderkammer? *International Journal of Cultural Studies, 12*(1), 43–60.

Gibbs, A. (2002). Disaffected, *Continuum: Journal of Media & Cultural studies. 16* (3), 335–341.

Gill, R., & Pratt, A. (2008). In the social factory? Immaterial labour, precarious cultural work. *Theory, Culture & Society, 25*(7–8), 1–30.

Gitelman, L. (2006). *Always already new: Media, history and the data of culture*. Cambridge, MA: MIT Press.

Glazowski, P. (2008). Billy Bragg tells Bebo to give some of his millions to the musicians. Mashable. Retrieved from http://mashable.com/2008/03/22/bragg-bebo/

Goldberg, J. (2004). *The ultimate survival guide to the new music industry: handbook for hell*. Hollywood, CA: Lone eagle.

Graff, G. (2007). Def Leppard nearly complete with "sparkly" new album. *Billboard*. Retrieved from, http://www.billboard.com/bbcom/esearch/article_display.jsp?vnu_content_id=1003598111

Grant. (n.d.). Is my-space a dying trend? Message posted to http://answers.yahoo.com/question/index?qid=20080812060415AAp7onz

Hall, S. (1998). Notes on deconstructing "the popular". In J. Storey (Ed.), *Cultural theory and popular culture: A reader* (pp. 442–453). New York: Prentice Hall. (original work published 1981).

HammaHouse (2008, November 24). The Indaba voting system. Message posted to http://www.indabamusic.com/forums/5/topics/2673

Hardt, M. (1999). Affective labor. *Boundary2 26*, 89–100.

Hardt, M. & Negri, A. (2000). *Empire*. Cambridge, MA: Harvard University Press.

Harmony Central (2007). Indaba Music launching advanced online production console for online collaboration/recording. Retrieved from http://news.harmony-central.com/Product-news/Indaba-Music-Production-Console.html

Hasty, K. (2008). Foo Fighter to rock with fans at grammys. *Billboard*. Retrieved July 4, 2009 from http://www.billboard.com/bbcom/esearch/article_display.jsp?vnu_content_id=1003691455

Hearn, A. (2010). Structuring feeling: Web 2.0, online ranking and rating, and the digital "reputation" economy. *Ephemera: Theory & politics in organization, 10*(3/4), 421–438.

Helfrich, D. (2008). Retrieved from http://www.myspace.com/ceciliasuhr/blog/371912935

Helfrich, D. (2008, April, 10). Myspace. Message posted to http://blogs.myspace.com/index.cfm?fuseaction=blog.view&friendId=4089821&blogId=371912935

Helft, M. (2010). For MySpace, a redesign to entice generation Y. *New York Times*. Retrieved From http://www.nytimes.com/2010/10/27/technology/27MySpace.html?_r=2&ref=MySpace_com

Helm, M. H. (2008, April, 12). MySpace. Message posted to http://blogs.MySpace.com/index.
cfm?fuseaction=blog.view&friendId=4089821&blogId=371912935

Herrera, M. (2009). Zee Avi. *Billboard*. Retrieved from http://www.billboard.com/bbcom/
breakenter/zee-avi-1003981967.story

Hesmondhalgh, D. (1997). Post-punk's attempt to democratise the music industry: The success and
failure of rough trade. *Popular Music, 16*(3), 255–274.

Hesmondhalgh, D. (1998) The British dance music industry: A case study in independent cultural
production, *British Journal of Sociology 49*(2), 234–251.

Hesmondhalgh, D. (1999). Indie: The institutional politics and aesthetics of a popular music genre.
Cultural studies, 13(1), 34–61.

Hesmondhalgh, D. (2006). Bourdieu, the media and cultural production. *Media Culture & Society,
28*(2), 211–231.

Hesmondhalgh, D. (2010). User-generated content, free labour and the cultural industries.
Ephemera: Theory & politics in organization, 10(3/4), 267–284.

Hesmondhalgh, D., & Baker, S. (2008). Creative work and emotional labour in the television
industry. *Theory, Culture & Society, 25*(7–8), 97–118.

Hesmondhalgh, D., & Negus, K. (2002). *Popular music studies*. London: Arnold.

Hesmondhalgh, D., & Pratt, A. C. (2005). Cultural industries and cultural policy. *International
Journal of Cultural Policy, 11*(1), 1–13.

Hiatt, B (2006). New ways of marketing artists, *Rolling Stone* 658 (November): 13.

Hiatt, B. (2007). Radiohead's Jonny Greenwood on *In Rainbows*: It's fun to make people think
about what music is worth, *Rolling Stone*, Retrieved December 2, 2008 from http://www.
rollingstone.com/rockdaily/index.php/2007/10/10/radioheads-jonny-greenwood-on-in-
rainbows-its-fun-to-make-people-think-about-what-music-is-worth/

Howe, J. (2005). The hit factory. *Wired Magazine, 13*. Retrieved from http://www.wired.com/
wired/archive/13.11/MySpace.html

Howe. J. (2006). The rise of crowdsourcing. *Wired*. Retrieved from http://www.wired.com/wired/
archive/14.06/crowds.html

Howe, J. (2008). *Crowdsourcing: Why the power of the crowd is driving the future of business*. New
York: Crown Business.

Howley, K. (2000). Radiocracy rulz!: Microradio as electronic activism. *International Journal of
Cultural Studies, 3*(2), 256–267.

Hutcheon, S. (2006). Second Life party animals. *The Sydney Morning Herald*. Retrieved from http://
www.smh.com.au/articles/2006/10/20/1160851121653.html

Huws, U. (2010). Expression and expropriation: The dialectics of autonomy and control in creative
labour. *Ephemera: Theory & politics in organization*, 10(3/4), 504-521.

Indaba Music collaboration (n.d.a). Retrieved from http://www.indabamusic.com/tour/collaboration

Indaba Music content archives. (n.d.b). Retrieved from www.indabmusic.com/contests/archives)

Indaba Music project. (2009). Retrieved from http://www.indabamusic.com/forums/2/topics/3234

Jannice, J. (2009). Bowing for Yo-Yo. *Yale Daily News*. Retrieved from http://www.yaledailynews.
com/articles/view/27004

Jadeius-the-Vndead. (April, 6, 2008). Unfair ranking system on MySpace's music chart. Message
posted to http://forums.MySpace.com/rss.aspx?ThreadID=3882325

Jag, N. (2008). *MySpace marketing: The promotional revolution the 2nd edition*. Charleston: Booksurge.

JC Lemay (2009, April 11). Future content voting. Message posted to http://www.indabamusic.
com/forums/5/topics/4863

Jenkins, H. (1992). *Textual poacher: Television fans & participatory culture*. New York: Routledge.

Jenkins, H. (2003). Quentin Tarantino's Star Wars? Digital cinema, media convergence, and
participatory culture. In. H. Jenkins, D. Thorburn & B. Seawell (Eds.), *Rethinking media
change: The aesthetics of transition* (pp. 281–314). Cambridge, MA: The MIT Press.

Jenkins, H. (2006). Introduction. "Worship at the altar of convergence": A new paradigm for
understanding media change. In *Convergence culture*, (pp. 1–24). New York & London: New
York University Press.

Jenkins, H. (2009). What happens before YouTube. In *YouTube: Online video and participatory culture* (pp. 109–125). Cambridge, UK: Polity.

Jensen, J. (2005). Introduction-on fandom, celebrity, and mediation: Posthumous Possibilities. In S. Jones & J. Jensen (Eds.), *Afterlife as afterimage: Understanding posthumous fame* (pp. xv-2). New York: Peter Lang.

Jones, S. (2005). Better off dead: Or, making it the hard way. In S. Jones & J. Jensen (Eds.), *Afterlife as afterimage: Understanding posthumous fame* (pp. 3-16). New York: Peter Lang.

Kahn, J.P. (2008). Nonfamily humor, straight from home. *The Boston Globe*. Retrieved from http://www.boston.com/ae/theater_arts/articles/2008/02/13/nonfamily_humor_straight_from_home/?page=full

Kahn, R. & Kellner, D. (2004). New media and Internet activism: From the "Battle of Seattle" to blogging. *New Media & Society, 6*(1), 87–95.

Kalliongis, N. (2008). *MySpace music profit monster!: Proven online marketing strategies!* New York: MTV Press.

Kar, Naveen. (2010). Facebook and MySpace merger prove market leadership in social networking. *Seer Press News*. Retrieved from http://seerpress.com/facebook-and-MySpace-merger-prove-market-leadership-in-social-networking/14595/

Kilgore, Kym. (2007). MySpace phenom Colbie Caillat hits the highway. *Livedaily*. Retrieved from http://www.livedaily.com/news/12812.html

Kincaid1. (n.d.). Is my-space a dying trend? Message posted to http://answers.yahoo.com/question/index?qid=20080812060415AAp7onz

King, B. (2010). On the new dignity of labour. *Ephemera: Theory & Politics in Organization, 10*(3/4), 285–302.

Klein, N. (2000). *No logo*. London: Harpers Collins.

Knab, C., & Day, B., F. (2007). *Music is your business* (third ed.). Seattle: FourFront Media and Music

Kreps, D. (2008). "Second Life" blues man gets record deal in real life. *Rolling Stone*. Retrieved from http://www.rollingstone.com/rockdaily/index.php/2008/08/14/second-life-bluesman-gets-record-deal-in-real-life/

Laing, D. (2003). Music and the market: The economics of music in the modern world. In C. Martin, H. Trevor, & R. Middleton (Eds.), *The cultural study of music: A critical introduction*. London and New York: Routledge.

Lange, P., G. (2008). Publicly private and privately public: Social networking on YouTube. *Journal of Computer-Mediated Communication, 13*(1), 361–380.

Lastufka, A., & Dean Michael, W. (2009). *YouTube: An insider's guide to climbing the charts*. Sebastopol CA: O'Reilly Media.

Lazzarato, M. (1996). "Immaterial labor" Retrieved from http://www.generation-online.org/c/fcimmateriallabour3.html

Lee, S. (1995). Re-examining the concept of the 'independent' record company: The case of was trax! Records. *Popular Music*, 14(1), 13-31.

Leopold, T. (2007). Musician finds second act—and Second Life. *CNN*. Retrieved February 9, 2009 from http://www.cnn.com/2007/SHOWBIZ/Music/04/25/michael.penn/index.html

Letowsky, R. C. (2002). Note: Broke or exploited: The real reason behind artist bankruptcies. *Cardozo Arts & Entertainment Law Journal, 20*(3), 625–648.

Levitin, D. (1992). *From demo tape to record deal: A musician's guide to creating and marketing effective demo tapes*. Van Nuys, CA: Alfred Publishing.

Levy, F. (2008). *15 mintues of fame: Becoming a star in YouTube revolution*. Exton: Apha.

Levy, P. (1997). Art and architecture of cyberspace. In *Collective intelligence: Mankind's emerging world in cyberspace*. (R. Bononno, Trans.). New York & London: Plenum Trade. (Original work published 1956)

Live performances. (n.d.). Second Life Wiki. Retrieved from http://wiki.Second Life.com/wiki/Live_Performance_Home

Love My Hubby-Hate His Mom. (n.d.). Is my-space a dying trend? Message posted to http://answers.yahoo.com/question/index?qid=20080812060415AAp7onz

Ludlow, P. (2007). *The Second Life Herald: The virtual tabloid that witnessed the dawn of the metaverse.* Cambridge, MA: The MIT Press.

MacKensen, S. (2008, April 6). Unfair ranking system on MySpace's music chart. Message posted to http://forums.MySpace.com/rss.aspx?ThreadID=3882325

Maney, K. (2006). Blend of old, new media launched OK Go. *USATODAY.* Retrieved from http://www.usatoday.com/tech/news/2006-11-27-ok-go_x.htm

Mariah remix. (n.d.). Indabamusic. Retrieved from http://www.indabamusic.com/contests/show/mariah

Marwick, A. E. (2008). To catch a predator? The MySpace moral panic. *First Monday, 13*(1), Retrieved from http://firstmonday.org/htbin/cgiwrap/bin/ojs/index.php/fm/issue/view/266

Masnick, M. (2008). It's not exploitation if you chose to take part. *Techdirt.* Retrieved from http://www.techdirt.com/articles/20080322/142342625.shtml

Masnick, M. (2008). Warner music musicians pissed off about YouTube dispute. *Techdirt.* Retrieved from http://www.techdirt.com/articles/20081226/1719353221.shtml

Mauel a. (2009, April 18). Future contest voting. Message posted to http://www.indabamusic.com/forums/5/topics/4863

Maxplays (n.d.). Retrieved from http://www.maxplays.net.

McCarthy, C. (2007). Justin Timberlake sign Youtube star to new record label. *NewsBlog.* Retrieved from http://news.cnet.com/8301–10784_3–9726590–7.html

McGorry, C. (2008). MySpace. Retrieved from http://www.myspace.com/ceciliasuhr/blog/371912935

McQuail, D. (2005). *McQuail's mass communication theory.* London: Sage Publication.

Mendoza. T. (2008, April 27). MySpace. Message posted to http://blogs.MySpace.com/index.cfm?fuseaction=blog.view&friendId=4089821&blogId=371912935

Message, K. (2009). New directions for civil renewal in Britain: Social capital and culture for all? *International Journal of Cultural Studies, 12*(3), 257–278.

Midgette, A. (2007). Watching a cyber audience watch a real orchestra perform in a virtual world. *New York Times.* Retrieved from http://www.nytimes.com/2007/09/18/arts/music/18seco.html

Miller, M. (2008). *YouTube for business: Online video marketing for any business.* Indianapolis, IN: Que.

Morrow, G. (2009). Radiohead's managerial creativity. *Convergence: The International Journal of Research into New Media Technologies, 15*(2), 161–176.

Morini, C., & Fumagalli, A. (2010). Life put to work: Towards a life theory of value. *Ephemera: Theory & Politics in Organization, 10*(3/4), 234–252.

MySpace (n.d.) Retrieved from http://en.wikipedia.org/wiki/Myspace

Nakashima, R. (2009). MySpace layoffs: Slashing workforce 30 %. *HuffPost Media.* Retrieved from http://www.huffingtonpost.com/2009/06/16/MySpace-layoffs-slashing-_n_216330.html

Nakashima. R. (2011). Justin Timberlake part of group buying MySpace. MSNBC. Retrieved from http://www.msnbc.msn.com/id/43581327/ns/business-us_business/t/justin-timberlake-part-group-buying-MySpace/

Naxos (2009). Alessandro Marangoni plays Rossini piano music on Second Life. Retrieved from http://www.naxos.com/news/default.asp?op=570&displayMenu=Naxos_News&type=2

Negus, K. (1999). *Music genres and corporate culture.* London and New York: Routledge.

Negus, K. (2002). The work of cultural intermediaries and the enduring distance between production and consumption. *Cultural Studies, 16*(4), 501–515.

Negus, K., & Pickering, M. (2004). *Creativity, communication and cultural value.* Thousand Oaks, CA: Sage.

Negus, K. (2006). Rethinking creative production away from the cultural industries. In J. Curran & D. Morely (Eds.), *Media and cultural theory* (pp. 197–208). New York: Routledge.

Neyland, N. (2010). Billboard launches a chart based on social networking stats. Retrieved from http://www.prefixmag.com/news/billboard-launches-a-chart-based-on-social-network/46678/

Newscorp. (2005). News Corporation to acquire intermix media, Inc. Retrieved from http://www.newscorp.com/news/news_251.html

Nichols, S. (2007). Winners and losers at YouTube "Oscars." *PCAuthority* Retrieved July 4, 2009, from http://www.pcauthority.com.au/News/76898,winners-and-losers-at-youtube-oscars.aspx

Noam, E. M., & Lorenzo, M. P. (2008). *Peer-to-peer video: The economic policy, and culture of today's new mass medium.* New York: Springer.

Noelle W. (2009, April 11). Future contest voting. Message posted to http://www.indabamusic.com/forums/5/topics/4863

Novikov, A. (2008). Straight no chaser. Retrieved from http://www.billboard.com/bbcom/breakenter/straight-no-chaser-1003922913.story

NPR. (2009). From broadband to bands. Retrieved from http://www.npr.org/templates/story/story.php?storyId=97609219

O' Brien, K.J. (2009). Royalty dispute stops music videos in Germany. *The New York Times.* Retrieved from http://www.nytimes.com/2009/04/03/technology/internet/03youtube.html

Ong, W. (1982). *Orality and literacy: The technologizing of the word.* New York: Routledge.

Oswald, E. (2011, Jan. 13). MySpace CEO says that News Corp may be looking to sell. *Betanews.* Retrieved from http://www.betanews.com/article/MySpace-CEO-says-that-News-Corp-may-be-looking-to-sell/1294948502

Pybus, J. (2002). Affect and subjectivity: A case study of neopets.com. *Politics and Culture,* (2). Eds. Kumar, A. & Ryan, M. Retrieved from http://aspen.conncoll.edu/politicsandculture/page.cfm?key=557

Reily, D. (2007). Rumors of the decline of MySpace are exaggerated. *TechCruch.* Retrieved from http://www.techcrunch.com/2007/06/20/rumors-of-the-decline-of-MySpace-are-exaggerated/

Robert, A. (2006). Second Life rocks (literally). *Wired.* Retrieved from http://www.wired.com/techbiz/it/news/2006/08/71593

Ross, W. (2007). Live music on Second Life: Part two. *TheStreet.com.* Retrieved June 2, 2008, from http://www.thestreet.com/story/10376748/1/live-music-in-second-life-part-two.html?puc=relatedarticle

Russian, J. (2011). Jessica Black brings death threat. *A&E Playground.* Retrieved from http://artsandentertainmentplayground.com/2011/04/21/rebecca-black-friday-performance-brings-death-threats-police-investigate/

Sandoval, G. (2008a). Musicians still waiting on a YouTube payday. Retrieved July 2, 2009 from http://news.cnet.com/8301-10784_3-9887167-7.html

Sandoval, G. (2008b). EMI hires 'Second Life' co-founder. *NewsBlog.* Retrieved from http://news.cnet.com/8301-10784_3-9963039-7.html

Sandoval, G. (2009). Sony joins YouTube and Universal on vevo video site. *Cnet.* Retrieved from http://news.cnet.com/8301-1023_3-10257359-93.html

Sanjek, D. (2005). I give it a 94. It's got a good beat and you can dance to it: Valuing popular music. In M. Berube (Ed.), *The aesthetics of cultural studies* (pp. 117–139). Malden, MA: Blackwell Publishing.

Saukko, P. (2003). *Doing research in cultural studies: An introduction to classical and new methodological approaches.* London: Sage.

Scholz, T. (n.d.). What the MySpace generation should know about working for free. Retrieved from http://www.collectivate.net/journalisms/2007/4/3/what-the-MySpace-generation-should-know-about-working-for-free.html

Second Life. (n.d.). Second Life. Retrieved from www.Secondlife.com.

Self, W. (2009). Colbie Caillat's insight into her MySpace success. *CMT news.* Retrieved from http://www.cmt.com/news/country-music/1606830/colbie-caillats-insight-into-her-MySpace-success.jhtml

Servaes, J. (1999). *Communication for development: One world, multiple cultures.* Cresskill, NJ: Hampton Press.

Shefrin, E. (2004). *Lord of the Rings, Star Wars,* and participatory fandom: Mapping new congruencies between the internet and media entertainment culture. *Critical Studies in Media Communication, 21*(3), 261–281.

Shepherd, J., Wicke, P., Oliver, P., Laing, D., & Horn, D. (2003). *Continuum encyclopedia of popular music of the world* (Vol. 1). New York: Continuum.

Shuker, R. (2008). *Understanding popular music culture.* London & New York: Routledge.

Sonicstate. (2008). Notion YouTube competition. Retrieved from http://www.sonicstate.com/news/2008/04/03/notion-music-youtube-competition/

Sonybmgmusic. (2008). U.S. Youtube competition. Retrieved from http://www.sonybmgmusic.co.uk/news/10061/

Smith, M. (2007). Unmaking the band: Social network for musicians takes face time out of studio time. *ABC News: Technology and Science.* Retrieved March 1, 2009 from, http://abcnews.go.com/Technology/TenWays/Story?id=3750858&page=1

Smith, D. (2009). MySpace shrinks as Facebook, Twitter and Bebo grabs its user. Guardian.co.uk. Retrieved April 3, 2009 from http://www.guardian.co.uk/technology/2009/mar/29/MySpace-facebook-bebo-twitter

Stahler, K. (2011). Rebecca Black is in Katy Perry's "Last Friday" video. *Hollywood.com* Retrieved from http://www.hollywood.com/news/Rebecca_Black_Is_In_Katy_Perrys_Last_Friday_Night_Video/7805127

Steib, A. (2009). YouTube orchestra wows Carnie Hall. CNN.com. Retrieved from http://www.cnn.com/2009/TECH/04/16/youtube.orchestra/index.html?eref=rss_tech

Strachan, R. (2007). Micro-independent record labels in the UK: Discourse, DIY cultural production and the music industry. *European Journal of Cultural Studies, 10*(2), 245–265.

Suhr, H.C. (2008). The role of intermediaries in the consecration of arts on MySpace.com. *International Journal of Media and Cultural Politics, 4*(2), 259–263.

Suhr, H.C. (2008a). The role of participatory media in aesthetic taste formation: How do amateurs critiques music performances and videos on Youtube.com? *The International Journal of Technology, Knowledge and Society, 4*(2), 215–222.

Suhr, H. C. (2009). Underpinning the paradoxes in the artistic fields of MySpace: The problematization of values and popularity in convergence culture. *New Media & Society, 11*(1–2), 178–198.

Suhr, H. C. (2010). Understanding the emergence of social protocols on MySpace: Impact and its ramifications. *Comunicar: Scientific Journal of Media Education, 17*(34), 45–53.

Sutter, J.D. (2009). Artists visit virtual Second Life for real-world cash. *CNN.* Retrieved from http://edition.cnn.com/2009/TECH/04/07/second.life.singer/

Sweetbeat. (2011). Rebecca Black has "gotta get down" at the OMAs. *A Sweet Beat.* Retrieved from http://www.asweetbeat.com/tag/friday/

Sweetmuseek. (2008, December 2). MySpace. Message posted to http://blogs.MySpace.com/index.cfm?fuseaction=blog.view&friendId=4089821&blogId=371912935

Sweney, M. (2008). MTV and MySpace band together. Retrieved from http://www.guardian.co.uk/media/2008/mar/03/television.MySpace.

Terranova, T. (2004). *Network Culture: Politics for the Information Age.* London: Pluto Press.

Thompson, P. (2005). Foundation and empire: A critique on Hardt and Negri. *Capital and Class, 86,* 73–98.

Toolsmith (n.d.). Retrieved from http://www.thetoolsmith.com

Toynbee, J. (2000). *Making popular music: Musicians, creativity and institutions.* New York: Arnold.

Ulf.S. (2009, February 18). Feedback and request/published collaborations. Message posted to http://www.indabamusic.com/forum_posts/search?q=i+took+part+in+a+collaboration+and+we

Ultimateguitar. (n.d.). Ok Go become worldwide popular owing to YouTube. Retrieved July 11, 2009, from http://www.ultimate-guitar.com/news/general_music_news/ok_go_become_worldwide_popular_owing_to_youtube.html

Van Buskirk, E. (2008). MySpace, major labels join forces for online music store. *Wired.* Retrieved from http://blog.wired.com/music/2008/04/MySpace-partner.html

Van Buskirk, E. (2009). Indaba Music goes mainstream on *Colbert Report. Wired.* Retrieved from http://www.wired.com/epicenter/2009/02/indaba-music-go/

Vincent, F. (2007). *MySpace for musicians.* Boston: Course Technology PTR

Walsh, T. (2006). Who really owns your 'Second Life'? *Clickable Culture.* Retrieved from http://www.secretlair.com/index.php?/clickableculture/entry/who_really_owns_your_second_life/

Wauters, R. (2009). Artist finds his own video removed from YouTube, lashes out on Twitter. *Billboard.* Retrieved from http://www.techcrunch.com/2009/07/23/artist-finds-his-own-music-video-removed-from-youtube-lashes-out-on-twitter/

Wauters, R. (2010). After more than 10 years, indie music community GarageBand.com folds. Retrieved from http://techcrunch.com/2010/06/24/garageband/

Weber, S. (2007). *Plug your business! Marketing on MySpace, YouTube, Blogs, podcasts and other 2.0. social network.* Weberbooks. (online publisher, city unknown)

Wells, A., & Hakanen, E.A. (1997). *Mass media & society.* New York: Ablex Publishing.

What do I do during the show? (2008). Second life music community forum. Message posted to http://slmc.myfastforum.org/What_do_I_do_during_the_show__about2099.html

Wikstrom, P. (2010). *The music industry: Music in the cloud.* Cambridge, UK: Polity Press.

Wissinger, E. (2007). Modelling a way of life: Immaterial and affective labor in the fashion modelling industry. *Ephemera: Theory & politics in organization, 7*(1), 250–269.

Wolff, J. (1981). *The social production of art.* London: Macmillan.

Yang, L. (2009). All for love: The Corn fandom, prosumers, and the Chinese way of creating a superstar. *International Journal of Cultural Studies, 12*(5), 527–543.

Ying, H. (2007). *Youtube-making money by video sharing and advertising your business for free.* Ontario: Self-help publisher.

Yo Yo Ma contest (2009). Indabamusic. Retrieved from http://www.indabamusic.com/contests/show/yo-yomacontest

Ziv, N. (2008). An exploration on community-based innovation: Indabamusic as a case in point. Proceedings from PICMET '08, Portland International Conference on Management of Engineering & Technology, Cape Town: South Africa

Index

...

General Editor: *Steve Jones*

Digital Formations is the best source for critical, well-written books about digital technologies and modern life. Books in the series break new ground by emphasizing multiple methodological and theoretical approaches to deeply probe the formation and reformation of lived experience as it is refracted through digital interaction. Each volume in **Digital Formations** pushes forward our understanding of the intersections, and corresponding implications, between digital technologies and everyday life. The series examines broad issues in realms such as digital culture, electronic commerce, law, politics and governance, gender, the Internet, race, art, health and medicine, and education. The series emphasizes critical studies in the context of emergent and existing digital technologies.

Other recent titles include:

Felicia Wu Song
 *Virtual Communities: Bowling Alone, Online
 Together*

Edited by Sharon Kleinman
 *The Culture of Efficiency: Technology in
 Everyday Life*

Edward Lee Lamoureux, Steven L. Baron, &
 Claire Stewart
 *Intellectual Property Law and Interactive
 Media: Free for a Fee*

Edited by Adrienne Russell & Nabil Echchaibi
 *International Blogging: Identity, Politics and
 Networked Publics*

Edited by Don Heider
 Living Virtually: Researching New Worlds

Edited by Judith Burnett, Peter Senker
 & Kathy Walker
 *The Myths of Technology:
 Innovation and Inequality*

Edited by Knut Lundby
 *Digital Storytelling, Mediatized
 Stories: Self-representations in New
 Media*

Theresa M. Senft
 *Camgirls: Celebrity and Community
 in the Age of Social Networks*

Edited by Chris Paterson & David
 Domingo
 *Making Online News: The
 Ethnography of New Media
 Production*

To order other books in this series please contact our Customer Service Department:

(800) 770-LANG (within the US)

(212) 647-7706 (outside the US)

(212) 647-7707 FAX

To find out more about the series or browse a full list of titles, please visit our website:

WWW.PETERLANG.COM